Image and Insight

PSYCHOANALYSIS AND CULTURE
Arnold M. Cooper, M.D. and Steven Marcus, editors

Frontispiece. Demeter of Knidos (c. 340/330 B.C.).
Greek marble, round; ht. 147 cm. British Museum, London. Photo cr.: Hirmer Verlag München.

ELLEN HANDLER SPITZ

Image and Insight

Essays in Psychoanalysis and the Arts

COLUMBIA UNIVERSITY PRESS NEW YORK

Columbia University Press
New York Oxford
Copyright © 1991 Columbia University Press
All rights reserved

Library of Congress Cataloging-in-Publication Data
Spitz, Ellen Handler
Image & insight : essays in psychoanalysis and the arts / Ellen
Handler Spitz.
p. cm. — (Psychoanalysis and culture)
Includes bibliographical references and index.
ISBN 0–231–07296–1
1. Psychoanalysis and the arts. I. Title. II. Title: Image and
insight. III. Series.
NX180.P7S65 1990
700'.1'05—dc20
90–39116
CIP

Casebound editions of Columbia University Press books are Smyth-sewn
and printed on permanent and durable acid-free paper

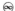

Printed in the United States of America
c 10 9 8 7 6 5 4 3 2 1

For my beloved father
Leslie Handler
whose
wisdom, patience, and courage
are laced with
an effervescent dash of playfulness

CONTENTS

PREFACE

God guard me from those thoughts men think
In the mind alone;
He that sings a lasting song
Thinks in the marrow bone.

—William Butler Yeats

Once after I had delivered an illustrated lecture on the paintings of
Magritte to an assemblage of clinicians at the Eitanim Hospital in
Jerusalem, a member of the audience rose and—in a voice crackling
with an anger that singed the cool reasonableness of his words—
announced that up to that moment he had always enjoyed Ma-
gritte's art. My lecture, however, had destroyed the pictures for him
forever. Never again would he be able to look at them without
thinking of the psychoanalytic interpretations I had made. He went
on to declare that he saw no point to analyzing art, which should
exist in a privileged realm and not be subjected to the kind of
scrutiny he had just heard.

As you can imagine, this gentleman's comment engendered a
lively debate among other members of the audience, many of whom
held opposing views. I mention the incident at the start of this book
not merely as a half-serious caveat to my readers—since, of course,
virtually every chapter here is devoted to psychoanalytic criticism
—but because, at the time, I was not only shaken but quite moved
by this man's anger. It was, I felt, a genuine anger, a righteous anger,
an anger stimulated by a wish to protect and defend beloved objects
—the paintings of a gifted artist. As such, it deserved not to be
shunted aside. Clearly, this man had established some private rela-
tion to these paintings that my lecture, my words, had disturbed.
His response was not unlike that of a curator who defends objects
against restoration lest they be falsified or distorted; not unlike
patients who reject a therapist's interpretations lest they disrupt
the equilibrium maintained by habitual defenses.

Potentially, every chapter of *Image and Insight* could give rise to
a similar incident and debate—though I would be chagrined if that

were all that were to happen. For sometimes quite the opposite occurs, and members of the audience for a psychoanalytic reading experience moments of immediate gratification and even exhilaration. They may feel themselves to be participating in exciting dramas of discovery and revelation as interpreters bring formerly obscure or boring works to life by disclosing meanings, unpacking densities, rendering surfaces problematic. New dimensions may come into focus, pleasure be immediately enhanced, perception stimulated and refocused, and reflection provoked.

What can we learn about the sorts of relations that obtain between criticism and aesthetic experience, not to mention pleasure? Between our perception of images and the sort of insights offered only by words—and by the sometimes unwelcome words of a psychoanalytic commentator? Surely, the words we utter and write about objects do often fail to enhance our pleasure in them and not always because they are off the mark or irrelevant. Yet, I would argue, this is at least in part as it should be. For one important function of criticism (as in clinical work) is precisely to challenge familiar preconceptions—including what is taken to be relevant and even where to locate the boundaries of works—to decenter our previous relations to selves and objects (whatever these may be) and, by so doing, open possibilities for return with finer-tuned perceptual apparati and an expanded range of feeling. Perhaps my Israeli interlocuter, in his moment of ire, spoke too soon: perhaps the pictures he loved so dearly had *not* been destroyed forever but were only momentarily defamiliarized. Perhaps my comments put his love to a test that both he and they *could* in fact sustain.

We cloak our artistic images in words—both to reveal and to conceal them. We make unexamined elisions (in our clinical as well as art critical discourses) between needs and desires to tell the truth about objects, selves, and relations and equally potent needs and desires to convince others (often ourselves) of whatever those truths are taken to be. How often do we neglect to factor in the rhetoric of historical, political, social, even economic forces and to consider the consequences of our blended agendas? My interest here, in an interdisciplinary text addressed to general readers and to clinicians as well as to other critics and scholars in the various fields touched on is to open avenues of inquiry onto such questions.

Other themes bind and burst the seams of this book. In addition to flagging an anxious competitiveness in contemporary culture between words and images, I am concerned with the nonverbal, subliminal dialogues that observers and objects conduct over time with one another—and with the subtle shifting of their referents

and boundaries. Above all, this text is dedicated to the problematic and strenuous paradox of gazing inward and outward at the same time.

Taking vision as their principal metaphor for understanding, the ancient Greeks considered it impossible to look in both these directions simultaneously. Teiresias, the seer, was precisely a *non*seer. He, who could peer into the minds of others and into the future, was necessarily blind to the external world, as was likewise Oedipus who, the moment he gazed upon the meaning of his acts, put out his eyes. Thus, it is not by chance that psychoanalysis, in its search for secrets of the psyche, takes place in a visually deprived environment: relieved of the problematics of perception, analyst and analysand can, as it is thought, gaze inward without distraction.

What, however, about critics, curators, and scholars of art, whose mission it is precisely to *look out*—at color, shape, texture, design —at paintings, films, sculpture, performance art—can they, can we, can I, look in both directions without scotomization? This very question, however, is sealed over by accretions of mythology that beget, mask, and preserve it, mythologies deconstructed in part by modern French thought—by authors, for example, like Roland Barthes and Jacques Lacan, whose Moebius strip model of the mind calls radically into question the inner-outer dichotomy and thus attempts to evade the presumed paradox of our embodied mind. Psychoanalysis has, from the beginning, taught that, when we look out, we see in fact what is already also within, the finding being always a refinding—a Nietzschean insight from which Freud himself recoiled into narrative and teleology.

In any case, the myths persist, and, like Yeats, I do not know that we can do without them. Our myth of professionalism, for one, which, when we don it, fits like a crash helmet, protecting us from head-on collisions with the pyrotechnic displays of being that are figured by the works of art we study (or by patients in treatment). Barricading us against all those human beings we run into, or over, it hides our own faces behind an intimidating façade of high-gloss, high-impact plastic.

Image and Insight seeks, in part, to reinstate, not unproblematically, the subjectivity (Yeats' marrow bone) of criticism. No Procrustean bed of theory unites the twelve essays included here. Written over a nine-year period, they are permitted to display their incorrigible diversity. While arranging them for this book, I relived each labored birth—a factor perhaps in choosing Yeats' particular lines as my epigraph. To mull over them has been to rethink each one and note patterns, omissions, embarrassments and, perhaps,

occasionally, to find something delicious—a gingery phrase that tickles the palate.

Ranging over just a fraction of the vast territory of my loves, they have been chosen as felicitous objects to share with interested readers. Three of the essays have not previously been published; several have undergone minor surgery; most, however, are simply gathered here in a convenient format, having appeared formerly in a wide variety of assorted settings.

Image and Insight includes: a chapter that develops a psychoanalytic approach to aesthetic pleasure; one that offers what I have called a psychoanalytic epitaph to the phenomenon of 1970s New York City subway car graffiti; a piece that explores the position of a naive viewer at an exhibition of African art; one that poses questions about the paintings of an eleven-year-old institutionalized schizophrenic child; a consideration of visual and literary imagery originating in trecento and early quattrocento Florence, Siena, and Padua; a psychoanalytic developmental and object relations approach to a piece of American postmodern music; an analysis of the ancient myth of Demeter and Persephone and its juxtaposition with contemporary fiction by women about mothers and daughters; an argument against critical strategies that deny the inescapability of tragedy; a tracing of the representation of perverse fantasy in Euripides' *Bacchae*; a psychoanalytic reading of film as dream; an intertext created out of a classic psychoanalytic paper and the tale of Aladdin from *The Thousand and One Nights*; and, finally, a critical discussion with biographical subtext of Otto Rank's writings on artists' relations to their art.

Despite the different original audiences and agendas for these essays, they all work more or less critically with psychoanalytic ideas and themes and seek not merely to apply them as givens to works of art as givens but rather to upend the usual posture of applied psychoanalysis. They ask, for example, how fluctuating scenes of art and culture might impact on presumably static psychoanalytic notions and even partially reconstitute them while, contrariwise, developing psychoanalytic thought might alter and reshape received notions about the reception and creation of art.

To close (but not to stop) the circles set whirling in motion by this preface, I feel compelled to end by quoting my favorite lines from ''The Circus Animals' Desertion'':

Players and painted stage took all my love
And not those things that they were emblems of.

ACKNOWLEDGMENTS

Most of the colleagues and friends who assisted me in the writing of the essays that comprise this book are acknowledged at appropriate moments in the body of the text, but to those persons who gave more general assistance I wish to express my gratitude here.

The book took shape while I was in residence as a Getty Scholar in Santa Monica, California, at the Getty Center for the History of Art and the Humanities. To everyone at the Center—the entire staff and each of my colleagues—I wish to extend my heartfelt thanks. Those who helped me directly with this project include: my devoted and infinitely resourceful research assistant, Jo-Anne Berelowitz; knowledgeable staff members, Marianne Tegner, Michelle Nordon, and Suzanna Aguayo; and fellow Getty Scholars, particularly Peter Jelavich, Mary Ann Caws, Annette Michelson, Anton Kaes, and James Herbert. Although my current text does not directly reflect the divergent historical and critical viewpoints of these colleagues, each of them has given me, during this period, new perspectives on all my work, and for this I am truly grateful. My acknowledgments to the Getty Center, however, would not be complete without explicit mention of the graciousness of its director, Kurt Forster, and his associates Thomas Reese and Herbert Hymans, each of whom has contributed indirectly to this project through their warmly reciprocated endorsement of interdisciplinary research in the humanities.

My New York-based aides have included: Mary Milo of TSI, a suberb photographer; Thomas Murphy, James B. Foster, Jr., and Annabel Eden-Bushell of the Larchmont Copy Center; and, of course, my delightful and patient editors at Columbia University Press, Jennifer Crewe and Joan McQuary, as well as Jennifer Dossin and Susan Pensak.

Lastly, my husband Harlan, and my three children, Jennifer, Nathaniel, and Rivi, have given me their love—although not without occasional subtle and not-so-subtle reminders that there's more to life than art.

Image and Insight

Looking and Longing

Reflections on Psychoanalysis and Aesthetic Pleasure

Why are we drawn so irresistibly to paintings, poetry, music, and the performing arts? This chapter offers a psychoanalytic viewpoint on aesthetic pleasure that draws on early Freudian theory. It also participates in and implicitly critiques recent trends within psychoanalysis and the humanities that seek to expand dualism in the direction of more mobile notions of subjectivity—subjectivity as a continuous flow of interaction, mediation, loss, and fleeting transcendence of what we take to be the polarities between imagery and insight.

"a Mosaic glance at the Promised Land of the real"

—Roland Barthes, 1972

We gaze at art, we listen to music, we attend theatrical performances, we read and recite poetry because, in each instance, these experiences give pleasure. Here I offer just one of many possible psychoanalytic approaches to aesthetic pleasure, one that focuses particularly on the art of painting. While for reasons of space I shall not distinguish among the qualities of experience afforded by the different arts, it is possible that what is presented here can be ascribed, with variations, to other media. Furthermore, from the perspective I am adopting here, efforts to dissect, describe, and classify the pleasure(s) of art fail necessarily to capture its special qualities; they are doomed in the same way and for the same reasons that Monsieur G, prefect of the Paris police, and his men, in Poe's "Purloined Letter," are barred from finding the missing document (we shall return in the end to Monsieur G)—doomed for reasons best expressed by parable.

Thus, I shall begin my essay by recounting an allegory—a Talmudic story (see the *Babylonian Talmud*, Tractate Shabbat 119A) in the somewhat embellished version I recollect from childhood. It concerns the sage Rabbi Joshua ben Hananiah, who was known and respected for his great wisdom. Rabbi Joshua, as the story goes, was an invited guest at the imperial palace of Hadrian, who requested him one day to describe how to prepare the Sabbath meal so that the emperor might experience for himself the wondrous tastes and exquisite pleasures he had often observed among the Jews as they ate their Sabbath dinner. At the emperor's command, Rabbi Joshua instructed the royal chefs, explaining in detail how each dish was prepared, describing with care each ingredient and procedure. When, however, the resulting meal was served to the eager emperor, he

could discern no difference in taste between these dishes and his ordinary fare. Disappointed, he sent for Rabbi Joshua and, in the rabbi's presence, interrogated his cooks to ascertain whether the instructions had been carried out precisely. Clearly, they had. Nevertheless, unlike the Sabbath Jews, the emperor had experienced no bliss, no desire to sing aloud with each mouthful. Surely, he cried, some *special* spice, some extra substance must have been omitted! The Sabbath food *must* have a special taste, for this was manifest in the expressions of the Jews when they were eating it. Unperturbed, Rabbi Joshua listened to the emperor and smiled. Yes, he responded patiently, there *is* a special taste, a unique spice, if you like, but the recipe cannot be given, for it comes of itself to those who love the Sabbath.

My essay is concerned with just this—that is to say, with a spice or taste for which no recipe can be given and for which no classificatory system composed of the characteristics of objects can account. This is because, as the parable reveals, desire and what I shall call the *pleasure of desire* are located *in the subject*. Not unique to, but exquisitely apposite to, the realm of the aesthetic, this quality of experience, this spice or *pleasurable desire*, is the element I hope to trace in what follows.

Whereas at least some traditional aesthetics (excluding existential and phenomenological work) is committed to a view of aesthetic pleasure that privileges the apprehensible properties of objects—begins, that is, with an examination of works of art themselves [1]—psychoanalysis locates aesthetic pleasure in the subject but also in a dynamic in which the spectator-subject may become object to the aesthetic object qua subject. In other words, the beholder of a painted image, drawn into what Gombrich (1960) has called the "magic circle of creation," may experience himself or herself as being radically determined by, as becoming the object of, the illusory gaze of that image. In a parallel phrase of Roland Barthes: "The text you write must prove to me that it desires me" (1975:6). I believe, therefore, that one unique contribution of psychoanalysis to a discourse on aesthetic pleasure is to take up a position radically other than that offered by those aestheticians whose project it has been to study external objects as if they were identical with the causes of pleasure. Further on, I shall discuss the work of one contemporary aesthetician who has written both on the disjunction between the objects and causes of pleasure and on the possibility of their elision and, in so doing, has provided an aesthetic discourse that complements the psychoanalytic approach I am here proposing.

The psychoanalytic texts that ground my thesis are Freud's *Interpretation of Dreams* (1900–1901), *Three Essays on the Theory of Sexuality* and *Jokes and Their Relation to the Unconscious* (1905), and *Beyond the Pleasure Principle* (1920). From these texts, three major precepts can be extracted. First: An object found is an object refound, and the refinding rather than the intrinsic properties of the found or chosen object is of prime significance. Second: the relations of joke/ teller/ listener (work of art/ artist/ spectator) imply a dynamic characterized by subtle reversals, complex alignments, and shifts of position: Third: Subjectivity, born of loss, stages the replicative recovery of its object through links with a symbolic system that radically determines this very subjectivity.

Thus, psychoanalytically speaking, we have in aesthetic experience the staging of a peculiar drama in which the presence of an object intensely engages a subject. The object's presence figures an absence, induces a lack (desire) in the subject which it (the object), in an imaginary way, fulfills. This dynamic can be both reversed and replayed. Thus, the subject experiences fulfillment and want— a *pleasure in desiring*—which constitutes the special quality of aesthetic experience. Capturing the beholder in this dynamic (which is staged in different ways in all the arts), the painting, for example, offers a kind of imaginary completion to the subject while simultaneously engaging him or her on the symbolic level. Thus it provides the conditions for pleasure while keeping desire always in play.

Curiously, many anthologies of articles on aesthetics currently in university use omit the topics of "pleasure" and "aesthetic pleasure."[2] Not only are these headings absent, but in many cases they have not even been indexed. Research into papers published over a six year period (1980–1986) in leading journals shows that the prominent *Journal of Aesthetics and Art Criticism*, for example, published only three articles that refer to "pleasure" in their titles, none of them a contribution that sparked continuing debate in the literature. This neglect or avoidance of the *pleasure* of art as a subject for academic discourse raises questions and rouses speculation.[3] After all, if art did not provide a measure of delight (if not, at least occasionally, rapture and desire), there would seem little point to exploring the more rarified aesthetic issues that *are* extensively treated by academic discourse—such as the ontology of art, its representational conventions, communicative possibilities, expressive qualities, ideological underpinnings, and so forth.

Interdisciplinary studies are always precarious and fraught with territorial imperatives; thus, it seems worthwhile to note that, like

the daughter of Pharoah, I have seized an opportunity to rescue (temporarily) a virtually abandoned issue. All but disowned by aestheticians since the eighteenth century, languishing in (con)temporary exile, aesthetic pleasure moans for recognition and embrace (even if not psychoanalytic embrace) and for adoption. Thus, it seems legitimate if not actually helpful to pursue my course in spite of the risks and to attempt to blend, gently, notions of aesthetic pleasure with a psychoanalytic perspective on desire.

One notable exception, to the rule of philosophers' neglect deserves more than cursory mention—an elegant and comprehensive work on aesthetics by Mary Mothersill (1984) that treats pleasure at length. This work, however, is not restricted to an analysis of beauty as found in works of art alone; its premise is that, whereas twentieth century aesthetics is often narrowly conceived as the philosophy of art, the problems of beauty and pleasure should not be so delimited. Her general view forms a compelling complement to the psychoanalytic perspective I am developing here.

Mothersill reinstates the notion of pleasure in aesthetic discourse by asking whether aesthetics as a philosophical discipline can lay claim to any primitive questions. She poses this query in the course of an attempt to counter the charge of fellow philosopher Stuart Hampshire (1952) that aesthetics is devoid of such questions and hence lacks a basic subject matter. Questions may be considered primitive with respect to a theory, Mothersill explains, when, first, they can be asked by and are of interest to persons who are naive about the theory and therefore can be put in terms that do not involve the theory, and when, second, the theory yields consequences that delimit the range of acceptable answers. Examples include: "Why is the sky blue?" (primitive for optics) and "What would be the right, the reasonable, thing to do?" (primitive for ethics). In her effort to find a comparable question for aesthetics, Mothersill turns to pleasure: "Why does this work of art please me?" she asks. Immediately, however, she identifies a problem with this question: namely, that it may all too easily generate answers that make it sound like a primitive question not for aesthetics but for psychology. The difficulty of finding answers that either fail to go beyond the personal and subjective or exclude them leads her to a discussion of pleasure in which philosophical psychology plays a major role. At the risk of oversimplification, one might read her argument as an erudite and at times supremely witty effort to save this particular primitive question for aesthetics and,

implicitly, to wrest it from the imperialistic purview of psychology —to show, among other things, that properties inhering in objects may and do legitimately count as a source of aesthetic pleasure. She supplies, as an important, even central, step in her argument, a definition of aesthetic properties based on indistinguishability: "The aesthetic properties of an individual O are those that define the class of items which, for a particular subject, S, under standard conditions, etc., are indistinguishable from O" (p. 364). This definition foregrounds the particularity of objects while implying (as well as granting) a significant subjective element—*indistinguishable* being an adjective derived from the verb *to distinguish*, which presupposes a subject. In other words, the statement defines a situation wherein a subject ascribes his or her pleasure to properties of a work of art that, by the indistinguishability clause, cannot be transferred or generalized. The object itself is thus privileged, and the possibility of deriving general laws or rules of taste from pleasure is obviated.

To cover for cases in which the subject attributes personal pleasure to the aesthetic qualities of a work but is mistaken, Mothersill adds to the first definition a second as follows: "Someone finds an individual [work of art] beautiful if and only if the individual pleases him and he believes that it pleases him in virtue of its aesthetic properties *and his belief is true*" (p. 347, my italics). Here, drawing on the distinction between belief and knowledge, Mothersill adds a strong objective element to her first definition. The role assigned to the object in the experience of pleasure is fortified. Her third definition, which binds the first two, states: "Any individual [work of art] is beautiful if and only if it is such as to be a cause of pleasure in virtue of its aesthetic properties" (p. 347).

The thrust of her effort here is to seek a solution to the double bind articulated by Kant in the so-called antinomy of taste (see Kant 1790, 1978:206). Kant here poses as a problem the juxtaposition of two theses that appear mutually contradictory but true. These are: that although judgments of taste are genuine (O is pleasing to S), they are not based upon concepts, for if they were they would be open to dispute (which, clearly, they are not: *de gustibus non disputandum est*). Surely, however, the opposite is also true: namely, judgments of taste *are* based on concepts, for if they were not there would be no place for contention, not even for claims to the necessary agreement of others with a particular judgment.

Earlier in the text of *The Critique of Judgment*, we find the following passage, which helps to illustrate the antinomy:

There can . . . be no rule according to which any one is to be compelled to recognize anything as beautiful. Whether a dress, a house, or a flower is beautiful is a matter upon which one declines to allow one's judgement to be swayed by any reasons or principles. We want to get a look at the Object with our own eyes, just as if our delight depended on sensation. And yet, if upon so doing, we call the object beautiful, we believe ourselves to be speaking with a universal voice, and lay claim to the concurrence of every one, whereas no private sensation would be decisive except for the observer alone and *his* liking. (p. 56)

In addressing this problem, Mothersill works out her ideas in part by elaborating on a text of Aquinas, the famous " *'Pulchrum dicatur id cujus apprehensio ipsa placet'*—'Let us call that beautiful of which the apprehension in itself pleases' " (quoted in Mothersill 1984:323). This dictum corresponds roughly to her third definition. She is thus deeply concerned with an aesthetic that can offer compelling reasons for the position that, in her words, some judgments of taste are genuine, that pleasure is, albeit with important caveats, caused by the aesthetic properties of the particular works perceived—and *perceived* means, importantly, that subjectivity is not omitted.

To define this position more clearly, Mothersill addresses problems introduced by theorists who have sought to separate the objects of pleasure from its causes. For example, we might imagine a beholder who, having attended the Miro retrospective at the Guggenheim Museum, experienced particular pleasure while gazing at the *Portrait of Mrs. Mills in 1750 (After Constable)* (figure 1.1). Taking it as the object and cause of her pleasure, she failed to remember that the last time she saw the painting, she was in the company of her mother since deceased. An analogous philosophical/ psychological issue can be extracted from the following three sentences in Freud: "[Dora] remained *two hours* in front of the Sistine Madonna, rapt in silent admiration. When I asked her what had pleased her so much about the picture she could find no clear answer to make. At last she said: 'The Madonna' " (1905:116).

Some theorists would argue that the object of pleasure (the painting) is noncontingently related to the subject's pleasure, in that she *heeds* the painting and it is the *target* of her gaze. The cause of her pleasure, however, is only contingently related to that pleasure in that it may or may not be (consciously) available to her. Mothersill

Figure 1.1 Joan Miro, *Portrait of Mistress Mills in 1750* (1920).
Oil on canvas; 46 in. x 35¼in. Museum of Modern Art, New York. James Thrall Soby Bequest.

gives her own example, as follows: "The object of his pleasure might be what he perceives to be a compliment or joke; the cause might involve physiological factors such as his reaction to the vodka he had been absent-mindedly sipping" (p. 280). A related, slightly different, example might be introduced: an opera buff, for instance, who states that although he adores *Traviata,* he regularly weeps at Violetta's death *because* it reminds him of his young wife's death years ago from cancer. At stake here, psychoanalytically speaking, is the issue of granting subjective status to unconscious trends (as in notions of the split subject, divided self, etc.).

Mothersill herself, for completely nonpsychoanalytic reasons, rejects a dualistic view that would separate objects from causes of pleasure. She points to the subjective element in the notion of "object of pleasure." This phrase is, as she puts it, "an ellipsis that allows us to speak of the cause of someone's pleasure *as it appears to him, relative to his beliefs, attitudes,* etc." (p. 283, my italics). In a cogent discussion she points out that objects of pleasure are not only not equivalent to ordinary objects but in fact serve only the minimal function of being referents for such phrases as "what S saw."

Her staunch refusal to bypass, deny, or eliminate subjectivity as an essential element in aesthetic pleasure situates her discourse closer to the psychoanalytic than that of many of her predecessors. (A counterargument here, however, might be that theories which sever objects of pleasure from its causes may actually fit better with psychoanalysis in that they mirror the radical psychic split postulated by Freud between what he called ego and id; here, however, I have chosen to operate within a psychoanalytic framework that privileges intersubjective byplay over rigid dualisms.) Mothersill's position is implied by her rejection of a dualistic theory of pleasure that entails two logically independent entities: namely, an object specified by a subject, and a causal hypothesis requiring evidential support. About such a theory she says: "Thus we have an island of Cartesian certainty in a sea of complex, contingent, psychological fact" (p. 287). Her preference, as I read her, is for a theory that inscribes the subjective/ objective disjunction so that each position is implicated in the other.

Mothersill's work stands as a unique effort in contemporary aesthetics to grapple with the issue of pleasure in art. In the course of her announced project, to clarify what we mean when we call an object beautiful, she addresses what she calls "the cloudy issues" surrounding the relation of "subjective" to "objective" (p. 347). Her

work models an attempt to thread through a maze of seemingly unavoidable intellectual inconsistencies rather than accept them as inevitable or collapse one set of terms into another. In so striving, she addresses, by implication, the fundamental dichotomy of mind and body that lies at the heart of the issue of pleasure.

Psychoanalysis, by contrast, makes problematic in radical ways the status of objects. It poses the question of aesthetic pleasure from the shifting positions of subject and signifier (rather than of perceptual object) and may even conceive of the aesthetic object dialectically as subject.

In deriving aesthetic pleasure from sexuality, Freud postulates a set of strategems for channeling energy and substituting both aims and objects. Yet the cherished psychoanalytic theory of sublimation is riddled with paradox. As Bersani (1986) has pointed out, sublimation is described as a psychic maneuver that not only denies (bypasses) and transcends sexuality but at the same time appropriates, extends, and elaborates it—is, thus, coextensive with desire. In formulating this theory and introducing, *pari passu*, the notion of displacement, Freud implicitly holds, contra aesthetics, that to ascribe intrinsic attractiveness to an object (sexual in the first instance, but by contiguity or displacement, metonymy or metaphor, aesthetic) is to commit a fundamental conceptual error,[4] like adherence to a seduction theory—since what is supremely important about finding any object is that, in fact, this object has been refound (see Freud, *S.E.* 7: Part III:5; see also Bersani, 1986:30–40).

In addition to the problematic status of the object, the nature of pleasure eludes Freud. Puzzling over the enigmas of forepleasure, endpleasure, and unpleasure, and the increase, decrease, and surcease of sexual tension, he opines not only that "psychology is still so much in the dark in questions of pleasure and unpleasure that the most cautious assumption is the one most to be commended" (*S.E.* 7:49) but that "everything relating to the problem of pleasure and unpleasure touches upon one of the sorest spots of present-day psychology" (*S.E.* 7:75). Out of such gestures of despair, however, out of the position of not knowing (of lack), are fascinating new questions born.

In Part III of *Three Essays*, for example, the roles played by forepleasure and endpleasure suggest analogies with visual and plastic as opposed to performing and literary arts. In the latter, fixed temporal dimensions may be seen as entailing a pleasure that comes to a specific endpoint or climax, a moment of satisfaction for which

each art provides a convention, a physical counterpart to the psychological process: a curtain falling, a conductor turning, a book closing. In the visual arts, by contrast, as in sexual pleasures that do not result in discharge, there is no definite limit to the experience, no particular duration of time one must linger before the painting or sculpture, no expectable conventions structuring or releasing the tension built up in the spectator. One remembers Dora's *"two hours"* in the Dresden *Gemäldegalerie* before the Raphael. And there is a document that describes Van Gogh's encounter with *The Jewish Bride* of Rembrandt (figure 1.2):

> [Van Gogh] spent the longest time in front of the "Jewish Bride"; I could not tear him away from the spot; he went and sat down there at his ease, while I myself went on to look at some other things. 'You will find me here when you come back,' he told me.
>
> When I came back after a pretty long while and asked him whether we should not get a move on, he gave me a surprised look and said, "Would you believe it—and I honestly mean what I say—I should be happy to give ten years of my life if I could go on sitting here in front of this picture for a fortnight, with only a dry crust of bread for food?" (Personal reminiscence of Van Gogh by Anton Kerssemakers, quoted in Auden, 1961.)

What happens in these stretched (or compressed) moments before a painted image? Is there any danger here analogous to the danger Freud perceives in the forepleasure? Freud speaks about lingering over such moments of pleasure as dangerous in that they may become an end in themselves, thus a perversion; they may perhaps become what Yeats describes in the lines: "players and painted stage took all my love,/ And not those things that they were emblems of." Yet, countervailing forces are provided by the presence of spatial, as opposed to temporal, structure, by the limits of various framing devices, as well as by the powerful presence of verbal texts (labels) that tame the perilous image and stem the tide of its regressive pull.

Psychoanalysis, I propose, offers an account of aesthetic pleasure that acknowledges risk and incorporates danger. The long look at any artistic image poses an implicit question as to why the spectator is *moved* or *held* thus to linger. Seeing, our metaphor par excellence for knowing, is shown to be riddled with desire. Thus, the long(ing) look of aesthetic contemplation is demarcated from rapid,

focused, teleological perception dictated by need. The two verbs chosen for the title of this chapter inscribe both the active and the passive elements inherent in these moments. The work of art— neither an object appropriate for the satisfaction of instinctual drive, nor an object merely redolent and evocative of desire, nor "a mere thing" (see Heidegger 1971)—comes into being at the intersection of the reflex arc of (sexual/scoptophilic) satisfaction; attenuated experience marked by frustration, delay, and disguise; and the values, expectations, and beliefs imposed by a culture. This triple registration of the work of art in the realms of the real, the imaginary, and the symbolic is exquisitely encoded in the paintings of René Magritte, who plays simultaneously with images and words. Long looks at his seductively enigmatic works have contributed incalculably to the thesis of this chapter.

But in such cases, surely it is art that informs psychoanalysis as well as the other way around. Perhaps art teaches psychoanalysis something about the dynamics of desire. In a recent lecture, Bernstein (1987) extended and elaborated Freud's account of the relations of joke/artist, object/painting, and secondary object/(listener/spectator) to analyze several paintings of Manet, among them Olympia (figure 1.3). She demonstrated that Manet constructs similar but even more subtle and labile structures of relation. These both parallel and turn the tables on the paradigm of the joke so that (in part) what was originally meant to be the exposure of the object (in Olympia, the image of the nude woman) is reversed into the exposure of the would-be subject (the beholder of the painting) as object of the gaze of the intended object now turned subject.

In Bernstein's analysis, the riveting gaze of Olympia marks out a privileged place for an absent spectator that each beholder is lured to fill. Olympia's carefully posed nudity, accentuated by the barest traces of dress and her dramatized display, arouse in each (male) beholder the desire to fill this place—the place of her desire. Yet, as Bernstein intimates, that dyadic relation is complicated by a triadic resonance, namely, the implicit imminent approach of a rival, another admirer, signaled by the bouquet held in the arms of the (black female) servant. Thus the beholder is confronted by an invisible double who, we may imagine, waits to emerge from behind the curtain. Meeting Olympia's gaze, the beholder reexperiences her allure and seduction as transformed now into frozen unavailability. Invitation becomes rejection (what the upper half of the body promises, the lower half refuses; what the right hand offers, the left

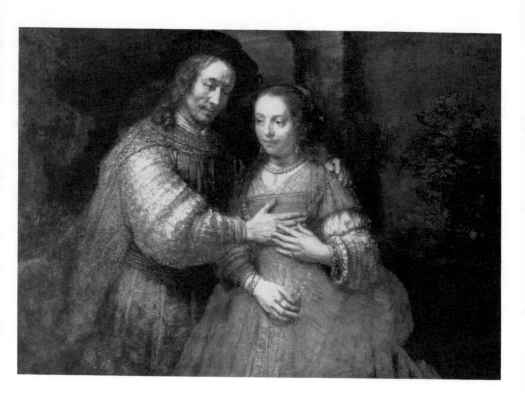

Figure 1.2. Rembrandt van Rijn, *The Jewish Bride* (c. 1665).
Rijksmuseum, Amsterdam. Photo cr.: Art Resource, New York.

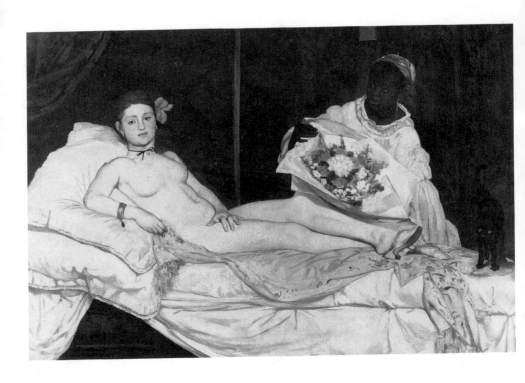

Figure 1.3. Edouard Manet, *Olympia* (1863).
Louvre, Paris. Photo cr.: Girandon/Art Resource, New York.

revokes). Gradually, the beholder becomes aware of himself as merely an infinitely replaceable object of Olympia's gaze. Brought face to face with his own lack, he circles again, trying to close the gap between himself and the painted image before his eyes.

In this dynamic, the painted image serves a mirroring function, reflecting to the beholder his own gaze; compelled to behold himself beholding and struggling to avoid a confrontation with his own self-alienation, he is both *moved* and *held*—spellbound, bewitched —by the painting. The ambiguous collusion of joke-teller/artist with listener/spectator has thus shifted toward a new (but equally ambiguous) collusion between spectator and painted image—a collusion that circles back into a version of the earlier configuration. Thus, the painting radically (re)constitutes its subject. As Barthes has put it: "The text is a fetish object, and *this fetish desires me.* The text chooses me" (1975:27).

Bernstein's analysis of the subtle interactions among the terms of image, artist, and beholder is applicable, in my view, well beyond *Olympia* and the oeuvre of Manet. The invisible circling relations of desire outlined here bespeak a psychoanalytic approach to imagery in general. And, with respect to the original Freudian text on which the interpretation rests, I would suggest that these sliding, eliding cross-identifications that compel interminable deferrals of satisfaction illuminate something about the artfulness of art as distinguished from the craft of joke—a distinction Freud made little effort to clarify. Bernstein's work offers clues as to why (at least for adults) even the best joke is good for only a couple of retellings, whereas the *Olympia,* for example, exerts a lasting fascination (see also Clark 1984).

A similar dynamic is activated by Magritte's painting entitled *Le Mois des vendanges* (figure 1.4). Here, multiple bowler-hatted men stare through an open window. Paradoxically, although they look inside the window, their gaze is simultaneously directed out, at the spectator of the painting, thus drawing us into the space of the image. As is usual for Magritte, the title is crucial: "The Month of the Harvest." Harvest brings food (grapes), that which is eaten or drunk, and, typically, Magritte here introduces a characteristic substitutive metaphor: he suggests a harvest for the *eyes* rather than the *mouth,* a harvest that can never truly nourish. This deeply conflictual thought (Spitz 1985) is both signified and suppressed by the image via its multiplicity of gazing eyes.

In a similar way, Caravaggio's paradigmatic rendering of the Medusa (figure 1.5) both evokes and denies castration by its multiple

snakes. Brilliantly, it figures the splitting of consciousness by conflating subject and object. Medusa, the sight of whose snakelike hair turns men to stone, is portrayed on the surface of a mirrorlike shield and given a visage that itself expresses the horror of her victim (for a recent iconographic analysis, see Poseq 1989; for a discussion of decapitation as a symbol for castration, see Schneider 1976). As the destroyer bleeds, sadism and masochism are, with the snakes, entangled.

Magritte's painting also conflates the aims of looking, of voyeurism, with those of exhibitionism. Like the spectator of the picture, the bowler-hatted men, personae of the artist, are simultaneously seeing and being seen while remaining anonymous. The title of the painting inscribes this notion as well, since the French *mois*, which sounds exactly like *moi*, can be read as a pun that underlines the splitting of self into many "me's" figured by the painted image. Thus the painting captures that existential moment when we come suddenly to know that we are not only subjects but objects for the consciousness of others, who are also not merely the objects of our gaze but subjects in their own right. In this way, the image exploits the uncanny; the repressed returns as beholders reexperience before it the enforced splitting of their own subjectivity and behold themselves beholding the painting—much as, on occasion, we realize that we are having a dream.

In like manner, Fried's (1978, 1987, 1988) work on Courbet relies on the psychoanalytic text but also raises questions about the dichotomies it embodies. Fried interprets masculinity and femininity as coming together in Courbet's images in ways that follow from, elaborate, and render problematic some of the standard oppositions (for example, activity/passivity) associated with gender. Obliged to reconsider these terms in the light of imagery that probes and blends them, we are warned against colluding in any interpretive exercise that would transfix a reality more fluid than what they can represent. Fried features the bisexuality of Courbet's imagery, its merging not only generally, of the sex of the beholder with that of the beheld, but specifically in this case, of the male painter-beholder with the female sitter-beheld. Most tellingly, he focuses on Courbet's sensual replications and displacements within his painted imagery of the physicality that attends the very act of painting. Fried sees this act as an intense bodily experience that figures ubiquitously in the artist's approach to imagery. In what he has called "fantasmatic conflations," the phallus, brush, and distaff are evoked together (figure 1.6), sword and blood may figure brush and

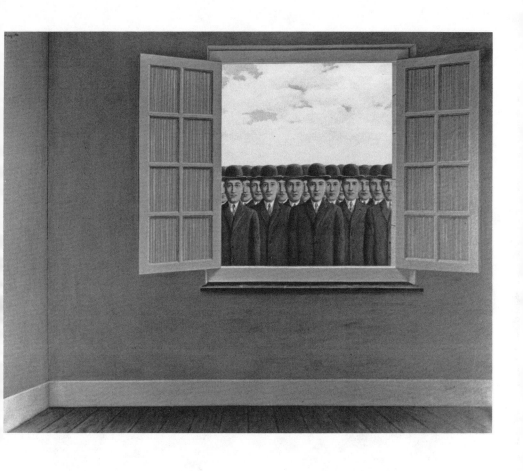

Figure 1.4. René Magritte, *Le Mois des vendanges* (1950).
Copyright © 1990 Herscovici/ARS, New York.

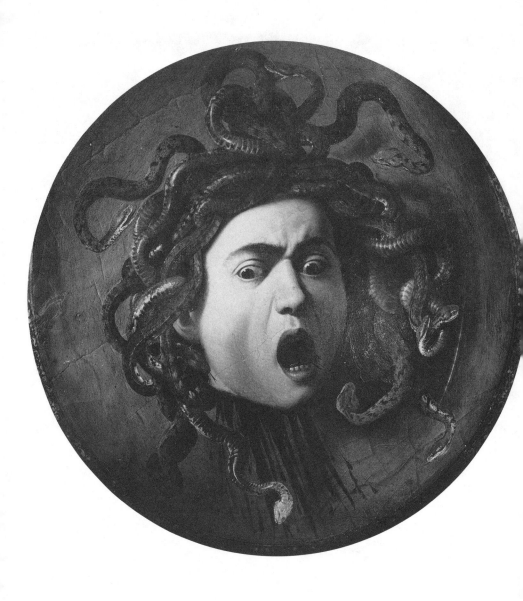

Figure 1.5. Caravaggio, *Medusa* (1608).
Uffizi Gallery, Florence. Copyright © 1989 Archivi Alinari. Photo cr.: Art Resource, New York.

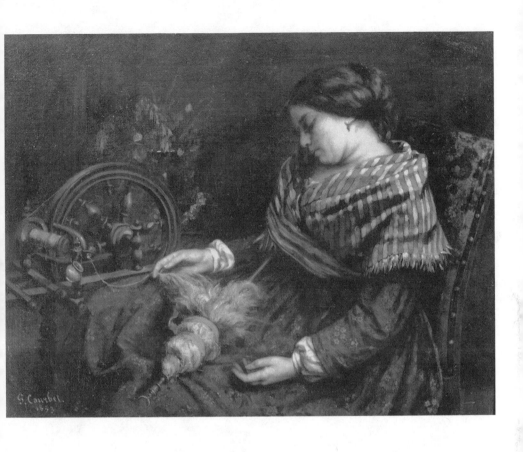

Figure 1.6. Gustave Courbet, *Sleeping Spinner* (1853)
Collection Fabre, Montpellier. Photo cr.: Girandon/Art Resource, New York.

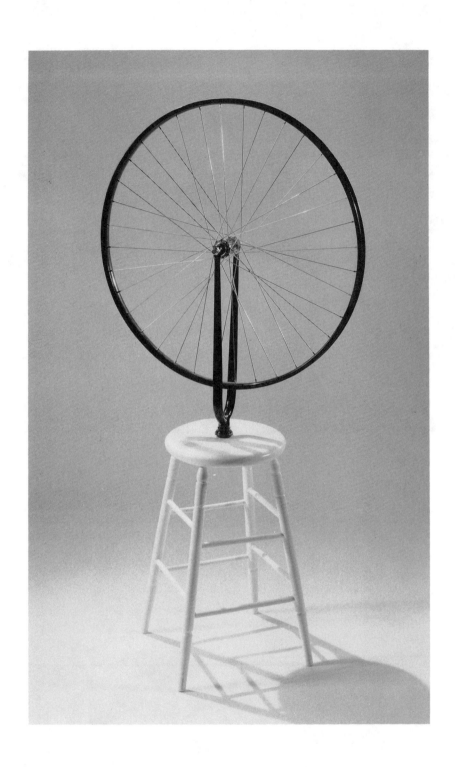

pigment, and, in other paintings, a flowering branch and a woman's hair are linked to both the phallus and the painter's brush.

Like Bernstein, Fried goes far beyond the specific paintings he addresses to adumbrate deeply disturbing and pleasurable and disturbingly pleasurable qualities of painted images per se, and to highlight their fundamental incommensurability with (any) words. His sexual readings of Courbet reveal the ways in which images both transfix and unsettle the equilibrium of the beholder, induce pleasure with anxiety, destabilize the preconditions for maintenance of control, and set in motion a lability that words cannot arrest.

Against the critique that psychoanalysis ignores the artfulness of art, that it honors the totality of works only in the breach by digging for more than surface coherence (Meltzer 1987), I have tried to demonstrate that, at least from the point of view presented here, it is not just superior wholeness or complexity of organization that distinguishes the art object but, paradoxically, its structured inducing of an experience of lack, lack that compels the long(ing) look we identify with the aesthetic. The task of psychoanalytic critics is, therefore, in part, to reveal the artfulness required in creating the very absence that awakens desire.

The difference between Marcel Duchamp's bicycle wheel (figure 1.7) and the one in my garage, the difference between Jeff Koons' Hoover vacuum cleaner (*New Hoover Dimension 1000*, 1986) and the one in any department store, is, psychoanalytically speaking, that whereas one object signifies, that is, attracts, frustrates, compels a search, the other, if and when it becomes focal, does so because it directly satisfies a practical need.

I now return, as promised, to Monsieur G, prefect of the Paris police, and close, for symmetry's sake, with another parable, actually another reading of a reading: an interpretation of Poe's "Purloined Letter," a text that illuminates with exquisite clarity the different way of looking implied by the aesthetic I have tried to convey. The thematic reading that follows draws on Jacques Lacan's "Seminar on 'The Purloined Letter' " (1980) and on extensive commentaries by Mehlman (1980), Derrida (1975), Johnson (1977), Holland (1980), Wright (1984), and Muller and Richardson (1988). My

Figure 1.7. Marcel Duchamp, *Ready-Made: Bicycle Wheel* (1913/1964). Philadelphia Museum of Art. Given by Schwartz Galleria d'Arte.

objective is not to interpret the story generally but to consider it from just the one vantage point.

You will recall that a letter of great (though unspecified) value is *found missing*. That we never discover its contents or the identity of its sender constitutes one of the greatest sources of (pleasurable) frustration for the reader. If the story is taken as a parable for psychoanalysis, this fact indicates that its objective is not to un- mask a hidden content, a notion that does, however, animate many misapplications of psychoanalysis to art.

The narrative of the story, carried, interestingly, via conversa- tions among the narrator, his friend Dupin, and Monsieur G, con- cerns the vicissitudes of the search for this letter, stolen apparently by a certain Minister D from the "Queen." As the search proves increasingly fruitless, the letter increases in importance and value: a metaphor for desire. Many wonderful and ingenious replications have been noted by the critics cited above, but I shall stress only the different modes of *looking* figured in the story.

Monsieur G, the realist, describes his search to the other two characters as follows: He and his squad examine the entire building from which the letter was presumably purloined. They scrutinize the furniture; they open every drawer (including "secret drawers"). They probe the cushions with fine needles. They remove the tops of tables. They excavate the rungs of every chair, the joinings of every piece of furniture. They dismantle the mirrors and test the beds, linens, curtains, carpets. Finding nothing, they finally divide the entire surface into numbered compartments and scrutinize every square inch with the aid of a powerful microscope. And so it goes, even to the point of opening every book. Not content with a shake, they turn over every leaf in each volume, probing the bindings with needles. Even this approach proves fruitless.

Dupin, however, finds the letter, by employing a completely different method. He discovers it soiled, crumpled, and carelessly placed in a card-rack among some visiting cards. It has been turned inside out, its edges frayed. In what can be taken as a metaphor for the critical/analytical enterprise, upon finding it he replaces it with a facsimile. In just such a manner, Minister D had earlier replaced the original with a facsimile when he had perceived its significance and had stolen it from the Queen. Dupin, asked by Poe's narrator why he bothered to replace the letter with a duplicate, replies that by so doing he will assure that D, who has the original in his possession no longer, will nevertheless proceed as though he did. He will be duped by the facsimile into continuing his previous (and,

apparently, ruinous) course of action, the precise nature of which is never made known to the reader.

Instead of describing his method of finding the letter, Dupin draws an analogy (a tactic that I am of course here replicating):

> There is a game of puzzles ... which is played upon a map. One party playing requires another to find a given word—the name of a town, river, state, or empire—any word, in short, upon the motley and perplexed surface of the chart. A novice in the game generally seeks to embarrass his opponents by giving them the most minutely lettered names; but the adept selects such words as stretch, in large characters, from one end of the chart to the other. These, like the overlargely lettered signs and placards of the street, escape observation by dint of being excessively obvious.

Dupin goes on to point out that *visual oversight* here is a precise counterpart of that inapprehension which causes the mind to by-pass unnoticed those considerations that are too obtrusively and too palpably self-evident.

A *different mode of looking* is intimated. The point is that the painstaking researches of the police fail to get at, fail to represent, the essentials of our experience (fail to find the letter). This must continue unless and until these researches can be reconnected with a signifying chain of linked meanings that will tie all the events together, orient them, and relate them to the letter perceived not as a "thing," not as a piece of paper that fits a certain fixed description, but as a *significant object of desire*. Desire, which cannot be expressed openly because of the inevitable gap between the body and culture, between the thing and any representation of that thing, is subject to multiple disguises and subterfuges. Unless this purloined letter is thus perceived as a symbol or signifier, it will be missed, quickly passed over, it will not be seen. To put it another way, some *thing* will be perceived and we can assume *was* perceived by the police, but *its significance will not be perceived* (just as, in my earlier parable, although Hadrian *ate* the Sabbath spice, he was unable to *taste* it). Psychoanalysis has to do with the perception of significances, with the restoring of links to chains of meaning.

Dupin describes the letter he finds as greatly altered in appearance: "To be sure, it was, to all appearance, radically different from the one of which the Prefect has read us so minute a description." So the shift involves looking with an awareness of the *mechanisms of disguise,* mechanisms Freud detailed in *The Interpretation of*

Dreams. Enactment and repetition are also crucial issues. Dupin does not merely see but actually replicates the ruse of disguise upon Minister D that the minister had practiced on the Queen. The interpreter thus partakes in the action.

The shift I wish to highlight with this allegory involves perceiving that what we take to be hidden or lost is always *really* there. The psychoanalytic project is to restore to the object its significance or, in other words, to recognize it *as a signifier*. Visible all along, it is not perceived because it is disguised by displacement (it was in the most obvious place, the card rack, where it was expected above all not to be found, and therefore both was and was not in its place). Other mechanisms operate too, as we have seen, for example, reversal: the letter is turned inside out. To the police, it is, therefore, rendered invisible. Furthermore, the letter has no intrinsic meaning. Meanings are conferred upon it by its location in a context, by its place, both in the sense that its presence evokes an absence (it is not what it seems) and in the sense that its invisibility, its disappearance, merely indicates that it is out of place.

Psychoanalysis is equally concerned with tracing the signifier back to the body and back to the earliest human relationships in which one's own body and that of the other are not differentiated. Longing looks evoked by works of art are, in part, a response to the ambiguous lure of painted images that promote fantasies of narcissistic completion but terrify by their lure to places where the law no longer holds sway.

As in subsequent chapters (see below, p. 66), we are here reminded of Exodus 20:4 and the second commandment of the Mosaic Law that bespeaks our latent fear of icons that tempt us with their secrets and forbidden pleasures. Necessary to object and image is the word. Necessary to perception is culture. As the Talmudic legend teaches, Sabbath spice can be tasted only by those who observe the law. But perhaps to love a work of art is rather more to stand like Moses on Mount Nebo—gazing into the promised land of Judah.

Notes

Much of the initial impetus for this essay came from a Symposium on Art History and Psychoanalysis held by the College Art Association in Boston, 1987, chaired by Professor Steven Z. Levine. In addition to thanking my colleagues there, I wish to express my appreciation also to Rabbi Jeffrey

Sirkman, Priscilla Wald, Julie Klein, and Nathaniel Geoffrey Lew for their bibliographic assistance, and to Professor Michael Fried who gave the manuscript a generous reading at the NEH Summer Institute on Image and Text at The Johns Hopkins University, 1988.

A version of this chapter appears in *Pleasure Beyond the Pleasure Principle*, eds. Robert A. Glick and Stanley Bone. New Haven: Yale University Press, 1990. Permission is here gratefully acknowledged.

1. I feel that this is the case even with respect to the work of Susanne Langer (1953) who, while emphasizing the relationship between viewer and art object, begins always with an examination of the object. In the case of sculpture, for example, she speaks of "virtual space," and of music of "virtual time," categories that have to do with perceptual qualities of the different arts that, as she sees it, *match* certain aspects of human psychic experience as it is mapped under the Kantian categories. She sees the object not as radically structuring the subject but as mirroring it and thus affording a kind of recognition pleasure.

2. See, for example, M. Philipson and P. J. Gudel, eds., *Aesthetics Today* (New York: New American Library, 1980); J. Margolis, ed., *Philosophy Looks at the Arts* (Philadelphia: Temple University Press, 1978); W. E. Kennick, ed., *Art and Philosophy* (New York, St. Martin's Press, 1979). Topics include: Aesthetic Judgment, The Nature of Art, Aesthetic Qualities, Representation in Art, Style: Form and Content.

3. Richard Howard, in his introduction to Barthes' *The Pleasure of the Text* (1975) makes the point that, unlike French culture, American culture tends to consider pleasure as a state that is unspeakable, beyond words. The fear seems to be, as he puts it, that "what can be said is taken—is likely—to be no longer experienced, certainly no longer enjoyed" (p. vi). Howard contrasts this position with that of the French, who have "a vocabulary of erotism, an amorous discourse which smells neither of the laboratory nor of the sewer" (p. v), and which allows them to speak of pleasure without necessarily being either coarse or clinical.

4. That Freud himself was not immune to such "errors" is a point that has been explored with increasing frequency in the literature: M. Balmary (1979), J. Masson (1984), L. Bersani (1986), A. I. Davidson (1987). Although Freud consistently reintroduces in his clinical, applied, technical, as well as theoretical papers the pivotal notion of the variability and inconstancy of the object, he almost as consistently undercuts his own conceptual innovation, "clearly reluctant," as Bersani puts it, "to accept the psychic and social consequences of the sexual and ontological floating which he describes" (1986:45). These hesitations on Freud's part, especially those in Part I of *Three Essays*, where the problem of the object is posed relative to the sexual perversions, are laid out in detail and analyzed from a slightly different but also Foucauldian perspective in a fine essay by Davidson (1987).

TWO

An Insubstantial Pageant Faded

A Psychoanalytic Epitaph
for New York City Subway Car Graffiti

This chapter comments on contemporary art and life, on speed,
fragmentation, and evanescence. Crocheted with many threads, its
graffiti "hook" was borrowed from psychiatrist Joel S. Feiner,
M.D., of the Albert Einstein College of Medicine, whose
remarkably sensitive first-hand study of the "writers" of subway
car graffiti in the Bronx persuaded me to consider the potential
significance of their exhilarating and mad/dening imagery.

And is every new piece of reality ... to be con-
sidered a contribution to *art?*

—Arthur Danto, 1981

I want these pieces to have an unbridled intense
Satanic vulgarity unsurpassable, and yet be art.

—Claes Oldenburg, 1967

Frames and Dichotomies

What kind of dialogue or parallel process is possible between art
and psychoanalysis? I approach this question with a heady mixture
of exhilaration and trepidation, due in part to a slippage and widen-
ing chasm between academic and clinical psychoanalysis—worlds
in which (through training and teaching) I have placed one foot
each. The sliding apart of these worlds produces a vertigo that is
reflected in the following essay and in its principal subject—al-
though surely exhilaration and trepidation are not unusual emo-
tions with which to encounter psychoanalysis, which disturbs for
the same reasons it fascinates. I have chosen, in what follows, to
accept this gap as given and to join ranks with the academic project
of borrowing (and reflecting on) psychoanalysis as a critical theory.

Like trepidation and exhilaration, two terms, *art* and *psychoanal-
ysis*, are implicitly linked in the subject of this chapter. Although I
prefer to construe their conjunction as indicating a mutual relation
without a covert privileging of one term over the other, such a
reading is not the only possible one, and the point of mutuality
needs underscoring. Such underscoring might respond in part to a
widely publicized critique of psychoanalysis that surfaced in a spe-
cial issue of *Critical Inquiry* where psychoanalysis was chastised
(although not without the leaven of genuine affection) and charged
with an imperialistic invasion of other disciplines, an abnegation of

Versions of this chapter appeared in *Art Criticism* 4(3):50–63, and in H. Risatti, ed., *Postmod-
ern Perspectives: Issues in Contemporary Art* (Englewood Cliffs, N.J.: Prentice Hall, 1989), pp.
260–275. I owe thanks to Donald Kuspit, Gladys Topkis, Bonnie Leadbeater, and the youthful
schizophrenic patients at the Ittleson Center for Child Research, Riverdale, New York, who
taught me to value process over product.

the responsibility to come to terms with the secrets and suppressions of its own history (Rand and Torok 1987), a disavowal of the tortuous implications of racial and religious prejudice in its self-proclamation as a species of medical science (Gilman 1987), a misprizal of the feminine (Gallop 1987), a failure to account for the defining differences of art—the literariness, for example, of literature (Riffaterre 1987), and a refusal to allow the texts it appropriates to challenge the concepts it applies to them (Cavell 1987)—in short, with aggrandizing itself into a "ubiquitous subject, assimilating every object into itself" (Meltzer 1987).

Implicated in such a vortex of powerful interdisciplinary cross-currents, any project of joining the terms *art* and *psychoanalysis* is bound to encounter danger, even attack—as is the parallel case of the subversive illustration I have chosen here—the phenomenon of urban adolescent graffiti (subspecies: New York City subway cars of the seventies and early eighties). This body of work, a borderline case on the slippery edge between art and nonart, serves as ready analogue for the project itself, which also straddles a tenuous border.

If we stipulate (in the customary manner) that psychoanalysis has to do with the embodied mind and that art has, likewise, to do with embodied mind in the sense both of objectified thought and feeling and the filtering of experience through mazelike defiles of signification—we seem to gain, by this twinning, a warrant for mapping one realm onto the other. We may assume, by such a move, that the structure of art mirrors in some sense the structure of mind—not a specific mind, but the dynamic organization of mind (this is a tack taken, for example, by Gilbert Rose in his 1980 book, *The Power of Form*). We may sense or expect or hope that there is or should be a correspondence between aesthetic form and psychic process. But is there any validity to such an assumption beyond the warrant it provides to play in both camps, so to speak, to borrow back and forth across the (barbed wire) fence between? What would it take to validate such a correspondence between art and mind? Would such a correspondence necessarily implicate us in a covert move from interpretation to explanation—a privileging of one term over the other (art construed by psychoanalysis)? Whereas, if such a correspondence could be permanently vitiated (if, say, the structures of metaphor and symptom could be proved radically *in*commensurable), would that not likewise vitiate the play altogether, replacing the *and* with a less friendly conjunction, or even more drastically dissever the pair? Can there be a relation between the terms that transcends the mutual tyranny of

master/slave? Turning to art history, can history, fact, and reality be severed (released) from fiction, fantasy, and representation? These are framing questions—too grand for short essays—but framing questions that seem necessary to pose in that they simultaneously ground and remove the ground from whatever else follows. A few more might be: How does critical practice bracket itself with respect to the theory on which it relies? Are, and if so, *how* are, critics responsible for (as well as responsive to) the theories they draw upon? Are critics who toy with psychoanalytic notions, and clandestinely cannibalize tasty morsels, not guilty of a reverse imperialism, the very same imperialism for which clinical psychoanalysis has itself been put on trial?

My own theoretical orientation, following the thrust of contemporary academic postmodernism *and* clinical psychoanalysis, is unabashedly eclectic, that is to say, Freudian and post-Freudian. Joining these viewpoints bespeaks no naïveté concerning their points of divergence and want of common philosophic roots (see Cavell 1987). It heralds the conviction that, despite their heterogeneity, they can and do belong together as overlapping fields of force—and with no implicit unity. Such staging of referential contexts leads not to unified interpretations but rather to composites of diverse perspectives, each of which may illumine a dark corner or, more radically, allow us not only to *un*cover and to *re*cover but actually to *dis*cover.

It is worth noting that those of us engaged in efforts to apply psychoanalytic ideas and modes of understanding to the visual arts have sought recently to extend the range of these applications. We have cast our nets in ever-widening circles—as has been the case with critical theory more generally. Efforts began, of course, with a kind of *auteurist* approach (which was considered in my first book, *Art and Psyche*, under the heading of pathography) that weaves together strands from an artist's life history and works (as in Freud's tediously overcriticized Leonardo paper). New horizons have extended to include the possibility of psychoanalytically informed studies of the history of critical responses (both to individual works and to an artist's *oeuvre*, see Sheon 1987), the shifting positions of a body of works with respect to a given canon (Yang 1987), and even, reflexively, of the very canons themselves. More radical are efforts to de-center the figure of the artist altogether (see Gouma-Peterson and Mathews 1987), and putative dethronements of hallowed divisions of artworks into periods and styles (Bryson 1981, 1983), as well as attempts to de- and renarrativize objects (Clark 1984; Fried 1988; Nochlin 1988) according to strategies not unlike

those that lead, in the clinical sphere, to continuous realignments and regroupings—to new stories being told and stranglegrips loosened.

In all of these efforts, the big fear on the part of art historians has been that psychoanalysis will work as a critical theory to dismantle the object (see Kuspit 1987). In the main, however, the privilege of the object has remained inviolate. Postmodernism, feminism, and deconstruction notwithstanding, art objects continue to be exhibited, recorded, and discussed even psychoanalytically *as objects*. The example that follows, however, does call this priority into question.

Strategies

Graffiti art of the New York City subway cars and murals painted in the seventies and early eighties fascinates us in part because, like Prospero's magic, it appears and disappears—"an insubstantial pageant faded" (Shakespeare, *The Tempest*, Act IV, scene 1). Created by artists to whose very existence we give the name *adolescent*— that is to say, evolving, changing, developing—the subway car graffiti, in its coming into being, is charged with intensity and evanescent excitement. Executed in motion, it is likewise perceived in motion—swiftly arriving or departing. Currently, the spectacle itself has been slowly vanishing altogether from the New York scene —its colorful designs dispelled in the wake, partly, of massive resistence by city government (figure 2.1) as well as by the fact that adolescence is itself a transient state: The generation of early writers has grown up. More ruinous to it has been its cooption by the establishment, its appropriation and cannibalization by commodity culture.

As counterpart of, but in contrast to, the reassertion of civic order with which Shakespeare terminates *The Tempest*—where Prospero voluntarily forswears his magic and resumes the duties of his dukedom—the City of New York has here forcibly imposed and reasserted its hegemony over this adolescent art by enforcing its illegality, by banishing it, and by disarming its rebellious spirits. For the radiance of its wild and tangled forms, the Transit Authority has substituted "graffiti-proof" trains—stark, silver cars imported from Japan, cars that blend without defiance (but equally without joy) into the grayness of the ghetto.

Ambiguities encircle this magnetic body of art. Its controversial

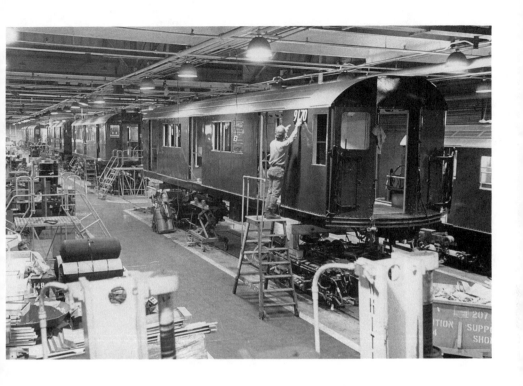

Figure 2.1. "On the Walls, the Fading of Graffiti."
New York Times, May 6, 1988. Cr.: Neal Boenzi/NYT Pictures.

reception/rejection has run the gamut from penalty to praise. The passion it evokes points up the fluid boundaries between genuinely creative efforts to transform and transcend environments and wantonly destructive, deviant, sociopathic behavior. Limited here to a collage of psychoanalytic perspectives, my essay addresses only in passing the fascinating adjacent issues—historical, stylistic, aesthetic, and sociological. Themes that will surface include: the prioritizing of process relative to product; the intertwining of image and inscription, of marking with making; the foregrounding of a set of powerful developmental imperatives (psychosocial and psychobiological) as motivation for this art and perhaps for all art; the role of aggression, both latent and manifest, as inextricable from artistic insertion into the cultural order; and the trajectory of graffiti, which follows an irresistible drift of art—from subversive start to conservative finish, from becoming to being, from maker to market or museum.

In considering these issues, the inquiry doubles back upon itself, with art informing psychoanalysis as well as the other way round—art teaching psychoanalysis not only about its own objects but about the dynamics of desire—which are constitutive of these very objects. And the issues themselves are entangled, a twisted skein.

Verbs

Graffiti shifts our focus from the object as beheld in its "finished" state to the process by which it comes into being—as well as that by which it is received. *Graffiti turns art into a verb.* It shifts our habitual arithmetic metaphor—art as product—to art as remainder. For what animates these marks and images are the traces of those exciting and dramatic performances through which they come into being. Kinaesthetic as well as visual in their origins, they link artistically with what critic Harold Rosenberg has labeled "Action Painting." Authenticity of gesture in part determines their quality and is read in traces of action—agility, boldness, spontaneity, angry sustained passages. Engaging large as well as small muscle movements and hand to hand encounters with metal walls, filling huge vertical spaces by spraying paint, solving drips, integrating accidents, the visual dynamics of graffiti evoke modified images of artists of the fifties, limning, stroking, spattering and pouring, their internal impulses and external systems of control engaged in dubious battle.

Correspondingly, a focus on process lies at the heart of psycho-analysis—constitutes, we might say, the heartbeat of clinical depth psychology. Recently, in the theoretical literature of applied psychoanalysis, several authors have advanced brilliant arguments that Freud's originality and genius lay precisely in his radical questioning of the object—a deeply disturbing move the consequences of which he strove intermittently to reject (see Bersani 1986 and Davidson 1987). Psychoanalysis has essentially to do with means and not ends, with branching roads (as in *Oedipus the King*) rather than with destinations, but this is an attitude of mind extraordinarily difficult to maintain because it challenges the mental habits with which we have grown comfortable—not only the logic and linearity of our explanations, but our deeply rooted craving for intellectual and physical certainty.

The reification of such certainty, expressed through our investment in the material objects of art, is thus doubly problematized. It is called into question not only by the adolescent graffiti itself, which is an experiential, nonsurviving art, but by psychoanalysis which, in its radical and restless search, doubts every object, interrogating it relentlessly. Constituted by ruptures and sutures in a continual process of refinding, revoking, reworking, and remaking, the object generates questions that, no sooner asked, bring forth another wave of questions. Like Calvino's Palomar on the beach, we submit ungently to frustration. We are loathe to recognize the suffering and loss implicated in our very acts of representation—unwilling to accept the insight that we cannot contemplate, we cannot isolate, we cannot interrogate—even momentarily—an individual wave. What must come to matter, rather, is the process itself and the capacity to go on asking: *Truth itself, perhaps, as a verb.*

To reintroduce or reaffirm the priority of process in relation to object is, I suppose, to conflate visual with performing art. Yet, as twentieth-century art demonstrates, these categories can and have been suspended not without intriguing results. In this spirit my title alludes to theater via *The Tempest* and to Shakespeare's fleeting images of Prospero's magic—Prospero who, like the adolescent graffiti artists, is both conjurer and banished citizen—and whose art, self-described, is, as some would style postmodern texts, but "the baseless fabric of [a] vision."

The performance aspect of graffiti surfaces in a manifesto given me by a former "writer" who has requested anonymity: "The actual execution of a piece [he says] is more of a statement than its style or content." Clamoring, however, against what he now considers

the *coup de grâce* for graffiti art as well as its final corruption, namely, its removal from the original context of street and station yard and its cooption by the media, he rages especially against the attention it has provoked in cultural circles—particularly in the established art world which, he implies, radically misunderstands it—having appropriated its aesthetics without its politics.

This young man describes graffiti as a journey—*and* as an expression of social outrage. Its overriding motive is an intense desire on the part of crew or clique to gain recognition from an indifferent world. To say this, however, is to articulate its fundamental paradox. For since the graffiti art, once executed, clearly and decisively *does* impact (whether negatively or positively) on the surrounding world, the metaphor must switch immediately from journey to destination. In this important sense, the aims of graffiti (as journey toward recognition denied) are revealed to be intrinsically self-contradictory, a point inextricable from any discussion of art as process as well as from the psychodynamics of (adolescent) rebellion.

Stagings

In a stunning paper on graffiti, John Carlin (1987) has focused on the way in which, as he puts it, this art "bombs history." In an effort to illustrate the radical restructuring of time and history that characterizes our era, he points to the media technique of juxtaposing images before us in sequences that disregard historic process. What is produced thereby he terms a kind of "feedback chamber of time"—a state of utter contemporaneity—which we experience both as insidiously lulling and as strangely disquieting. In a striking analogue, the bubble letters, flourishes, and tags of graffiti art also burn time. While initially rejuvenating the drab, they simultaneously reveal it; they refuse the old while making it older. They bring into visual awareness the rupture between generations; by inserting new signifiers, they disrupt the extant order of signification.

In this unremitting assertion of denied subjectivity and blatant demand for visibility (though, not equally for legibility—since making style inimitable, "hard to bite," is definitely part of the game), graffiti art stages an ambiguous drama of presence. Simultaneously proclaiming presence *and* absence, it declares provocatively to beholders that *it* is there but soon won't be there, and that its adolescent artist *was* there but *isn't* there any longer: It teases,

like the saucy refrain of the children's rhyme: "Run, run, as fast as you can—you can't catch me . . ." and so on. Powerful, subversive dynamics structure this drama. Fascinatingly, however, they are played out by choice in terms not of violence to persons but in terms of representation and the manipulation of signs—and, in the best instances, of visual art (figure 2.2).

Names, the most pervasive theme of graffiti, assume transcendent significance for a psychoanalytic approach that privileges the notion of subjectivity over issues of self and identity (see Lacan 1977). Untranslatable from one language to another, names both preexist and outlast bodies. The name, unlike our ever-changing face, figure, and physique, denotes and survives us and is, finally, engraved as our memorial. The inscription of one's name, therefore, counts as a paradigmatically significant act—a direct and unique engagement with the symbolic order (see Richardson's psychoanalytic study of the Vietnam War memorial, 1985).

In the case of the radically alienated young graffiti artist, however, this act bifurcates into charged ambivalence. Paradigm becomes paradox. For while it proclaims the assumption of a subjectivity denied both to the unnamed and to the uninscribed named, this particular version of the act trenchantly challenges the very symbolic order to which it seeks to gain access. The tags are self-given (or, what is essentially the same for this point, peer-conferred). Thus while actively seizing the right to *be* named, they overtly reject the position of having *been* named: they both grasp and refuse subjectivity. And the tags are (like nearly everything else about graffiti) impermanent. Impermanent not only in the ways previously mentioned—including the fact that, illegally sprayed on public subway cars, they travel under and across the City of New York—but impermanent more radically in that the tag of any particular artist may, unlike the parentally conferred name, actually change several times (often for social, safety, and artistic as well as emotional reasons; cf., "Black Cloud" to "Semi-Soul," see Feiner and Klein 1982). Hence the paradox: fetishistic naming here coincides with maximum public anonymity.

Developmental Imperatives

Psychoanalytically speaking, what needs and tasks are met, set, avoided, motivated, by this art in particular, by that of adolescents more generally, as well as by that of art more generally, and by that of these adolescents in particular? Such a developmental perspec-

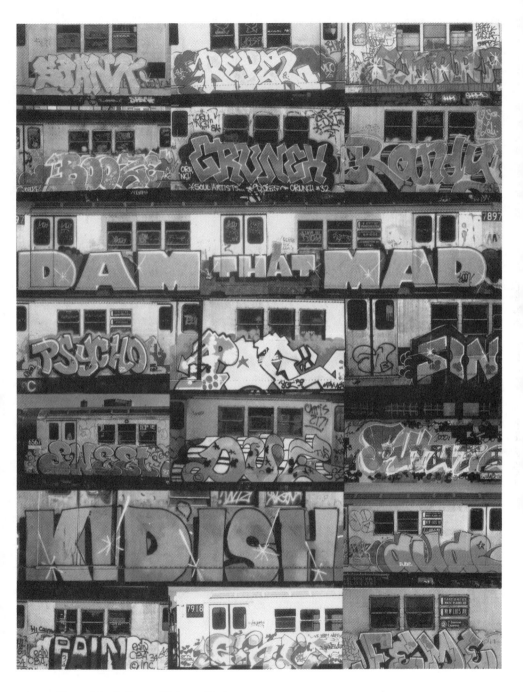

Figure 2.2. *Collage of Subway Trains*
Martha Cooper and Henry Chalfant, *Subway Art* (New York: Holt, Rinehart, & Winston, 1984).
Copyright © 1984 Martha Cooper and Henry Chalfant.

tive, it could be argued, actually post-dates Freud. The notion of "adolescence" as we know it is absent from his *Three Essays on the Theory of Sexuality* as well as from the "Dora" case, where its omission has been sorely lamented in both the clinical and scholarly literature. When Freud does, a few times in his *Studies on Hysteria*, mention adolescence, the term denotes puberty rather than the more complex psychosexual-social entity to which it currently refers, although cultural as well as biological factors are implied. (For a fine interdisciplinary account of adolescence, see *Daedalus*, Fall 1971.)

Yet, a possible position here (perhaps a covert return to Freud) is that adolescence, as defined in contemporary clinical discourse, involves imperatives so deeply and pervasively human that it might be more accurate to describe them as stage-intensive than as stage-specific. It may be that the imperatives we associate with adolescence bear such an intimate relation to art-making in general that features associated exclusively with this developmental period retain a lifelong urgency for creative artists (cf., Greenacre 1971).

Post-Freudian perspectives link adolescence with the theme of identity (see Erikson 1959, 1968; Blos 1962; and it is worth noting that Erikson himself, theorizing identity, actually renamed himself in a paradigmatically autogenous act). Likewise, names are endowed with privileged significance. Since early tags were nicknames followed by street numbers, they have been interpreted as reinforcing the transition from home to a wider turf. Cross-culturally, the assumption of new names has generally been associated with rites of passage. Replacing family surnames, rejected along with devalued parents, street numbers may be emblematic for the world at large, and, in some cases, mark a progression from foreign parental cultures to the allure of the modern American city—where numbers have replaced nouns (see Feiner and Klein 1982).

Other adolescent developmental imperatives are implicated as well. To name is to tame—to claim possession. To inscribe one's name in gargantuan, savagely luxuriant, resplendent letters on the walls of trains that travel to places unknown and predictably return condenses urgent, ambivalent issues of separation. Vicariously, the young graffiti writer undertakes a (dangerous) journey to alien parts, always with the confident expectation of return—an "as-if" adventure par excellence. Issues of control are implicated. To gather in the stations and watch the names rumble past confers an illusion of power over outside forces that seem callous, threatening, and augmented in fantasy by the projection of inner turmoil.

The very choice of subway cars as a locus for painting bespeaks a

craving for locomotion that, in contemporary American culture, with the dearth of formal rites of passage, assumes a symbolic meaning—the trains possibly analogous, for these urban youths, to the so-called "wheels" of their suburban counterparts. Driven by increased sexual and aggressive impulses and by wishes to establish independence from parental and societal authority—to defy, to escape, to explore, and to *be seen*—the wish for a means of locomotion is multiply determined. Experienced as extensions of the body, vehicles are embellished accordingly. Thus, graffiti art serves, in fantasy, as adornment and decoration as well as mutilation and desecration. On a deeper level of fantasy, the subway trains may carry both phallic and even more primitive anal signification in that they disappear in repetitive cycles into the depths, the entrails, of the earth.

Barring quilts and tapestries, graffiti art is singular in being performed in *groups*—"writing clubs"—a subspecies of peer culture that enables the adolescent to detach from earlier object ties. Writers with notably elegant styles, writers who "get up" in particularly dangerous locations, win respect and admiration (see again, Feiner and Klein 1982). Thus, the activity, perilous and skilled, creates a theater for both competition and cooperation in which bodies, momentously involved, are placed at risk—an exclusive world, where old familiar rivalries, risks, and passions can be displaced and defused (figure 2.3).

Faced with outer turbulence, permeated by inner turbulence, youth seeks distraction by the frantic filling of both time and space. Graffiti writing, from this perspective, occupies the emptiness of hours as well as the barrenness of walls. As such, it invites comparison with the familiar teenage passion for flooding consciousness with pulsating sound and accompanying kinaesthetic sensation. It takes adolescents out of themselves —out in surroundings that fail to provide even minimal opportunities for socially approved activity—contexts where the problem of evading the discordant self becomes (and remains) acute.

Antisocial Artistry

What amazed some of us most about graffiti art was that, despite (and because of) the pervasive immediacy of a deteriorating city with crumbling, charred tenements, unrepaired streets, accumulating refuse, visual and auditory chaos, these young artists managed

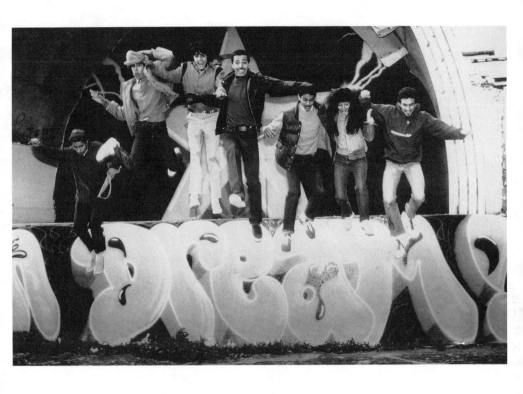

Figure 2.3. *Collage of Subway Trains*
Photo cr.: copyright © 1984 Martha Cooper.

to mobilize color, line, shape, and design. Cloaking ugliness with bold imagery, vitalizing the dreary, and, minimally, catapulting into our visual field that which had been previously ignored, their achievement gainsays (while being sustained by) its own destructiveness.

Rebellion is a complex issue here. Resisting authority, winning peer approval, attempting to achieve independence (albeit in some cases by a return to pregenital defenses that may betoken rather a denial of separation), and, secondarily, undergoing retaliation from authority—all of these are present in tandem. As D. W. Winnicott (1956) points out: "the organized antisocial defense is overloaded with secondary gain and social reactions which make it difficult for the investigator to get to its core." What is it, actually, that the graffiti artist wants?

Graffiti teaches psychoanalysis about aspects of aggression that derive not solely from inner developmental imperatives but from particular external surrounds, from, in this case, a quantum of dehumanization that breeds violent feelings and hostile acts. Winnicott (1956) interprets further that openly aggressive feelings and acts may well be considered adaptive in such contexts. To perceive hopeful, self-curative undercurrents in what appears behaviorally destructive is to underscore the positive side to these youthful efforts to project an imagery that speaks both to and for its makers —that reflects back to them, as to the world, some semblance of their unacknowledged desires. Inscribed as graffiti, these desires can be read as intensely charged—positive/negative, artistic/delinquent, profoundly personal/blatantly political.

Satanic Vulgarities

One contemporary artist who admired graffiti from the start is Claes Oldenburg. A convergence between its themes and his own might probe the wider significance of process and performance, of repetitive cycles of doing and undoing, and fantasied enactments of aggression, control, and ambivalence—might show their bearing beyond adolescence, their relevance to the making of art more generally (figure 2.4). Let us consider a few statements taken from *Store Days* (1967). This manifesto, written by Oldenburg in his mid-thirties, retains every iota of its refreshing and salacious irreverence:

> Residual objects are created in the course of making the performance. . . . The performance is the main thing. . . .
>
> I am for an art . . . that does something other than sit on its ass in a museum.
>
> I am for an art that grows up not knowing it is an art at all, an art given the chance of having a starting point of zero.
>
> I am for an artist who vanishes . . .
>
> I am for the art of scratchings in the asphalt, daubing at the walls.
>
> I am for an art that is put on and taken off, like pants, which develops holes, like socks, which is eaten, like a piece of pie, or abandoned with great contempt, like a piece of shit.
>
> At the completion of my work I'm afraid I have nothing to say at all. That is I have either thrown it away or used it up. (Oldenburg 1967, *passim*)

Thus, Oldenburg (cannily) describes art not in terms of technique, convention, and style (derivatives of what psychoanalysts call ego function) but rather in terms that exploit the polymorphous incarnations of infantile sexuality. He evokes not only the instinctual regressions (explicitly oral and anal) that may serve in adolescence as a defensive flight from genitality, but also its typical ambivalence—conveyed through images that abruptly juxtapose instinctual gratifications with corresponding renunciations. This abruptness has its counterpart in the sudden shifts endemic to adolescent behavior—its changeability and "as-if" interactions with the environment (e.g., putting things on and taking them off).

Oldenburg's words proclaim that art should be something absolutely new and different ("a starting point of zero") and, in addition, that we must not become too attached to it. His description implies a defiance of (parental) authority (i.e., the museum) and the wish for a chance to grow up without parents (i.e., without an artistic tradition). Such wishes evoke the reaction formation in adolescence that serves to defend against recrudescence of incestuous love for the first objects (the parents). His words point, by repudiation, to the oedipal conflicts unconsciously implied in any creative endeavor—to make something new being, aggressively, to replace the old. But, at the same time, we must be able to abandon our own work with contempt—lest it be saved and incarcerated in a museum. Nothing less than perpetual revolution is advocated: art must be original and disposable—like the vulnerable traveling spectacle of graffiti.

No longer equated with any good sanctioned by society, art con-

Figure 2.4. Claes Oldenburg, *The Black Girdle* (1961).
Painted plaster; 46½ in. x 40 in. x 4 in. (118.11 cm x 101.6 cm). Whitney Museum of American
Art, New York, Gift of Howard and Jean Lipman 84.60.2.

sists not of products made, cherished, and preserved, but of the acts of marking and making. Performances, not objects, are cathected. Ambivalent and destructive wishes underlie these thoughts, fitting the motives and practice of young writers who pilfer materials, cut wire fences to enter forbidden spaces, execute paintings at night, abandon them at the whine of sirens. The very relish with which they greet peril fulfills Oldenburg's criteria.

Important adaptive needs are served by the destructive wishes expressed in this manifesto—principally the need to separate from (and deface) real, displaced, and fantasied parental objects and to create thereby a horizon for the emergence of the new—a need that clearly continues beyond adolescence to pervade the life cycle of the artist.

Psychoanalysis, however, postulates an intrapsychic museum— *a museum of the mind.* This is a fate that can be escaped neither by rebellious youth nor by the artist of any age. For in such museums are eternally preserved the traces of each individual's earliest relations—all that has been loved and lost—which, unlike pants, cannot readily be taken off and which, unlike excrement, cannot easily be abandoned with contempt. For as psychoanalysis teaches, this past, the contents of this metaphoric reliquary, even if split from consciousness, must always be, has always been, and continues to be, psychically metabolized—is forever in the process of intruding and extruding, of becoming (however maddeningly) one with us. In this psychoanalytic sense, there is no possibility of starting from zero.

Perversities

It is difficult to evade anal themes in Oldenburg's manifesto as well as in the graffiti phenomenon itself. Besides the explicit comparison of art to feces in the previously quoted passage, Oldenburg has praised graffiti by calling it a "big bouquet from Latin America" (1975). What has this particular aspect of fantasy to do with art and with wishes to transform reality?

In a brilliant paper, the French psychoanalyst Janine Chassequet-Smirgel (1983) proposes a stunning link between anality and the human desire to transcend the ordinary. Pointing out that human beings have always sought to reach beyond the narrow limits of existence, "to push forward the frontiers of what is possible and unsettle reality," she speaks of such wishes as constituting a temp-

tation in the mind that motivates an array of fantasies and acts. Such (perverse) acts may, she suggests, serve to overturn the "universal law" that distinguishes body parts from one another and separates human beings into the fundamental categories of gender and generation. This temptation is prompted, she proposes, by a retreat from the pain and loss that follow inevitably upon the recognition of sexual and generational differences and prompted also by a defiance of paternal authority (which forbids access to the mother). Such temptation may lead not only to perverse behaviors of wide-ranging diversity but also to a dazzling array of experiments in thought and act, including art.

As her principal example, Chasseguet-Smirgel chooses the Marquis de Sade and indicates that the Sadian hero puts himself in the position of God, becoming, by a process of destruction, the creator of a new kind of reality. In order to do this, all differences must be annihilated, until finally the fundamental difference between life and death, organic and inorganic, is denied. In this way, an anal universe is created, wherein all things, erotogenic zones and functions, sexes, classes, siblings, ancestors, are intermixed in a crucible of undifferentiated matter. Emphasizing the hubris of the individual who dares take the place of Creator, Chasseguet-Smirgel links the sin of hubris with hybridization, with mixture, and with the transgression of boundaries. The anal-sadistic universe that thus results constitutes both a parody of and regressive flight from the repudiated adult genitality.

The relevance of this fantasy to adolescent and artist is clear: both stand accused, even guilty (not in fantasy alone) of hubris. They also dare, while baring and transfiguring it, to defy convention, rule, and law. Creating themselves as demigods, daring to invent a universe, they must also wantonly and destructively (even if in fantasy alone) abandon the old in search of the new; they must bring forth form from chaos. Parenthetically, in a recent interview in *Dialogue* (September/October 1987, p. 29), Chicago painter Roger Brown—whose works are represented in MOMA, the Whitney, and Washington's National Gallery—is quoted as saying: "I'm not interested in recreating the world; I'm interested in transforming it. The goal is to evoke a parallel universe. I'm God and I'm going to create my own world."

Chasseguet-Smirgel unmasks our collusive denial of intimate links between anality and the aesthetic, art and aggression, creativity and destruction. When even in part, as in the case of subway car graffiti, the creation of art springs from roots nourished by deep

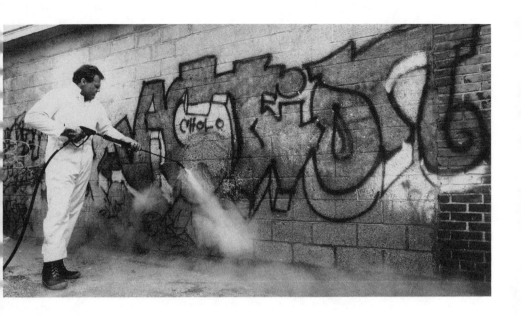

Figure 2.5. "Doing Battle with the Scourge of Graffiti."
New York Times, May 10, 1987. Cr.: Penny Ann Dolin/NYT Pictures.

Figure 2.6. Boutique, Larchmont, New York (1988).
Photo cr.: the author.

human desires to reach beyond what we are, to devise new forms and meanings, new combinations and new sights, it provokes powerful resistances, both internal and external, as the New York City youths have, repeatedly, discovered.

Deconstructions

Graffiti has (almost) been tamed—its meanings confused and "hypocritized" to use the words of my previously cited correspondent. Its removal from the streets has been effected by caustic detergents described recently in a *New York Times* article with the dramatic caption: "Doing Battle With the Scourge of Graffiti" (figure 2.5). Far more dramatic has been its success. No longer a raw, painfully brash, energizing effort to bridge the abyss between subjectivity and signification, between the imaginary and the symbolic order, graffiti art has been domesticated, its power caged and drained. Wild-style spraypaint effects have assumed today a ubiquitous presence in American culture—in art galleries, magazine advertisements, ballet stage sets, children's T-shirts, fabric designs for linen and drapery. "Graffiti" is now the epithet for a fashionable boutique in New York suburbia (figure 2.6).

Meaning has been deconstructed, appropriated, reassigned, and fixed. *Verb has become noun.* For graffiti art was subversive: like psychoanalysis, it exposed what we did not want to see. While sabotaging, it revealed an unpleasant dis-order of things. It gave us, like Prospero's magic, a fleeting pageantry—and not without its Calibans: Satanic and vulgar, like Oldenburg's credo—yet, it was art!

The ambiguity of art lies in its twin powers, terrifying and exhilarating, to undo and to make new. Psychoanalysis, grasping (and instantiating) this paradox, aligns art both with health and with illness, with optimal functioning and with driven, repetitive, symptomatic behavior. Such polar views of art, deeply embedded in our cultural heritage, are thrown into bold relief and de-dichotomized by the masterpieces on the trains.

By interpreting partly against a background of adolescent developmental themes, I have sought to contextualize this art with regard to some aspects of the subjective experience of its makers. But this whole enterprise could be called into question: Is such contextualization relevant to artistic valorization? The same phenomenon viewed from the outside (Is it [good] art?) and from the inside (How

[well] does it function for the individual creating it?) may yield asymmetrical responses for, although both questions imply judgments of value, the systems of value brought to bear are discrepant. Paintings that signify a great deal emotionally or developmentally to an artist may later prove relatively ineffective in their capacity to move, delight, or interest spectators. Other works that, in their actual creating, have played a far less dramatic intrapsychic role for the artist, may, however, claim fervent attention from future viewers. A core (and too often unrecognized) problem for the psychoanalytic critic is to avoid conflating these discrepant systems of value.

My effort here has been to open avenues of identification between a marginal and ambiguous body of work and its (often hostile) beholders by highlighting psychological themes that, though especially powerful in adolescence, and in the urban environments where graffiti has flourished, recrudesce throughout the lifespan and throughout history to animate the experience of both creators and recreators of art. I have tried to show that—*pace* the sacrosanctity of the aesthetic—psychoanalytic perspectives enrich rather than diminish our interpretive efforts. They augment our awareness of the complexity of art. They refuse to permit us the luxury of premature resolutions.

Charged Objects

Reflections on an Exhibition of African Art

This chapter was originally a lecture at the Center for African Art in New York City. The other speakers engaged for the series were recognized scholars of African art history and native artists who were to show and discuss their work. I, however, had been invited to provide some psychoanalytic perspectives on the then-current exhibition and saw myself in this context as the proverbial "naive" viewer. In preparing my lecture, I had to reconsider what it might mean to assign this role either to oneself or to others. Moreover, the art at the Center, with its torrents of energy, pointed up by way of contrast a certain tiredness in our own culture. This essay attempts to share my responses to this body of art—quite new to me—and, for the courage to do so, I am indebted to Melanie Forman, then assistant to the director of the Center; her gentle persuasions overcame my hesitations.

A collage of observations based in aesthetics and psychoanalysis rather than in African scholarship or ethnology, this essay is frankly speculative and interpretive in nature. Neither an attempt to address, nor to appropriate, the discourse of the *other*, it inescapably adumbrates issues of cultural xenophobia, issues that have come under intense scrutiny in intellectual life today and are a part of the unacknowledged legacy of psychoanalysis. Despite and because of its occidental orientation, an oxymoron that condenses both the ambiguity and authenticity of this writer's own perspective, it raises questions that by the close of the essay must remain open.

Up to quite recent history, the only art from the continent of Africa to which American undergraduate art history students were introduced was that of ancient Egypt. As gaps and exclusions of this sort in academia are increasingly brought to light, exhibits such as the one under discussion here, mounted by the Center for African Art in New York City in 1987, can serve as powerful catalysts in the process of cultural change.

Invited to discuss this exhibit, I was at first reluctant because, like most Western viewers, I am an avowed latecomer to the scene and approach African art with untrained or, to be more precise, otherwise trained, eyes.

It was, however, the objects in the exhibit that persuaded me to try. I have called them, in my title, *Charged Objects.* Their power and eloquence so captivated me that it seemed impossible to refuse their invitation. In fact, such a refusal might well have been construed as a radical comment on their very status as works of art. This is so because, if the only persons qualified to speak about such objects are those with detailed knowledge about the cultures in

A version of this chapter will appear in *New Issues in Psychology*. Permission from Pergamon Journals is here gratefully acknowledged.

which they are produced, the objects themselves are easily reducible to a species of artifact. Under such circumstances, viewers are made to feel that communication with the objects depends on mediation by expert interpreters. Such a state of things dooms marvelously evocative pieces to a rarified or dismally diminished status— as ancillary data or as source material for cultural information projects—anthropological, historical, and, certainly, ideological. Meanwhile, their tantalizing presence as works of art may be altogether forsworn.

The very particularity of research methods brought to bear often serves to delimit and conceal objects, to bar access to them as anything other than artifacts, to occlude their intrinsic capriciousness. For, while serving importantly as emissaries of their many cultures (and it is well to remark in passing the fiction of "Africa" itself, a Western term that tends to obscure differences among diverse peoples, languages, and traditions), these objects are not just emissaries of other cultures. They are endowed with qualities of immediacy and urgency that transcend as well as evince their origins. Dialogues with them yield questions with no easy answers or connections.

In a certain style of frameless freeform Pygmy quilt (Thompson 1987), the familiar Western wish for closure, for sewing things up, is frustrated and replaced by encounters with sudden breaks in pattern, breaks that figure the possession of some new force, breaks intended to push someone over into another world. Such quilts might serve as a metaphor for this essay. Or, to take up weaving rather than quilting, an imaginary loom is warped here with alternating yarns—with silken threads of aesthetics and textured cords of psychoanalysis. The weft, of course, must necessarily be a personal seeking, finding, losing, and refinding both of objects and of self—important because, as psychoanalysis teaches, description always reveals a subject as well as an object (a point especially relevant to this particular exhibit, which was organized around the theme of perspectives). Central to my approach is an emphasis on the fundamental incommensurability of images and words, a major theme, as I take it, of the show itself.

The world is *charged* with the grandeur of God.
 It will flame out, like shining from shook foil;
 It gathers to a greatness, like the ooze of oil
Crushed. . . . (emphasis mine)

Borrowing from Gerard Manley Hopkins, whose sonnets struggle valiantly to comprehend tragic splits between (in his own terms)

spirit and self, I have used the word *charged* in the title of this essay and mean it, as does the poet, to condense all the ambiguity it can muster. For each piece in this exhibit of African art is at least doubly charged. Electrified, explosive, potent with energy and emotion, it is likewise charged in the sense of having been *entrusted*— charged, that is, with a sense of responsiveness, responsibility, commitment. For "charged" implies a relation. Some*one* charges, and some*one* or some*thing* is charged. Thus, what I am suggesting is that art itself, all art, comes into being in a special kind of *charged* relation, and a visual analogue for this charged relation is created by the cover of the catalogue for this exhibit.

Entitled "Perspectives: Angles on African Art," the catalogue cover (figure 3.1) offers a grid of faces. Surprisingly, these are not just faces of works of art, as one might expect to find in a museum publication. Instead, one encounters rows of *alternating* faces— countenances of works *and* of those individuals who selected them for exhibition, and in so doing, *charged* them in the sense indicated. Thus, pictured in tandem, these carved and human faces form sets of the kind of relation that results in the emergence of art. Also, since within the book, each guest curator comments sensitively on the act of choosing and choices made, the entire catalogue format serves to thematize contingency and relatedness and, by extension, to underscore the subjectivity of all exhibitions and of aesthetic experience *per se*.

Often, by contrast, the element of choice is suppressed in exhibitions, and works of art are, rather, presented to beholders with an aura of autonomous rationality and anonymous objectivity. Descriptive texts (labels) are yoked to images and deliberately unsigned. Rather, like tags affixed to botanical specimens, such ancillary texts are presented as obligatory wisdom. Complicitously, with unregenerate positivism and well-oiled defenses, beholders accept them without protest. Dutifully, we focus our attention on each object displayed and, to keep its elusive boundaries under control, strive to master whatever has been written about it. In struggling thus to master *it*, we seek, of course, as psychoanalysis teaches, to master ourselves.

By accepting a cliché of art as fixed external object open to disinterested description, a paradigm exploded by this wonderful exhibit on African art as well as by psychoanalytic approaches to it, we miss the point of the doubling on the catalogue cover. We fail to notice, or *fend off* noticing, that the boundaries of all beheld objects are blurred, blurred for the awkward reason that we are implicated in our own acts of looking. Bent on acquiring knowledge about a

work, we cease to perceive it: we overlook its tendency to fade and
bleed. We fail to see it as a mirage that draws us irresistibly closer
while receding continually from our grasp. Duped into mistaking it
for an object of knowledge, we fail to recognize it as an object of
desire. Thus, labels can work to soothe, blind, and defend us; for,
whereas knowledge construes its objects as fixed and stable, the
objects of desire must slip and flutter. Their elusiveness or what
has been called their "excess" tends to unsettle their beholders—to
lure, snare, and frustrate our gaze. Factual knowledge quiets and
calms us by recasting the qualities of objects in manageable terms;
whereas, desire provokes and stimulates us, keeps us looking, long-
ing, and returning (see discussion in chapter 1). Thus, a great part of
the genius of this African art exhibit is that it celebrates the subjec-
tivity of choice, the mutuality of art as relation and as inescapably
contingent.

Enigmatic and enticing, the sculptures evoke questions, both
psychoanalytic and aesthetic, about the legitimacy of Western
knowledge in relation to them. How do they, their subject being
almost exclusively the human figure, challenge our occidental dual-
isms of mind and body? gender and generation? the relation of what
is conceived as human to both the animal and the divine? our
notion of masks? our familiar constructs of nurturance, aggression,
dominance, pain, and death, and how these themes interweave
male and female identity and experience? Each image, as it evokes
associations with artistic traditions more familiar to its beholder,
reveals that art is born and reborn in quintessentially intersubjec-
tive moments of beauty, playfulness, absorption, desolation, and
wonder: *charged* moments!

In an essay on the aesthetics of African art, Susan Vogel (1986)
has observed that in many African cultures the beautiful and the
good are conceived as a unity. In this context, it may be fruitful to
point out another connotation of the word *charged* that offers to
the cultural intertextuality I am weaving here a deeply religious,
even a *moral* quality. The grandeur of each piece of African art in
this exhibit may, in Vogel's terms, thus be conceived as stemming
from a confluence of spiritual and moral as well as erotic and
aesthetic elements. Such a confluence, when it occurs, as Hopkins
also implies in the sonnet quoted above, calls forth a profound and
ineluctable human response.

What can words do for images? Do we really believe that words can
draw objects closer or bring them into sharper focus? That words
can explain, control, capture, or arrest the power of images? Stuart

Figure 3.1. Catalogue cover, *Perspectives: Angles on African Art* (1987).
Courtesy of the Center for African Art, New York. Photo cr.: Jerry L. Thompson.

Hampshire (1966) has argued that interpretations of works of art may be interesting or dull but *never* true or false. Partly, as this exhibit demonstrates, this is because each piece inhabits a phenomenal realm, what psychoanalysis has called an *intermediate space* (Winnicott 1966), and comes into being *as art* when it is so beheld. Thus its boundaries expand and contract with the projections we bestow and the profusions of meaning we attribute.

An exquisite illustration of the gap between language and experience—between, as we might say psychoanalytically, the symbolic and the imaginary—is to be found in B'reshit, the *Book of Genesis*. For here we are offered not one but two versions of the story of Creation. In the first version, God creates the universe entirely by the use of words, by a pure process of naming. He says in the text, "Let there be light," and there is light. He calls this light Day, and by so doing, creates day. He names the expanse Sky, and thereby makes the sky, and so on. Verbal language performs, acts, and executes.

In the second version, however, He creates the world quite *differently*—not here by language, not by speaking, but rather by functioning in a completely different mode. He does it by intervening directly with substances, with materials. He actually forms man from the dust, blows life into his nostrils, plants the garden in Eden, forms the wild beasts and birds, and so on. I take these two stories, told side by side, as a parable. Just as it was necessary to create the world twice, once by tapping the awesome power of language, and once by means of touching, molding, breathing, shaping; so it is with us: We can neither sever words from experience nor ever find words equal to experience. Struggling to say *exactly* what we feel or see, we contend against this rupture, for what we see can never be fully conveyed by what we utter. As in *Genesis*, our worlds must always be created twice. And yet, is this itself a mere Western conceit?

Psychoanalytically speaking, the two modes—that of the symbolic order of language and that of perceptual experience—are clearly (perhaps too clearly) linked with the law of the father on the one hand and the early formative imaginary relation to the mother on the other. They are seen as anxiously competitive. Oedipal strives with preoedipal: law versus blood. (We may remember, for example, Freud's commentary in *Moses and Monotheism* on the Oresteia, where he speaks of it as instantiating the inevitable trajectory from mother to father, from body to word.) Yet a latent bisexuality disrupts this narrative. In considering what words can do vis-à-vis

these powerful images of African art, another Biblical text comes to mind: the second commandment (Exodus, 20:4), which enjoins us not to make for ourselves any sculptured images. Here, the preeminence of this prohibition—second of all the ten—testifies mightily to the strength of the fear against which it defends. Word and image vie for hegemony over our experience, and, as bearers of the law, words, as we are taught, must win out. Words, naming, interpretation are all efforts at establishing control over the lability of images which, though devalued as mute, inferior signs, may well be seen as stimulating such contempt as a means of warding off the danger they evoke.

Such a deep psychological reading of the second commandment, suggested by the potency of these sculptures, is adumbrated by art historian David Freedberg (1985, 1989) who speculates on the motives of iconoclasts—sociopathic individuals driven to deface and destroy works of art. What stirs their fear and rage, he asks; what engenders the hostility that results in their desperate acts of mutilation? Without the word, without the comforting label, without the security of some narrative context, *a powerful image can collapse all distance between signifier and signified* (figure 3.2). A painted or sculptured image can suddenly become reality—a phenomenon both too radically alien, too unbearably different from us, and at once too horrifyingly ourselves. Thus, we must talk and write. We must try to bring such objects under control, familiarize them, arrest, explain, and appropriate them—all in an effort to preserve our unsteady mastery over art and its troublesome power to disturb our gaze.

Unwritten histories, the stories normally left untold by the discipline of art history, include tales about the changing aesthetic responses of viewers to particular works, a rich and underexplored field for psychoanalytic scrutiny. This is pertinent here because, to many Westerners, African sculpture is new, new in ways that Donatellos or Michelangelos are not; hence, there is a temptation to disparage our responses to it as naive and uninformed and to dismiss them.

Art historian Robert Rosenblum (1986), however, in a personal vignette of unusual candor, demonstrates how knowledge can intervene to drive a wedge between beholder and object. In a moving

Figure 3.2. Figure. Kongo, Zaire.
Wood with screws, nails, blades, cowrie shell; ht. 46¾in. Courtesy of the Center for African Art, New York. Photo cr.: Jerry L. Thompson.

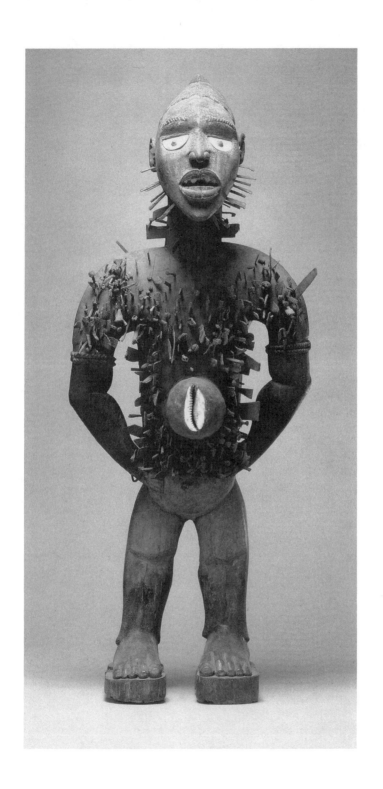

account, he details his private encounters with paintings by Leger, Picasso, and Miro, works he first saw as a child in New York in the forties. Exhilarated by them, he saw these paintings as triumphant fantasies of a streamlined future. With their flat, clean colors, sleek energy, fresh visual vocabulary, and strident defiance of the laws of gravity, they seemed to him emblematic of the horizons of a new world. Poignantly, however, he describes the wearing away of this first enchantment—a process accompanied by his acquisition of greater knowledge about the artworks themselves—knowledge for example, about who Picasso's three kaleidoscopic masked musicians actually were, and about the referential aspects of abstract paintings more generally, their intimate connections with politics and war. Pictures that once seemed effervescent harbingers of a magical new world, daring visions of the future, gradually transformed themselves, under his gaze, into venerable monuments of the recent past, testaments of an accepted period style. Ruing the absence of that "Eureka!" with which he had first beheld them, Rosenblum opines:

> Perhaps it is only sentimental nonsense that makes me feel, for a nervous moment, that my first ignorant and juvenile experience [of these works] may have been far more potent and authentic than my complex responses to the same paintings today. (p. 48)

What fascinates me here is the very need to label one's first reactions as "sentimental nonsense," when, in fact, such reactions represent an authentic *moment*—often, even, a *charged* moment—in the history of one's own aesthetic response. Indeed, it is not clear that without that first "Eureka!" the later reactions would be possible in quite the same way or even occur. To document both the subtle and sweeping alterations in one's private reactions to artworks over time is to face the partiality of the histories that are in fact inscribed, the reactions that are acknowledged, made public, and normalized. Once inscribed, such "informed" responses are hyperinvested such that initial encounters must be trivialized and dismissed. In cases like the Western response to African sculpture, it may similarly be that, to bring the objects themselves inside the (academic) pale, our first reactions must be tamed, tempered, or even radically denied. If this is so, then yoking text to image must be seen as quintessentially *paradoxical*. Verbal language, while bringing an object into clearer focus in any one sense—be it critical, art historical, or philosophical—must always distance us from it in another.

In the pages of contemporary criticism, debates are raging and arguments being polemically advanced that all efforts to interpret surviving objects and texts from reconstituted positions are chimerical, that we cannot repossess the vision of the past or of the geographically distant present, that attempts to do so are futile and profoundly misguided. Thus goes a triumphant, manic, sometimes bitter antirationalism that privileges the *otherness of the other* and frowns with suspicion upon those who would use critical or interpretative vocabularies to domesticate the strange or demystify the occult. Such voices articulate our loosening grip on the once-thought-firm boundaries of objects and texts. And we cannot dismiss them as symptomatic merely of changing winds in academia. None of us can avoid the subtle changes that are occurring culturally in our relations to space and to time: our sense of collapsed time, of synchronic as opposed to diachronic time, deconstructed and/or reversible time, the convergences of different orders of temporality that result in and from a replacing of time by space (on the television screen, for instance) and of narrative by imagery—all of which has conspired to topple the privilege and authority of traditionally accepted interpretations of the past.

Psychoanalysis has contributed, deplored, and invested high stakes in all this. For psychoanalysis, while revealing the unconscious mental processes that explode rationality and erupt into the linear flow, strives also, in its aspect as a rational science, to ascribe causes and write histories. Thus, within its corridors and between the covers of its journals, similar debates are being entertained. As an erudite cultural relativism vies with persuasive claims for the universality of psychological and aesthetic experience, so construction vies with reconstruction, and fantasy with seduction. And the terms of such contests are never truth versus fiction. They are, rather, truth somehow as fact against fiction somehow as truth. An exhibit that confronts both academicians and clinicians with the art of non-Western cultures—which we importantly *cannot* and just as importantly *can* understand—brings these intellectual conflicts into sharp focus.

To turn to the sculptures themselves and behold them is to engage with the challenge of their inscrutable silence (figure 3.3). Because

Figure 3.3. Male/Female Pair. Madagascar.
Wood; ht. 32 in. Courtesy of the Center for African Art, New York. Photo cr.: Jerry L. Thompson.

they too are bodies, each piece, strong, solid, polished, or cracked, serves both as an analogue for and occupies an extension of the beholder's spatial environment. Like a living human body, it commands not only its own tangible space but a complement of emptiness around itself. Even the smallest figure creates the semblance of a living form by centering its own three-dimensional environment. Powerful abstractions, yet anthropomorphic par excellence, these sculptures both lure and forbid. Their tempting tactile surfaces dare the conventions of Western art that relegate sculpture to the gaze alone (see Drewel [1988] on the touchability of African art objects)—a deprivation that often works paradoxically to reinforce our identifications by stimulating fantasy. Each piece seems not so much a mere thing as a living presence that shares our being in the world.

Repeatedly, these images compel us to reflect on our own bodies. As we look at them and take in *their* bodies, they both do and do not remain inscrutable. Stylistically ornamented with patterns of scarification, each surface, figuring human skin, is etched into as a living work of art. Thus, they figure a merging of nature and culture and force us to reexamine our own conceptual scarification—in the form of deeply ingrained and heavily encrusted dualisms. Pain endured in the process of scarification, thus inscribed in, and inextricable from, the beauty of the designs, lends an added level of meaning to Yeats' epigrammatic line: "that we must labour to be beautiful" (figure 3.4).

Psychoanalysis, locating the first self as a bodily self (Freud 1923) and as the projection of a surface (a kind of imaginary sculpture), affords thereby an irresistible perspective from which to view figurative sculpture (see Kutash 1987). An example of this is offered by one exquisite ivory pendant from Zaire, which, though barely three inches high, is both embryonic yet intensely human (figure 3.5); whereas, a finely wrought female figure also of ivory (figure 3.6) may provoke Western viewers to ponder, in contemplating her, not only where and how the sculptural subject can be located but where the beholder is located—whether we *are* or are *in* our bodies.

Other pieces (figure 3.7) work even more directly to alienate us from our Cartesian dualisms, our agonistic models of body and mind. They expose our Western habit of splitting the self into

Figure 3.4. Nimba Headdress. Baga, Guinea.
Wood; Ht. 47 in. Courtesy of the Center for African Art, New York. Photo credit: Jerry L. Thompson.

binary elements conceived not only as polar opposites but as conflictual. For such pieces seem to challenge this model, a model conjured up by literary images from disparate centuries: by Sophocles' character Philoctetes, for example, who *is* to others his wound, his snakebitten foot, his festering sores—not a person but a body, a repugnant body, a target for the disgust of his comrades—while yet remaining a man. And by the image of Cyrano de Bergerac who, because of his bodily deformity, was condemned to love Roxanne only with his words, with his mind but not with his body; while Christiane could love only with his body. And, in poetry, one thinks of Yeats' painful lines: "Consume my heart away; sick with desire/ And fastened to a dying animal."

One small female figure (figure 3.8) illustrates a union of strange and difficult separations between body and mind. Severed, she is all of a piece, designed in repetitive patterns—teeth and toes, ear and genitalia. With her ear at the highest point, she appears to be listening. Broken and whole, open and closed, fragile yet sturdy, she smiles. Her enigmatic image suggests not only that human fragmentation and oneness are indissoluble but that this enigma extends to that of gender. A mourning figure perhaps, she signifies the breaking apart of continuity, but also affords associations to birth, to that time when a woman's head and body, in fantasy and in sensation, are also rent asunder and new life issues, in mingled joy and pain, from an opening into an enclosure of arms: when one splits into two, and the upright position of the head is abandoned (by the mother) and has not yet been reached (by the child).

Contrast this severed head image with familiar counterparts in Western culture, with Goliath, Holofernes, John the Baptist, and Bertrand de Born from Canto 28 of Dante's *Inferno*. In Dante, the severing of head from body works as a ghastly synecdoche, a hideous punishment inflicted on a wicked Provençal brigand who must suffer retribution for his crime of turning a son against his own father. By contrast, the African sculptured image links the severing with cyclical themes, with the recurrence of loss and renewal, with birthing as well as with mourning. In Dante's art, and in other Western images, it must be read quite differently—as a dreadful castration, brutal and unredemptive.

———

Figure 3.5. Pendant. Luba, Zaire.
Ivory; ht. 3⅞ in. Courtesy of the Center for African Art, New York. Photo cr.: Jerry L. Thompson.

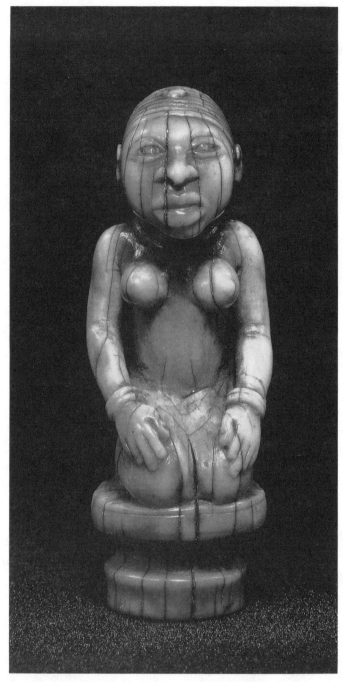

Figure 3.6. Figure. Kongo, Zaire.
Ivory; ht. 3 in. Courtesy of the Center for African Art, New York. Photo cr. Jerry L. Thompson.

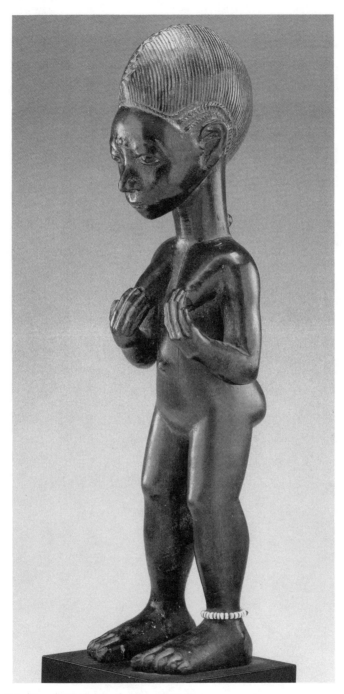

Figure 3.7. Female Figure. Baule, Ivory Coast.
Wood; ht. 12½ in. Courtesy of the Center for the African Art, New York. Photo cr.: Jerry L.
Thompson.

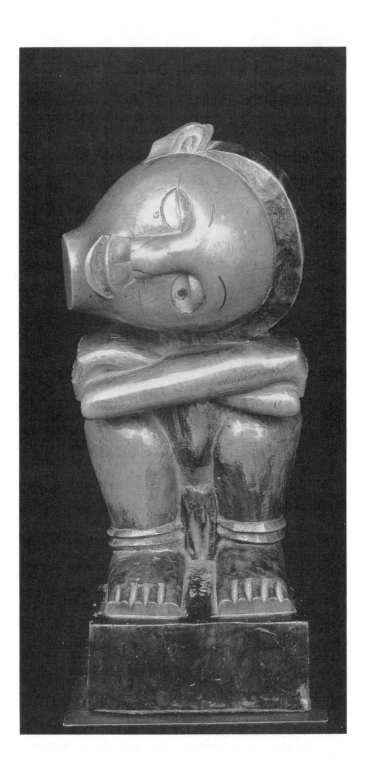

Let us, in closing, consider several images of mothers and infants, a theme prominent both in art and in psychoanalytic discourse.

Among the oeuvre from Zaire, we find several small, compact, intense sculptures (figure 3.9), their wood burnished to satin. These pieces stimulate in the beholder a desire to touch and stroke them, and, in so doing, they reproduce via aesthetic experience a response analogous to the mother's own sensations with respect to the skin of her child's body. One thinks here, for example, of Euripides' *Medea*, where the moment of sharpest conflict and anguish comes for that tormented mother when she actually *touches* the flesh, the bodies of her ill-fated children (see Segal 1986).

Formally here, we see the child as a completion and continuity of the mother's body. The elliptical space enclosed by her arms and cradle of legs and the child's own nursing body are repeated in positive ovals that represent the infant's and mother's head and breasts.

These mothers do not look at their children. Rarely do sculptured images of African infant-mother dyads depict eye contact between the figures. Perhaps they represent a different kind of mirroring. Their open-mouthed expressions and curved forms may reflect a maternal state of absorption, of being drawn into and suckled by the very experience of suckling, both via the deep identification of each mother with her child (thus a reenactment of her own past experience at the breast of her mother) and as nurturer and provider to her infant in the present. If so, a profoundly cyclical quality inheres in these sculptures. A timelessness. Formally and expressively they capture the nonnarrative, nonlinear quality of infant-mother symbiosis, that first consuming intimacy of every human life. Pointed teeth and sharp necklaces attest both to its power and its fragility. The mothers' faraway gaze is a stare that sees both everything and nothing; thus, it figures perhaps what Winnicott (1956) has termed the "primary maternal preoccupation," that is, the mother's intense investment in inner rather than outer space and her temporary withdrawal from the world. Here, however, an alertness accompanies the abstraction, thus indicating that to guard and to protect are also central to maternity. In contemplating these smoothly finished figures from Zaire, we may recall contemporary

Figure 3.8. Seated Female Figure. Kongo, Zaire.
Wood; ht. 7 in. Courtesy of the Center for African Art, New York. Photo cr.: Jerry L. Thompson.

mother-child sculptures by Henry Moore (see Schneider 1985), evocative pieces that body forth this primal relation in terms both aesthetically and psychologically other.

The faraway gaze is repeated in one beautiful mother and child also from Zaire (figure 3.10) where the mother has placed the child on her foot, namely, that part of the body which is in contact with the earth. Since the earth signifies also, transculturally, a mother, once again the cyclical experience of nurturance is evoked (see, for a discussion of the cyclical process of nurturing, chapter 8 on the myth of Demeter and Persephone).

Finally, this: a brilliant piece from Mali (figure 3.11)—in all its riveting ambivalence, a sculpture that, with the sparest of means, synthesizes worlds of psychological wisdom. Integrated into the body of its mother, a child emerges from her, its body echoing hers. Psychoanalysis speaks of the infant as the phallus of the mother, an appendage of her body. Here, however, the forms also suggest a layering, a progression, of developmental separations, from birth to the reaching of an upright position. Unarticulated ovoids reinforce the opening between the mother's and child's legs, a bounded space that opposes the unbounded realms commanded by the mother's uplifted arms. These maternal arms, failing to hold the child who is, yet, nonetheless, securely held, bespeak an awesome power in this mother, a latent aggression and capacity to withhold as well as to give, a significant capacity that here forces her child to reach and strain, in fact, to grow.

Winnicott (1947) has written of hatred on the part of the mother towards her child and its counterpart in the analyst's hatred of the patient, a potent and unacknowledged wellspring of energy that supplies fuel for the countertransference. Can a mother's arms, this sculpture poignantly asks, protect without stifling a child who must emerge physically and psychologically from the womb into the world and develop arms of his or her own? Almighty, every mother is also tragically helpless. Depicted here, her own subjective relation to the openings, separations, repetitions, and her own conflicting wishes both to succor and to let go are primed to resonate with Western beholders in a ceaseless round of ambiguity.

Here, roughly carved in wood, the multiple stages of giving birth

Figure 3.9. Mother and Child. Kongo, Zaire.
Wood; ht. 10¾ in. Courtesy of the Center for African Art, New York. Photo cr.: Jerry L. Thompson.

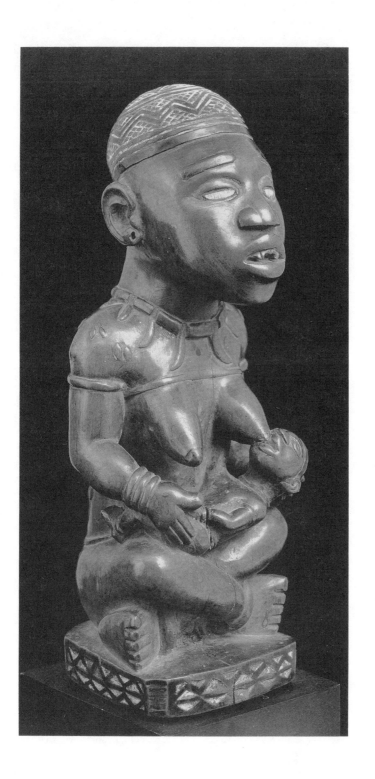

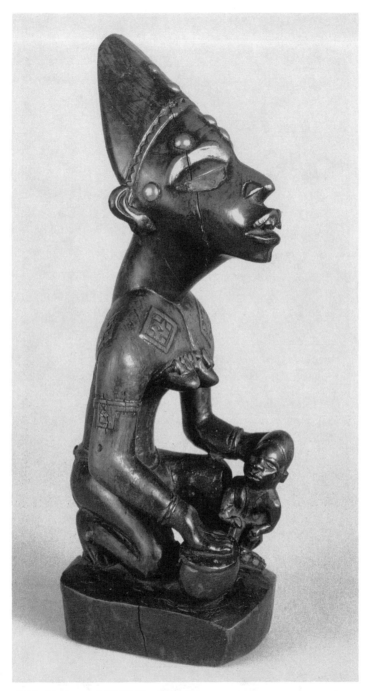

Figure 3.10. Mother and Child. Kongo, Zaire.
Wood, brass tacks, glass; ht. 11 in. Courtesy of the Center for African Art, New York. Photo credit: Jerry L. Thompson.

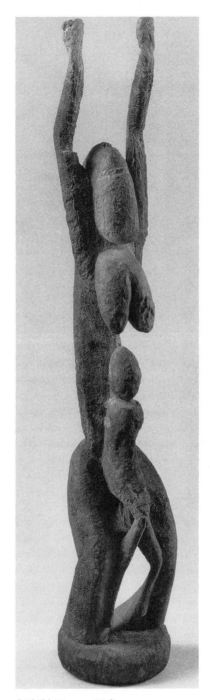

Figure 3.11. Mother and Child. Dogon, Mali.
Wood; ht. 18 in. Courtesy of the Center for African Art, New York. Photo cr.: Jerry L. Thompson.

engender a flow of richly textured fantasy. As with the finest instances of all art, this image of African art draws each beholder contemplatively into the recesses of his or her own psyche. Confrontation with the other becomes a transforming encounter with the self.

Artistic Image and Inward Gaze

Toward a Merging of Perspectives

The gestation of this essay occurred on a pilgrimage to Florence, Siena, and Arezzo—a breathless, colorful, art-crammed adventure —on which I served as lecturer to an indefatigable group of American psychoanalysts, psychologists, and other mental health professionals. How, I wondered, could I relate the arts to their clinical worlds and vice-versa, without ignoring the intellectual perils inherent in such an enterprise and without allowing these perils to jeopardize either their or my own aesthetic pleasure?

The artist is the one who arrests the spectacle in
which most men take part without really seeing it
and who makes it visible . . .

—Maurice Merleau-Ponty, 1948

There are moments, even in a wordy culture like
ours, when images start from no preformed program
to become primary texts. Treated as illustrations of
what is already scripted, they withhold their se-
crets.

—Leo Steinberg, 1984a

How shall I say
what wood that was! I never saw so drear,
so rank, so arduous a wilderness!
its very memory gives a shape to fear.

—Dante, *Inferno* (Ciardi 1954)

Inspired in part by Merleau-Ponty's (1948) efforts to grapple with
the way in which art reveals truth, I shall follow and extend John
Ciardi's translation of Dante's lines by suggesting that works of art,
through their imagery, give shape to inner experience. Furthermore,
I shall claim that visual images, including the hallucinatory (in the
present context, those called up by a literary text), serve, by com-
bining maximum intensity with economy and latent ambiguity, a
powerful and unique organizing function for psychoanalytic work.

For over three decades, Rudolf Arnheim (1966, 1969, 1974, 1986),
the eminent psychologist of art, has developed his thesis that visual
perception plays a dominant role in the cognitive exploration of
reality. I seek, by adopting a phenomenological perspective, to ex-
tend this thesis from cognition to affect and from the outer reality,
with which Arnheim is principally concerned, to the deep and
recondite wells of inner reality into which the psychoanalyst is

Versions of this chapter were read at the Fall Meeting of the American Psychoanalytic Associ-
ation, New York, December 1986, and at the May 1987 meeting of the Israel Psychoanalytic
Society in Tel Aviv. It was first published in 1988 by The Guilford Press in *The Psychoanalytic
Review* 75(1):111–128; permission is here gratefully acknowledged. My cordial thanks to Dr.
Stanley Leavy for his thoughtful comments.

drawn. If, with Arnheim, we agree that artistic creativity consists in structuring the bewildering chaos of external stimuli, then we must acknowledge that it draws on and likewise reveals the ordering of inner turbulence, of fantasy, and dream.

Therefore, despite the current vogue of taking psychoanalysis to task for making short shrift of history, I resist that tide here by stressing the experiential aspects of artistic imagery. In a reversal of the usual direction, which has been to "explain" art by appeals to universal psychoanalytic concepts, I shall claim that artistic images are primary and irreducible; that they are fundamental structurings and orderings to which psychoanalysts can turn and return in their quests for knowledge of the human psyche. Although no clinical material is cited in this chapter, I trust some readers will be stimulated to remedy this omission by remembering and conjuring examples of their own.

A suggestion has been made (see Michels 1983, 1985, 1988) that psychoanalysis be divided into two large bodies of theory: theories about technique and treatment, which involve relatively fixed principles, laws, rules of procedure (a claim that would, no doubt, be disputed by some); and a second category of theory which, unlike the first, consists of a loose network of interpretive models upon which the therapist can draw. Such models would include the familiar notions of drive and structure, of self and object, and the various developmental schemata that analysts draw upon more or less freely in their daily work. Into this second body of theory would fall, for instance, the notion of the Oedipus complex with its wealth of metaphorical proliferations. (For an assessment of this construct that adumbrates a viewpoint similar to that which I am elaborating here, see Leavy 1985.)

According to this division of theory, which I shall stipulate for present purposes, only the first body, the rules for clinical practice, is prescribed, while the second body of theory is relatively open for addition and modification. Here, analysts, in their interpretive work, are freer to experiment, to imagine, and to draw upon a wide range of personal, cultural, as well as clinical experiences as sources of inspiration. With this division firmly in place, it is clearly into the second body of theory that interdisciplinary work in the arts must fit and thereby find its psychoanalytic home. Clinical psychoanalysts who live with and cherish the arts and who are educated in one or more of them have thus the possibility of employing an ever-expanding interpretive repertoire and thereby contributing to their own theoretical preserve in the second sense. Works of art may

come to serve, as they more than occasionally did for Freud, as primary sources of understanding about the human psyche. From time to time, for example, it may suddenly occur to a therapist that she has in treatment a Prometheus or a Cassandra, or, as Leavy (1985) suggests, "an Aeneas on the couch," or that, like Orestes, a particular patient is tormented relentlessly by the Erinyes.

Although the following essay manifestly addresses problems inherent in the application of psychoanalysis to Italian Renaissance art (in particular, that of the trecento and early quattrocento in Florence and Siena), its purview extends beyond the limits of this period, for the issues raised by such a project have a broader bearing. Thus, I shall take the art of this place and time as a paradigm for my proposal that images in and of themselves may serve, in reverse of the usual direction (psychoanalysis applied to art) as primary sources of enrichment for the analytic enterprise.

Pathography is a psychoanalytic approach to the realm of art that depends on detailed knowledge of an artist's personal life history, particularly the early childhood, in order to develop convincing hypotheses about the relations between that life and a body of creative work, about the influences upon artistic choice of unresolved trauma, persistent intrapsychic conflict, and unconscious fantasy. Freud (1939) emphasized his own commitment to the overriding importance of such knowledge by saying, "the experiences of a person's first five years exercise a determining effect on his life, which nothing later can withstand."

When one thinks, however, of Florentine and Sienese artists of the trecento and even of the quattrocento, it is fair to say that, with few exceptions, there is scant biographical information and less that is undisputed. Furthermore, what is known has to do not only with the exigencies of artistic convention but with the prodigious powers of patron and purse. It is now a commonplace that artistic decisions are culturally embedded—that is, decisions both as to form and content are not the result of individual artists' sensibilities alone but rather a tangled compromise between inexorable and warring factors: political, fiscal, clerical, as well as private. How difficult then to speak without nullifying qualifications about these artists' intentions and/or their developmental histories, to interpret works of early Renaissance painting as expressions of deep inner realities!

Artists in the period of the Florentine trecento were accorded status principally as craftsmen. Not, with rare exceptions, considered, as in the nineteenth century, uniquely gifted, hypersensi-

tive, exotically deranged, misunderstood, they, importantly, did not sign their works, and thus attributions are an ongoing source of dispute. Only within the past decade, for example, has the equestrian portrait of "Guidoriccio," that redoubtable fellow with his undulating lozenged draperies, riding along on the wall of the Palazzo Pubblico, time-honored emblem of the city of Siena, and taken for years as a genuine Simone Martini, come under suspicion of inauthenticity (see Raynor 1984). Furthermore, it is well documented that the price paid for materials was greatly in excess of that rendered for an artist's input or labor. Technical proficiency, material, craftsmanship, was valued far above innovation or originality (see Cennini [c. 1400], 1960).

Consider, along these lines, the constraints imposed on all Christian artists by the didactic imperatives of an illiterate populace. (For an interesting discussion of the effects of illiteracy on iconography, see Bryson 1983.) Conjure up the historiated predellas of numerous annunciations and crucifixions, all designed to be "read" as narrative strips by a churchgoing public, all requiring characters (saints, martyrs, confessors, the Holy Family) who could be recognized at a glance. Think of some favorite examples of this narrative obligation: Duccio's intricately detailed and elaborated *Maestà* panels in Siena; Giotto's deeply moving story cycles on the walls of the Scrovegni Chapel in Padua; or, over a century later, Piero's monumental *Legend of the True Cross* in Arezzo. It is not that such obligations left no room for the projection of the artists' fantasies. (A similar case might be made with regard to Attic black- and red-figure vase paintings or to Egyptian tomb paintings.) But, in such cases, we must take special care not to factor out the givens but, wherever possible, to detect and analyze the contributions of convention to the resultant imagery. An analogy with the psychoanalytic situation is apt. One could trace a fascinating history of sensitive psychoanalytic authors since (and including) Freud who have attempted to examine the effects of the givens of treatment on the form and content of productions and constructions in analysis— both those of the analyst as well as those of the patient.

Further problems appear when we consider these story cycles. For we no longer see them as they were once beheld by original artist and audience. We have only remnants, damaged and partial artifacts, faded and eroded by time. Take Ambrogio Lorenzetti's *Allegories of Good and Bad Government,* again on the walls of the Palazzo Pubblico in Siena. Is it only chance that *Good Government* has survived virtually intact, whereas the portrayal of the sinister

effects of *Bad Government* is in ruins, virtually destroyed? The very boundaries of many works are in question. When we see a panel that has been cut, mutilated (a donor's portrait removed, for example, possibly by a feuding enemy) or when the deterioration of a sixteenth-century wall painting reveals traces of a fourteenth-century fresco beneath it, how do we judge the extent of what is missing?

In addition, there is the problem of restoration with its awesome complexities and wide variations in quality, appropriateness, and legitimacy. (For a good discussion of these issues, see Saito 1985.) When does the restorer cross that tenuous line between recreating the original work and obliterating it? Substituting a new work in its place? How much guessing is too much guessing? By what authority and on what grounds are decisions made as to when and whether and how to restore a given work? How much of a piece should be reworked and how much of it left as it is? Or, if one begins to restore the work, will it become necessary as a consequence to tamper with parts that at present seem intact? One notes already the poignant parallels with psychoanalytic process, with the difficult diagnostic and therapeutic choices of the analyst: what to touch and what not to touch. Or should the work be left in its present state? As a ruin. Ruins have their own aesthetic. (See Peter Fuller's 1980 account of the history of the mutilated *Venus de Milo*.) Art historian Erwin Panofsky also cautions us:

> When abandoning ourselves to the impression of the weathered sculptures of Chartres, we cannot help enjoying their lovely mellowness and patina as an aesthetic value; but this value, which implies both the pleasure in a particular play of light and color and the more sentimental delight in "age" and "genuineness," has nothing to do with the objective, or artistic, value with which the sculptures were invested by their makers. (1955:15)

What we see is not what the artist saw. Consider the problem of altered contexts. We do not experience works as they were once intended to be experienced because so often they have been moved: from choir screen to nave wall, from church to gallery, from town to city. Standing in the Academia before Michelangelo's *David*, all one's perceptions are changed entirely if one suddenly remembers that this colossal statue was once intended to be placed high upon the roof of the Duomo, much like the acroteria of ancient Athens. Or, imagine sitting down quietly in the Cloister of Santa Maria

Novella and realizing that this is actually the very church Boccaccio chose for his opening narrative in the *Decameron*. One begins to conjure up the characters—Pampinea, Fiammetta, Dioneo, Filostrato, and the others—when suddenly one realizes, looking about at the bewildering assortment of architectural and sculptural features, that much of all this postdated 1350 and would have been entirely unknown to Boccaccio. Naturally, visually, now one tries to subtract and substitute, to imagine not only the church minus what was not there in the trecento but—harder yet—to guess what in fact was in its place so that at least some semblance of Boccaccio's original experience can be constructed, some viable image of the church he carefully chose to weave into the first bright threads of his literary tapestry.

In the light of such complexities, the task of the pathographer— to reconstruct the artist's deepest intentions, to find a way back to something approximating even the outer, not to mention the inner, conditions of his art—seems Herculean. Those brave souls who have attempted pathographies of Renaissance artists (Liebert 1983) have chosen their subjects with great care, wisely selecting artists of the High Renaissance who bequeathed a vast corpus of literary as well as graphic and monumental work. But even the best of such psychoanalytic authors has not escaped the sparks of interdisciplinary fireworks (Steinberg 1984b). Each has been chided for not taking sufficient account of the limited and tangled context for his interpretive endeavors.

What to do? Is there another tack that will avoid these shoals and whirlpools? Applied psychoanalysis need not be limited to pathography. Works of art can in part be severed from their makers and their milieus. They can be bracketed, framed, de- and recontextualized. (See Richard Kuhns' 1983 theory of enactments.) Freud (1914) attempted something of this sort in his "Moses" paper, and likewise analyzed selected works by Sophocles and Shakespeare without significant reference to these authors as persons.

One problem is that, when we apply this approach to the trecento, we run up against a subset of the same obstacles that confront the pathographer. Chief among them is the issue of the boundaries of the work of art itself. We have already considered how very difficult it is to know precisely what a given work of art was like in its original state. However, suppose we set such worries aside. Let us consider, for example, just one panel of Duccio's enormous *Maestà* alterpiece in isolation (figure 4.1). A spirited little *Temptation*, it does have, perhaps, much to say quite on its own, and its presence

Figure 4.1 Duccio, *Temptation of Christ on the Mountain* (c. 1302).
The Frick Collection, New York.

Figure 4.2 Giotto, *Flight Into Egypt* (1304–1312).
Scrovegni Chapel, Padua. Photo cr.: Fratelli Alinari/Art Resource, New York.

far from its native Siena provides an opportunity for viewing and interpreting it out of (at least its geographic) context.

The small wooden panel, which invites the spectator to approach closely, portrays a nasty but sinuously seductive Devil who falls just short of dominating the scene by virtue of the sultry silhouette he forms against its golden sky. A somewhat effete but elegant Christ pointedly warns him "to get thee behind me, Satan," and we cannot fail to notice the two courtly angels who hover in the wings with graceful hands extended (just in case Christ should decide to take the dare and jump; see Matthew 4:1–11). Nonetheless, our eyes are drawn magnetically to the Devil himself. Our gaze is riveted upon him—attracted by the shape of his mysterious dark silhouette, by the furtive, diabolical quality of his figure. Whereas every other form in the composition is illumined, his is obscure. Thus, the image compels us, lures us, Faust-like, to desire knowledge of him. With consummate artistry and psychological acumen, Duccio coopts the viewer, even across the centuries. As his image works its ineluctable effect on us, it embodies, it instantiates, it reproduces the very essence of temptation.

Another interesting example is Giotto's *Flight into Egypt* (figure 4.2) (from the Arena Chapen in Padua) with its epic quality and its sense of urgency: the Madonna tensely astride her patient donkey, the baby held facing toward her and clinging to her mantel, giving visible shape to what Freud (1914) would centuries later come to call the notion of the "anaclitic." Joseph's worried countenance betrays a foreboding masked by serenity, and one small, gracious angel overhead beckons them on, gesturing to them and guiding them through the bleak and rocky landscape—a projection into imagery, a making visible, of what Kleinians might see as the good, protective parental introject. Another panel (also from Padua), is the *Lamentation* (figure 4.3) with its great tragic diagonal of rock, tender in its expression of human sorrow, its bevy of wildly grieving angels overhead, their delicate hands and faces, even wings, contorted by their anguish, an exquisite evocation of the fragmentation produced by tragic loss.

Consider, lastly, that most psychologically gripping and complex image of all, *The Betrayal* (figure 4.4), Giotto's commanding vision of the very essence of treachery: the blasphemous kiss of Judas. (For a contemporary nonpsychoanalytic formalist analysis of this painting, see Bryson 1983.) With lips pursed, staring boldly under heavy-lidded eyes into the face of his chosen master, the traitor envelopes Christ with a weighty yellow mantel in one magnificent, sweeping

gesture that condenses aggression, lust, identification, protection, and shameless concealment.

How fascinating to realize while contemplating this image that nearby and during approximately the same decade, another immortal artist was creating a parallel image of treachery against the master—in poetry rather than in paint. For Dante, as well as for Giotto, and in the common culture of trecento Florence, this act was considered the most heinous of all human crimes: Dante punishes Judas at the very nadir of his *Inferno*. On the terrible ice of Judecca, the broken body of the arch-traitor is gnawed and eternally bitten by the "rake-like" teeth of Satan in a ghastly orgy of retributive oral sadism—oral sadism that not only echoes but also reveals the deepest source of horror in the kiss of Giotto's painting.

Is it worthwhile or even possible, however, to bracket such images and set aside all problems of their boundaries, contexts, and sparse accounts of the artists who created them? To mine them for their own deep psychological content? To analyze the dream without the associations of the dreamer? It seems clear, without rehearsing the pitfalls inherent in such an approach, that to do this is largely to take one's own responses as primary data for the interpretation.

Yet is this really as radical a move as it first appears? Is it not merely a shift of focus to that which has always been present but peripheral? In an analogy with the psychoanalytic situation, Leo Stone (1961) among others, has stressed that psychoanalytic interpretations necessarily involve the analyst's own mental activity, emotional life, biases, and "subjective transformations" of patients' material. Studies of Freud's own life (e.g., Balmary 1979; Anzieu 1986; Rudnytsky 1987; and Gay 1988) have demonstrated the "subjectivity" of his various technical, theoretical, and narrative choices. Such revelations, constructively read, serve not to diminish the stature of the resultant oeuvre, but rather to remind us of the power of the unconscious, the ubiquity of transference, and of the vast, nonobjective wellsprings of all human endeavor.

Imagine walking slowly through the streets and by the monuments of contemporary Florence, including the Palazzo Davanzatti, where everyday life in Renaissance Florence springs suddenly into being as palpable and real. The private houses were built tall with narrow stairwells and endless steps so that it is possible, while climbing today, to experience with immediate urgency the impact of Dante's famous passage from the Paradiso (Canto 17) in which he describes the pain of exile: "how salty tastes another's bread, and how hard a path it is to go up and down another's stairs."

Figure 4.3. Giotto, *The Entombment* (1304–1312).
Scrovegni Chapel, Padua. Photo cr.: Fratelli Alinari/Art Resource, New York.

Figure 4.4. Giotto, *The Kiss of Judas* (1304–1312).
Scrovegni Chapel, Padua. Photo cr.: Art Resource, New York.

While treading the stones of Florence, rebellious thoughts may surface: that, as I have been suggesting, a focus on *the perceptual and affective experience in the present* is not entirely out of place for psychoanalytic explorers of the arts; that it might prove refreshing to forego doomed struggles against the truth that Florence is today a layered city with one century overlapping or juxtaposing another; that *what* really happened *when* is recoverable only in fragments; that, just as in our psychoanalytic models of the mind, there are screens and scrims. There are images freshly cleaned and gleaming with a radiance that approximates their original state (e.g., the Raphaels in the Palazzo Pitti) alongside others, dusty and dark, like those beautiful Giottos of the Bardi and Peruzzi chapels in Santa Croce, waiting to be illuminated, waiting for the patient hands of a conservator, or, in the psychoanalytic analogy, waiting to be remembered, revived, and worked through.

Rather than struggle only to untangle knotted and broken threads, rather than import prepackaged psychoanalytic theories into this kaleidoscope or, worst of all, aim awkward potshots at works of art as if they were painted targets in a bizarre psychoanalytic shooting gallery, perhaps a more receptive approach is preferable. Perhaps, like the finest clinicians who allow theory to recede so that patients' material can gradually emerge as inner reactions and responses to it are monitored, we must allow the works of art to appear, to emerge, to reveal themselves to us as they are in the present. Perhaps we must allow *them*, by means of their rich resources of imagery, to teach *us*; treat them as primary sources of knowledge about the human psyche; give them the opportunity to blend their perspectives with ours and thus enrich our storehouse of interpretive possibilities.

I do not mean to suggest we abandon all efforts at historical reconstruction, forego pathography, or eschew the task of teasing out narratives of drive, defense, and unconscious fantasy in works of art. Methodological difficulties should and will continue to constitute an ongoing challenge for interdisciplinary studies. However, to choose to bypass that arduous route, at least temporarily, *as we all do* from time to time, and to go directly to the works themselves for primary inspiration, is not without special value for the psychoanalyst. A spirit of adventure is imperative. Like the daring, innovative Florentines themselves, we must be risk-takers in the art of interpretation. The images themselves—their color, their irrepressible affect, their eruptions of fantasy, and their stubborn refusal to be forgotten—can, if permitted, deepen clinical sensitiv-

ity and serve to reintegrate the humanities with the scientific aspects of the psychoanalytic endeavor.

In the history of psychoanalytic theory, an apt analogy might be made to the development of our changing views on countertransference. After being identified, labeled, and meticulously described, countertransference was initially considered an arch-enemy of good clinical technique, an impediment to the requisite "blank screen" of the ideal analyst, inimical to the analytic attitude, a demon to be exorcised by further analysis. Gradually, however, countertransference came to be seen not only as an inevitable aspect of the analytic situation but, within limits, as a potentially helpful and at times even indispensable tool for deepening the exploration of the psyche. Having at least partially recognized it, one today works with it, rather than limiting oneself to a struggle against it—as I believe can and should be more openly and consistently the case in applied psychoanalysis. Such a shift of focus may open new interpretive possibilities by, for example, serving to prevent the misuse of existing theory as a defensive barrier between us and the works of art we cherish.

In the paintings of Duccio, Giotto, Simone Martini, Fra Angelico, and the masters of the Black Death, such as Bonaiuti and Traini, and in the pages of Dante and Boccaccio, we encounter images that sear the mind and remain smoking through the mists of memory. In them we can actually *see,* we can discover, we can inspect (by means of shape, color, and graphics, visual tropes and metaphor) a range of human agony that bears directly on modern clinical practice. And although such human agony must, in all its intensity and complexity, elude our final comprehension, yet, in our never-ending quest for understanding, for illuminating representation, we will be rewarded by gazing at these Florentine images.

To stand, for example, before Masaccio's fresco of the *Expulsion* (figure 4.5) in the Brancacci Chapel of the Church of the Carmine is to grasp with visceral force the primitive bodily manifestations of shame. Here is the moment when Adam and Eve are driven out of the Garden of Eden. Masaccio has painted two adult figures, a man and a woman, whose naked bodies appear so lumpish, so awkward and unidealized that we, participating in their shame, are almost impelled to turn away from them to avoid exposing them to the

Figure 4.5. Masaccio, *Expulsion of Adam and Eve* (c. 1425).
Brancacci Chapel, Santa Maria del Carmine, Florence. Fresco. Photo cr.: Art Resource, New York.

further pain of observation. Leaving behind what is familiar, Adam walks forward blindly, his head bowed, both hands up before his eyes, concealing them from the world and the world (which has suddenly become strange) from his eyes. Eve walks by his side. Her head, by contrast, is thrust back, her mouth half-open in a moan or howl. Her left arm and hand are occupied in hiding her breasts, while her right hand covers her now offensive genitals. The image conveys a sense of utter desolation; the misery it evokes is complete. And, clearly, it is shame that moves us here, not guilt, as in Michelangelo's rendering of the banished couple on the ceiling of the Sistine Chapel nearly a century later. Here, in Masaccio, we are made to feel the horror of the couple's changed sense of themselves, their altered relations to their own bodies. Not the trespass or the sin, but the *dissevering of self.*

If we turn momentarily from painting to Florentine poetry, to the pages of Dante's *Inferno,* we enter a world of nightmarish imagery that refines with fevered intensity a fantasy world akin to that of early childhood, where the body and its projected parts and products serve as symbolic carriers for meaning: imagery that peels the layers of complex ideas and reveals within them their instinctualized core.

In Canto 20, for example, we come upon that moving and terrifying portrait of the false diviners and prophets whose damnation erupts grotesquely with what Freud would later call "primary process." The retribution of these sinners, who practiced forbidden magic in an attempt to peer into the future, entails the reversal of their faces on their necks. Standing beside Dante as we scan his *terza rima,* we gaze into the pit and can actually see them coming on backwards, piteously staring at their loins, doubly blind as tears burst from their eyes and run in rivulets down the cleft of their buttocks. Their bodies proclaim their sin: their punishment is a reversal of their act. Dante himself (as poetic persona) weeps at their cruel subjection to the talion law, their abject humiliation. Likewise, we also cringe, we who, often in our pride, seek brazenly to order, predict, and control the future while secretly nursing wishes to undo our past.

Another of Dante's unforgettable portraits is that of Filippo Argenti in Canto 8, an image that has captured the imagination of artists from the Tuscan trecento at least through the French Romantic period—with Delacroix's monumental painting of *The Bark of Dante* (figure 4.6). Filippo Argenti, Dante's personal and political enemy, appears here as an angry sinner in the circle of the wrathful.

Rising momentarily from the foul mud of the River Styx, he turns his insatiable fury against himself, biting his own body in a transport of primitive, impotent rage. And, in a striking, parallel moment of self-revelation, Dante permits himself a display of overt vindictiveness, an unveiling in the text of his own sadism, his own cruel pleasure in the torments he is both creating and "witnessing." This display, had it been omitted, would have diminished the truth, the whole appalling truth, of his masterpiece.

Most uncanny of all, perhaps, among the single images of the *Inferno*, is the figure of Bertrand de Born, in Canto 28, a Provençal brigand, sower of discord between kinsmen. He is condemned for eternity to the ninth ditch *(bolgia)* of the eighth circle of Hell. Having rent sacred bonds asunder by turning son against father, he now suffers, by a hideous synecdoche, the sundering of his own body: Doomed forever, he "holds his severed head by its own hair/swinging it like a lantern in his hand."

As emblems, as signs, as beacons of radiating light, such visions require no added context. The art itself supplies its viewers with what is required, bestowing upon us simultaneously signifier and signified. Psychoanalysts, seeking to probe the many meanings of the human condition, need only gaze: Such images will return that gaze, establishing a phenomenal space, a potential space (as Winnicott would have put it) in which inward and outward foci converge.

In arguing his case for what he has called "visual thinking," Rudolf Arnheim (1986) persuasively illustrates the centrality of perception to cognition by showing that even concepts at high levels of abstraction, such as logical propositions, cannot be understood without recourse to visual imagery. One of his examples concerns the syllogism—that formula of inferential logic which enables the thinker to draw a valid conclusion from two valid premises. Thus, "If all a are contained in b, and if c is contained in a, then c must be contained in b." He demonstrates that a glance at the famous diagram of Euler (three sets of concentric circles) will reveal the range of enclosure obscured by attending to the words alone. Even if we balk at claiming that such a concept cannot be understood without recourse to a model that represents its relations in spatial terms, we are nonetheless struck by the clarity afforded by the visual image.

In this essay, I have suggested a similar role for artistic imagery vis-à-vis psychoanalytic understanding. Freud himself knew well the power of the image. In addition to his diagrams in chapter 7 of *The Interpretation of Dreams* as well as his bulgy little sketch of

Figure 4.6. Eugene Delacroix, *The Bark of Dante* (1822).
Louvre, Paris. Photo cr.: Alinari/Art Resource, New York.

the relations between the topographic and structural models of the mind (Freud 1933), he enlivened all his writings with similes and metaphors as well as continuous references to works of art.

As against traditional historical approaches to art and still prevalent intellectual fashion that exalts the word over the image, I have argued here for a reconsideration of the artistic image as a primary, originary ordering of inner and outer, conscious and unconscious, perceptual, cognitive, affective, and kinaesthetic experience—an ordering with matchless and revelatory resources for the psychoanalyst. Avowedly, such a claim raises epistemological questions that lead far beyond the scope of this chapter. My effort here has been to propose a supplement if not an alternative to the usual dialogue between art and psychoanalysis by considering the possibility of a merging of horizons whereby emphasis shifts from historical reconstructions and appeals to a corpus of supposedly transhistorical principles to a more relative stance that stresses the dialectic between beholder and image (a dialectic that has already been explored in other contexts in chapters 1 and 3) and that highlights the encounter itself in the full impact of its immediacy and presence.

Art Without History

Reflections on the Paintings
of a Schizophrenic Child

I am haunted by the face of a little boy whose dark brown eyes often avoided mine and whose limp, moist hand I can still feel as when we walked together through the dank halls of the residential treatment center toward a basement room where, for a short time each week for two years, we sat together and he painted. With mingled affection and sadness, I dedicate this chapter to that child, whose portrait in this book bears witness to the lives of countless other children who, like him, have within them both images and insights that may never be adequately reciprocated.

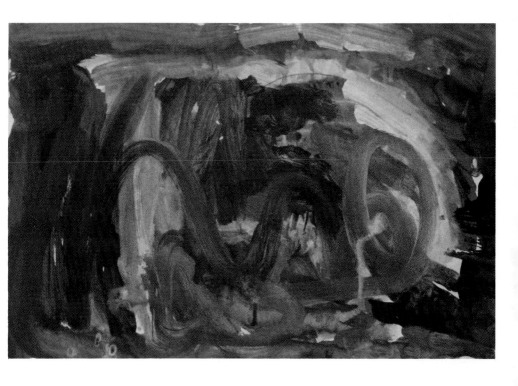

Figure 5.1. "Avi," 11 years old.
Painting on paper. Photo cr.: the author.

Figure 5.2. "Avi," 11 years old.
Painting on paper. Photo cr.: the author.

Figure 5.3. "Avi," 11 years old.
Painting on paper. Photo cr.: the author.

Figure 5.4. "Avi," 12 years old.
Painting on paper. Photo cr.: the author.

For two years I worked as a volunteer at a residential and day treatment center for schizophrenic children. In tandem with a registered art therapist, I spent several hours each week with a young boy who challenged me, heart and mind, with painting that sparked tantalizing questions. The illustrations accompanying this chapter (figures 5.1, 5.2, 5.3, and 5.4) are photographs of just four of the dozens of paintings on paper executed by this child during that period.

In what follows, I shall explore the challenges they offer: Are such paintings artworks? Are they even images? Do they have a history? If so, what sort of history? Do they require interpretation? Along what lines? Do they have aesthetic merit? If so, on what basis? What light, if any, do they shed on problems of art and expression, art and intentionality, on the ways in which feelings and visual representation are connected? What can they teach us about iconophobia and iconoclasm? And about nonvisual elements in the creation of and response to visual images?

The eleventh birthday of this institutionalized schizophrenic child occurred shortly after the beginning of his painting with me, and I say that his birthday "occurred" rather than that he "celebrated" it because on that day he was silent, withdrawn, and unable either to

An early version of this chapter was read at the College Art Association Annual Meeting in Boston, February 11, 1987, chaired by Professor Irving Lavin, and un updated one at the American Society for Aesthetics Annual Meeting, Kansas City, October 29, 1987.

This chapter is dedicated to Judith Duboff, A.T.R., a talented and devoted clinician and loyal friend.

speak or to make any marks at all on paper. The child, whom I shall call "Avi," had been, when I met him, recently admitted as an inpatient to his current placement, a center that provides comprehensive care for schizophrenic children between the ages of five and twelve years.

Avi's paintings and, even more, his painting process, inspired me to reopen theoretical issues I had previously ignored or considered closed, for his work strongly challenged the conventional bounds of art history—not only in the sense of calling into question the limited range of objects upon which this discipline chooses to bestow its attention, but most especially its tendency to privilege and idealize objects *per se* with only limited concern for the processes by which they come into being and, particularly, without attention to the nature and changing qualities of the human context in which they are produced. Unfortunately (or fortunately, perhaps) nearly all my questions remain unanswered. Although I have pondered them before, during, and since the initial writing of this essay, they continue to scamper just out of reach—like mischievous gingerbread men baked in the magical ovens of childhood. They remain alive, delicious, elusive, and proliferative. Nevertheless, before turning to Avi's paintings, I should like to begin with a brief theoretical discussion.

The notion of "art without history" might be taken to imply an art that lacks a history in the sense, for example, of the putative first marks on the walls of paleolithic caves (Davis 1987), in other words, art without history in the sense that it was first: that nothing else came before it. Or it might imply an art that exists outside of history like certain folk arts, or, say, children's artworks, which have no recorded history—groups of works whose history has not been written because they have not been claimed for the canon of works usually admitted and studied. But are such notions self-contradictory? Is art not *defined* by history, by its inclusion in the history of art?

One noteworthy position, articulated by Arthur Danto (1981), holds that the coming into being of art implies an antecedent theory of art (however tacit), since it is precisely theory that enables us to identify objects as works of art. Thus, theories create histories of art. A ready example of this viewpoint is Danto's invocation of an Andy Warhol "Brillo Box," vintage 1964 (figure 5.5). Without a theory of art, Danto argues, it would be impossible to see this object as making, in his words, its "revolutionary and ludicrous demand"

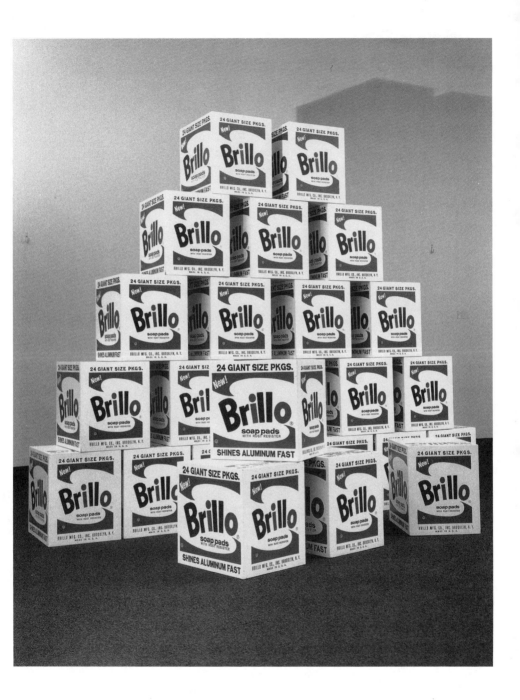

Figure 5.5. Andy Warhol, *Brillo Boxes* (1969 version of 1964 original).
Silkscreen on wood. Norton Simon Museum, Pasadena. Gift of the artist, 1969.

to be enfranchised in a certain "society of artworks"—in other words, to see as art either the Warhol "Brillo Box" itself or that very "society of artworks" to which, as he claims, it clamors to be admitted (1981:208).

This claim of the anteriority of theory to art, or at least of the embeddedness of art in theory has an obvious historical corollary. Danto's premises imply at least two interpretative (methodological) strategies. First, to identify the status of any given object in a culture, one must attempt to reconstruct that culture's peculiar theories of art and, insofar as possible, to interpret from a reconstituted position within the context that produced the object. The limitations of this approach are probably best addressed in the literature of anthropology (Crapanzano 1987).

An alternative strategy would simply ignore the historical particularity of contemporary theory and apply it uncritically to the objects of other times, places, or categories of artifact. Among the gains and losses implied by this strategy are the not infrequent seeing "as art" objects (or qualities) that may have been otherwise designated in their original settings as well as the overlooking or dismissal of those that were once so appraised. A corrective for such omissions and misconstruals, however, can be achieved in some cases by study of the art criticism of a given period, criticism contemporary with the objects themselves, a landmark example of this sort of work being Michael Fried's (1980) study of the relations between Diderot's art criticism and the salons of eighteenth-century Paris.

In ordinary practice, both approaches are combined, so that, for example, an Ethiopian camel pot that was conceived by its maker as purely functional can be displayed as a work of art by its contemporary New York owner, yet its figuration and/or design interpreted according to a sophisticated knowledge of the culture in which it originated.

Thus, any history of art is a complex story of inclusions and exclusions. When we view any one position (or period) from another, we incur the inevitable risk of exposing the partiality not only of the other but of our own current position. And, as Danto has pointed out, the very passage from one period to another may reveal perceptual features that were formerly unobserved. In general, the unpleasant consequences of such risk-taking are averted by heroic efforts to subsume into one's current purview all that is experienced as other—subsumed not only, that is, by the familiar mode of inclusion but by the means of radical exclusion as well,

since acts of excision, like acts of negation, are fundamentally imperialistic.

Thus, one way to construe "art without history" might be as art of alternative histories, suppressed histories, unrecorded histories, as art "without" not in the sense of "lack" but in the sense of "outside"—"outside," however, understood always as implying its own unacknowledged core. And, while it is true that contemporary scholarship sanctions the transcription of neglected, previously untold stories, the filling in of newly perceived gaps, and an unprecedented alertness to the lives and works of outsiders (that is, those of different gender, race, and social class); nevertheless, this openness, extended to written texts in the disciplines of history and literary criticism, has been less fully granted to the sorts of objects which have been, traditionally, within the purview of art history.

Bracketing the question as to whether the artifactual counterparts of such alternative histories ought be included in the canons of art, we may yet perceive that one way to take seriously a notion of "art without history" would be to align ourselves with such an endeavor. Furthermore, to demur on the basis of so-called aesthetic considerations and to urge such considerations as a caveat would be to evade the issue, for the very aesthetic referred to by such an appeal must necessarily derive from the very inclusions and exclusions that have, in a circular manner, been previously inscribed in its name. Thus, to rewrite the histories of objects with well-established canonical status may be as instructive as the pursuit of new objects—if, indeed, such interpretive endeavors can be altogether separated. For, however minor a role one wishes to assign it, there is a sense in which to rewrite the history of a work of art is to create that work anew (Stern 1980). And, paradoxically, in a certain sense, to destroy as well as to preserve it.

One example of a kind of neglected history that might illustrate the making and unmaking of works by spectators is that of a critic's own evolving sense not only of what counts as art but of his or her own relationship with works already accepted as art—a topic I take to be at but one remove from that directly under scrutiny here (see above, chapter 3). The notion of "art without history" opens out on the possibility of many such histories (each with its inevitable disavowals) that document both subtle and sweeping changes in our private reactions to artworks over time. These changes, in turn, shed light on the ways we choose the histories we *do* write that, being inscribed, are, in their turn, often so deeply invested by us that we tend to dismiss as trivial our earliest, unrecorded experi-

ences with the now historicized works, works that we have often distorted in order to bring inside the pale.

Finally, it is worthwhile to note the ethical and political implications of art history-writing and of object choice. If to study an object is to prize it and, by extension, to prize the complex of associations that emanate from and irradiate it, then criticizing and historicizing (the critics' choice) stand as clear testaments to positive valuation, regardless of the content of critical commentary and appraisal. For, whereas words create significance (at least in part) by evoking their absent referents, silence and the blank slate cannot so serve. To historicize a body of artworks is thus to exalt it with all that, in each individual instance, this entails.

Avi is a dark-haired boy of normal height and build with gentle large brown eyes and a beautiful but undefinably strange appearance. In his early childhood, his deeply disturbed mother had tried on several occasions to commit suicide in his presence with a kitchen knife. In each case, the child's desperate, piercing, and sustained screams alerted nearby adults and thus forestalled imminent tragedy. The mother has never been able to manage a paying job and regularly attends a day hospital treatment program for ambulatory schizophrenics. Avi's father, whose pathology includes a near total lack of personal hygiene, a symptom relevant for an understanding of Avi's disturbances, underwent in his adolescence a prolonged hospitalization for mental illness and has also and even more recently than his wife made attempts on his own life. The latest of these, driving his car into a steel girder, resulted in a hospitalization that vitiated temporarily even his minimal capacity for normal functioning.

When I first met Avi, in the late spring, he was withdrawn, silent, and painfully anxious. He made meaningless perseverative hand motions and spoke only in barely audible whispers with his head averted, so that it was virtually impossible to decipher his verbal communications. Almost totally absorbed in an inner world, he seemed to be responding to experiences accessible to himself alone. Not only did he not want to paint or draw (that is, touch or use art materials), he was uncomfortable and awkward with his own body. He worried, for example, about the position of his feet on the rungs of his chair and could not comfortably hold hands with another person. His difficulties around issues of the body—body bound-

aries, body products, etc.—gradually eased (an easing, however, only within a severely limited range, both spatially, temporally, and interpersonally). Slowly, however, over many months, the act of *painting* became a source of pleasure to him. To witness the unfolding of his drama with the paints and brushes and to see their intimate links with the bodily issues that preoccupied him was a lesson in the power of art's physicality, its materiality, and its insistence on the engagement of flesh with external substances (Fried 1988).

Avi's initial (and ongoing) conflation of self and external world and his struggle with these issues through the medium of colored pigments throws into relief the highly intellectualized posture often adopted by scholars and critics toward painting and reemphasizes the realm of art as a field for the interplay of body and mind. In the twenty-four months I worked with this child, many changes occurred in him and in my relationship with him. His paintings, nonfigurative, nonrepresentational, ostensibly unconnected to the world of art as we know it, reflect in part the story of these changes. Interpreted as such, they may be said to have a kind of history of their own, a point to which I shall return.

Because it is so difficult to locate Avi's paintings within the field of contemporary culture in the ordinary sense of that term, they demand of us, if we pay attention to them, a reformulation of that notion in light of the data they provide. Both Avi's work and my work with Avi, which were at times inextricable, press continually for a reopening of issues that previously seemed closed. In this sense, the world of the schizophrenic child is endlessly provocative and fascinating. Like the music of John Cage, its repetitions are forever modulated with subtle variations that become increasingly absorbing as one learns how to listen. Emerging in and reflective of a developing and ongoing human relationship, Avi's paintings remind us that the root of "culture" derives from the Latin *colo*—"to till, to care for, to nurture." The work of this special child, remote in so many ways from the larger culture, thus implies a more basic view—culture as a nurturing matrix, through which complex cues in many registers can be processed. For Avi, the institutional setting served as a miniculture, a vehicle through which he, as artist (perhaps), could experience that vaster and more complex society of which he is inevitably a part but from which he is, simultaneously, apart (barred).

Imagery, art, or simply marks on paper, the paintings of this child

raise with special poignancy the assignment of category: If we deny them status as art, this will be attributable, largely, to their falling "without," in the sense of "outside," history in the conventional sense of cultural history or history of art. Contrarily, if we agree that they may be called art, we face difficulties in relating them to the realm of conventional art objects. What is the role, for example, of *zeitgeist*? To look at Avi's paintings is instantly to recall abstract impressionism, a style utterly unknown to this child. It is a style well known, however, to staff members at the treatment center, one of whom, on seeing them in an exhibit of patients' work, actually expressed a desire to buy one. The well-meaning misapprehension of this staff member, however, reveals to us the enormity of gulfs that may open between intention and reception—a gap roughly analogous to my earlier example of the Ethiopian camel pot: an arena of aesthetic inquiry subtly and repetitively posed by Avi's work, which sometimes reminded me of the art of Hans Hofmann.

Affect (feeling) has been a fascinating theme to track in my work with this child. As painting itself gradually became more pleasurable for Avi and his inner conflicts over regression temporarily subsided (so that mixing, messing, transgressing boundaries, feeling the paint everywhere, on nose, lips, sleeves, shoes and me as well as on paper lost much of its terror), the paintings themselves became joyful in quality. Their affect, however, seemed to be derived not so much from the overall tenor of Avi's inner being, not from what was happening to him in other sectors of his life, but, specifically, from the *immediate experience* he was having with the materials themselves in this particular aspect of his milieu. What interests me about this is the way it complicates even a sophisticated psychoanalytic discussion of artistic intention. Such discussions tend to focus too abstractly on notions of deep intrapsychic conflict and defense (e.g., Mozart's exquisite passages for soprano in *Figaro* interpreted as a defense against melancholy and recurrent fears of death). But Avi's paintings, by way of contrast, with their splashes and strokes of color, often seemed less an effort to ward off anxiety, terror, and buried rage than to give vent graphically to an immediate joy. *Many of the paintings of this deeply disturbed child are not disturbing* (a point to which I shall return). Thus, to generalize, it may be as plausible to interpret the affect carried by any art work as stemming directly from the artist's focal experience of his art as to take it as inevitably reflecting remoter events and themes. For

many artists, as for Avi *qua* artist, the art itself in the moment of its creation constitutes life's most intense experience.

As to the subtle matter of labeling affect, however, context strongly determines perception. These protosymbolic, often vague, coarse, uncontrolled painted surfaces are not, clearly, the "normal" products of a boy of eleven or twelve. In this sense, they can, by comparison with a given norm, seem disturbing: that is, they fall outside the range of the expectable. Yet, if we can adjust that range a bit and intuit, even to a limited extent, the subjectivity of this child, who is other, but without collapsing his otherness, then we can, I believe, be present to and even experience, their joy.

. . .

After the first few weeks of alternating mutism and virtually inaudible murmuring, Avi began to speak more openly and distinctly and actually to converse with me while painting. It was six long months, however, before he could bring himself to pronounce my name—an intensely charged moment for us both. As I struggled to make contact with his world and to connect his speech with the painting process, there seemed an important sense in which the two tracks were independent or only marginally related, again, an observation not perhaps without wider significance. Occasionally, it was possible to observe a reversal, such that, while different colors were being applied, language perseverated, and vice-versa. More often, however, word and image seemed to run along in a complex, almost musical counterpoint, and an analogy that often recurred to me was that of the relation between the two hands of a violinist. Aspects of difficulty would surface in the verbal register and then subside as painting occasionally ceased, and Avi would tap loudly with a brush or vigorously mix paints together in utter self-absorption.

Words themselves, their meanings and use, became a source of concern to him, and the issues he raised rose on occasion to Wittgensteinian levels of perplexity. One memorable morning, after I had given him some paper towels, he uttered an appropriate "Thank you" and received a forthright "You're welcome." Then, in a rapid, urgent monotone, he rejoindered: "I take it back! [pause] But if *I* take it [the 'Thank you'] back, do *you* take your 'You're welcome' back? But that's all right because it's inside me, and there's more inside me. . . . But that's all right. . . . *Is* thàt all right?" and so on, obsessionally. Like concrete objects, like possessions, the words, if

relinquished, might, with the fragile self that had uttered them, be lost. It was, I suddenly saw, as though words could be only possessions and not currency to this child who, as the victim of troubled parenting (among other ills), had never experienced that foundation of trust upon which trade, exchange, and symbolic communication must be built.

Avi is a child who, even at twelve years of age, has not sufficiently individuated, in body and mind, to grasp his own subjectivity. The response he received from me that day involved the notion that, once words were spoken, in the context of our ongoing relationship, they *could* be taken back but, because they had been uttered and heard, they then nevertheless belonged to both of us. Avi's response to this was: "But suppose I *didn't* say it. Suppose I just imagined it." To this I replied that this would have been different because "what you imagine belongs all to you; whereas, when you say something to me, then it's mine too: it's ours together." "Even if I take it back?" was the next question. To which my reply was "Yes, even if you take it back, because you have said those words, and I have heard you. I believe you when you speak to me, and this is important because we are working together." Aimed at emphasizing relatedness and communication rather than at reinforcing Avi's fragile sense of control over his own thoughts (which would have been another possible tack but one that seemed at this juncture less focal), my comment stressed themes of sharing and losing, of giving and having.

During this conversation, Avi worked on a painting that started with red, the color that often in these months he chose to use first. After a pause, during which he was painting with blue, he said softly: "Suppose you decide not to work with me any more. . . ." He received my reassurances but later in the session, as an impending brief separation was mentioned, his painting began to change: the semistructured areas of red and blue vanished. Overpainting them with increasing agitation, he announced, "I like black!" While rapidly demanding more and more of that color, he daubed the now heavy-laden paper with a thickly coated brush. In an accelerating frenzy, he said: "I'm getting excited. The paint is making me excited. . . . I'm getting *too* excited. Is that all right?" By now, densely textured paint covered every iota of the surface of his paper, and all previously applied colors had merged into a dark sea of pigment. Gradually, my words reached an Avi who himself seemed, despite his words, to have merged momentarily into the painting process. Getting too excited can become very frightening, I said, and finally

he was able to hear me and to undergo a certain calming. This took place, however, only outside the painting process, which by then had ended.

In this session, the act of painting seemed at first to parallel Avi's verbal themes. Formally, the affect could be described as exploratory, tentative, semistructured, but with an anxious *leitmotiv*. After this initial period, however, it rose to a crescendo and, stimulated by the content of our verbal interchange (in particular the mention of our looming separation), it erupted into a cacaphony, still with efforts, *sotto voce*, at modulation in the verbal sphere (Avi labeled his own affect as "excitement" and asked for my reassurance). It is noteworthy that, in his growing anxiety over the idea of separation in the human sphere, Avi could not tolerate that his *colors* should be separated: he forced them to merge and blend in a way that, eventually, however, threatened to overstimulate and overwhelm him. One could not, perhaps, find a more vivid illustration of the psychoanalytic notion of projective identification as it functions within the context of the use of art materials.

On the day Avi spoke my name for the first time, a complex and dramatic session, I asked him afterwards, several times, whether he wanted a fresh piece of paper to work on. He ignored me each time until, finally, I commented on his failure to respond. He looked up at me from the heavily encrusted sheet on which he was still working and said quietly: "I just want to finish this." Instantly, the meaning of his refusal to permit my intrusion came radiantly into focus: The painting process was, for Avi, an analogue for our ongoing relationship as well as for the verbal dialogue we were conducting. Thus, to have started a new piece of paper at that juncture would have been to close off, disrupt, *erase,* some aspect of the momentous exchange that had just taken place between us and was ongoing!

For Avi, I learned, art was never located in the "real world" of objects where aesthetic or even practical considerations matter (i.e., no more room on the page). Objects were never judged finished or unfinished with respect to their intrinsic colors, shapes, patterns, etc. Rather, art existed and had meaning only in the context of our relatedness, his and mine, and of whatever aspects of this relatedness he was beginning gradually to internalize and use for himself. How much, one wonders, is lost even of the greatest, most transcendant masterpieces when they are removed from their embeddedness in their own analogous first matrices?

In a fine study of the relations between words and images, W. J. T. Mitchell (1986) discusses the dialectic between iconophilia and iconophobia and the enlisting of verbal language on both sides of this recrudescent struggle between the worship of images on the one hand and fear of them on the other. From a psychoanalytic point of view, the role of words in either case is anxiously competitive, as word and image vie for hegemony over our experience, and words, bearers of the paternal law, must triumph. Parenthetically, this is another sense in which there is no art without history: for without the word, without the label, images may prove too threatening, too radically same or other—sexually, aggressively, racially, politically. Thus, to keep them in check, we establish canons, write histories, invent criticism, all to protect ourselves from the power of their gaze.

Avi fears images. He has always been afraid to look at his paintings when they are finished. And, although he paints with a passionate, self-absorbed intensity, the process itself is not predominantly visual. Likewise, while he is working, he cannot brook the distance it would take to look critically at his developing product. Either he seems to fuse with both act and object, or he experiences them as radically other and turns his head away as an infant would from an unwelcome stimulus. Here we can perhaps study *in statu nascendi* the phenomenon of iconophobia, the origins of iconoclasm.

A. Whitney Davis (1987) has spoken of the artist as "remarking" his mark and has identified this act as a crucial step in the origins of image-making. My work with Avi, however, suggests that kinaesthetic, even synaesthetic, sensations may play an important role in such acts of remarking and that "remarking" should not be conceived as purely visual. I say this because, although this schizophrenic child does not remark his work in the sense I take Professor Davis to mean, nonetheless, it would be wrong to think of him as making first images again and again. Further, it is important to comment that although Avi does not indicate any perception of aesthetic qualities in his work and seems, in no conscious way, to plan structure, yet, structural elements do inhere in his paintings— variations and repetitions of color, shape, gesture, and brushstroke, a rhythmicity and sense of two- and even three-dimensional design. Can this be an indication perhaps of some unconscious roots of artistic form?

Is there a history to Avi's work? In this essay I have historicized his paintings: that is, construed them as the record of a relationship.

Yet, I have eschewed both a linear chronology and a clinical terminology. My effort has been rather to reimplant these marks, images, or artworks in the soil in which they originally flourished, to reevoke their culture in the basic meaning of that term. However, aesthetic judgments, like their counterparts in ethics, are sometimes thought to be independent of such contextualizations, and I remain restless with unanswered questions. As we, in contemporary scholarship, struggle to comprehend, without cannibalism, the embodied experiences of others, of outsiders, like the painting of this all-but-forgotten child, and as we search to find ways of inscribing their neglected histories, we, in so doing, must inevitably change the very courses of our own.

A Cycle of Songs

Ancient Voices of Children
by George Crumb

As a participant in the late seventies and early eighties in the
Lincoln Center Institute, I was introduced to a piece of music
which resonated with me in a deeply personal way. It seemed to
figure in complex musical, verbal, and choreographic terms the
bonds between a mother and a child; it featured a boy soprano at a
time when my own young son Nathaniel was singing soprano solos
at Juilliard; and it gave a principal role to the oboe, an instrument
with deep roots in my past, for it was seriously studied by two
close family members. This chapter grew slowly out of my love for
this piece of music and my desire to share with others all I then
heard and still hear in it.

In recent years, speculative thought in anthropology, linguistics, and psychoanalysis has increasingly been brought to bear on criticism in the literary, visual, and performing arts (see works, for example, by Tunstall [1979], Segal [1986], and Bryson [1981, 1983, 1984]). This essay participates in that trend by employing concepts drawn from psychoanalytic developmental theory in the interpretation of a work of postmodern music. For the psychoanalytically trained listener, the composition considered in this essay, *Ancient Voices of Children* (1970) by George Crumb, all but *compels* a psychoanalytic approach because of its subtle but unmistakable preoccupation with developmental themes. Freud, as is well known, was unresponsive to music and left no significant texts that directly relate his insights to this art form (see, for example, "The Moses of Michelangelo" [1914], p. 211). The task, therefore, of applying to music a psychoanalytic understanding of the human psyche has fallen to subsequent authors. Although it has been remarked that the art of music has received scant attention within the body of psychoanalytic criticism, a modest number of such studies are extant. For some exceptionally fine examples, note the work of Stuart Feder (1978, 1980a, 1980b, 1981, 1982, 1984). Much of what has been written, however, falls more or less into the category of pathography or psychobiography, the thorny problems of which are well

Versions of this chapter appeared in *Current Musicology* (1985) 40:7–21, and in *The Psychoanalytic Study of the Child* (1987) 42:531–543. Permission to republish this material is here gratefully acknowledged.

I also wish to thank the following persons for their valuable comments: Maureen Buja, Murray Dineen, James E. Gorney, Nathaniel Geoffrey Lew, Mitchell B. Morris, and Brian Seirup. Special appreciation goes to soprano Barbara Martin for her inspired performances of this piece at Juilliard under the auspices of the Lincoln Center Institute.

known and have been extensively discussed by modern aestheti-
cians (see Bouwsma [1980], Tormey [1978], and Kivy [1980] and my
own analysis of their contributions in Art and Psyche [1985]).

It is my aim here, however, to demonstrate the possibility of
quite a different psychoanalytic approach to music, one which re-
moves the work from any biographical references to its composer.
When heard with a knowledge of post-Freudian psychoanalytic de-
velopmental theory, Ancient Voices of Children subtly but in-
tensely evokes an aesthetic experience of the first drama in which
all human beings participate, namely, the positively and negatively
charged interactions between mother and infant.

Although I believe it may be possible to extrapolate from what is
presented here a more general psychoanalytic approach to musical
form, this chapter is limited to an interpretation of the one work. I
draw on theoretical schemata taken not directly from Freud's own
writings but principally from those of two of his followers who,
although deeply influenced by him, felt a need to modify and extend
his ideas along certain lines, particularly to fill in important lacunae
in his thinking. For nonpsychoanalytic readers, I begin by giving a
brief account of these lines and some of the developmental notions
of the two psychoanalysts in question, Margaret S. Mahler and
D. W. Winnicott.

Mahler, a distinguished Viennese-trained pediatrician, psychia-
trist, and psychoanalyst, devoted much of her clinical research to
the study of preverbal development in infants. In particular, she
explored the infant's earliest ties to its first object (the mother) in
more depth and detail than Freud had ever attempted. Her writings
are complemented by those of the eminent British pediatrician and
psychoanalyst D. W. Winnicott, who developed many of his ideas
simultaneously with Mahler during the 1950s and 1960s. Although
they worked quite independently, their conceptual frames for un-
derstanding early development mesh comfortably and may be re-
viewed in tandem without detriment to either.

Extensive work with autistic infants (that is, infants who, within
the first year of life, manifest apathy, fail to respond to the approach
of caregiving adults, and shrink altogether from human contact)
persuaded Mahler that the sources of such disturbance must be
sought in these infants' earliest dyadic relations with the mother.
Freud's major interest in child development, however, was the Oe-
dipus complex, which he described as structuring the young child's
relations with both parents at a later stage (from three years of age
to five or six) when the conflicts endemic to these relations can be

verbally expressed. The earlier preverbal dyadic tie that precedes the oedipal stage was left relatively unexplored by Freud, who considered the triadic phase as critical in human development, the pivotal stage for the genesis of character structure and subsequent (neurotic) psychopathology. It is interesting to speculate on the connection between Freud's lack of interest in music and his relative lack of interest in the preverbal child. It is striking, moreover, that those more recent psychoanalytic authors who *have* studied the early infant-mother dyad (see, for example, Stern 1985) have developed ideas with remarkable applicability to music.

In recent psychoanalytic literature, however, owing largely to the pioneering work of Mahler and her colleagues, preoedipal development has come to be recognized as far-reaching in its effects on the psyche of the developing child and as coloring and shaping all later and more complex intrapsychic configurations. Through her observation and treatment of both normal and psychotic infants, Mahler gradually labeled and described a stage-series of early forms of relatedness. Central to her theory, which pertains roughly to the first three years of life, are the gradual development of self-consciousness and the incipient, fluctuating boundaries between self and other: "Consciousness of self and absorption without awareness of self are the two polarities between which we move with varying ease and with varying degrees of alternation or simultaneity" (Mahler 1972:333).

Stressing that the human infant is born unprepared to sustain life unaided, Mahler explored the psychological consequences of this biological dependency. She concluded that such total initial reliance on another being, a "mother," who is usually but not always the biological mother, leaves traces that remain imprinted on the human psyche even "unto the grave." She spoke of a "gradual growing away from the maternal state of symbiosis, of oneness with the mother [as] a lifelong mourning process" (1972:333).

Mahler's developmental sequence includes the following stages, described briefly below: *normal autism, symbiosis,* and the process of *separation-individuation,* which is further subdivided into the phases of *differentiation, practicing,* and *rapprochement.* The first stage in the "psychological birth of the human infant" (see Mahler, Pine, and Bergman 1975), as described by Mahler, is *normal autism,* which occurs in the first weeks following birth. The newborn sleeps for long periods of time, and wakeful periods center around efforts to achieve physiological homeostasis (that is, to avoid painful tension, usually emanating from internal, digestive disequilibrium).

The mother's ministrations at such times are not distinguished by infants from their own efforts to preserve equilibrium. Thus, this first stage is one of psychological undifferentiation of self and other. (For an alternative view, however, and a critique of this aspect of Mahler's thought, see Stern 1985.)

Gradually awakening to an awareness of a need-satisfying object, the infant functions "as though he and his mother were an omnipotent system—a dual unity with one common boundary" (Mahler 1968:8). Mahler calls his state—prior to clear differentiation between inside and outside, between the "I" and the "not-I"—the *symbiotic phase*. As yet unaware of the mother as a specific whole person, the infant experiences her as a need-gratifying extension. The exquisitely pleasurable quality of this symbiotic phase (as experienced in cases where the fit between infant and mother is, in Winnicott's term, "good enough") comes from the mother's sensitive attunement and adaptation to the infant's needs. Her selective responses to her baby's demands and the subtle climate created by her conscious and unconscious attitudes confer a sense of well-being—a foundation for what Winnicott has called the "true self" (Winnicott 1965).

By adapting to the infant's needs in this symbiotic stage, the mother creates in her child a sense of power and control—a sense of magical omnipotence that persists as long as she remains for him or her a part of the self. Thus, the good enough mother (Winnicott's term) provides a situation in which her young infant can experience and trust his or her own creation of reality. Although the infant initially experiences tension and discomfort, the mother, by presenting herself and repeatedly alleviating distress, conveys "the illusion that there is an external reality [that] corresponds to his own capacity to create" (Winnicott 1953:95). The magical omnipotence that results—the sense of being able to create and recreate reality—has obvious connections with subsequent experiences in the arts (and, of course, with a child's burgeoning capacity to invest in imaginative play, see Winnicott 1966:368–372). Preferential smiling at the mother is often a sign that the infant is safely anchored within this symbiotic orbit.

After providing her child with optimal opportunities for creating illusion during symbiosis (up to the age of about five months), the mother's next task, during the developmental stage of *separation-individuation*, is the gradual disillusionment of the child. This is necessary, for were the child not to expand beyond the symbiotic orbit, he or she would remain unable to distinguish fantasy from

reality (a state common to acute phases of severe psychosis). Disillusionment is a step-by-step process aided and abetted by the maturing infant's own increasing motor and perceptual faculties.

"Hatching" from the symbiotic orbit is often marked by a new look of alertness and persistence on the part of the infant. Infants at this stage will commonly strain and lean away from the mother to look at her while being held; they may engage in manual, tactile explorations of the mother's face, pull her hair, and play peek-a-boo —all signs of increasing *differentiation*. When all goes well, the mother is able to provide a stable base for this growth by responding to her infant's cues. Optimally, she will foster a healthy movement toward differentiation without pushing her child into premature independence. She collaborates, in other words, with the developmental trajectory and thus facilitates the infant's gradual renunciation of symbiotic fusion with her.

Weaning is the physiological counterpart of this psychological process, but the psychological precedes the physiological by many months, and it is, as Mahler points out, a process never fully completed. For mothers, as for infants, the full experience of this period must involve loss as well as gain. To function in the real world, infants must give up a measure of the magical omnipotence derived from their illusion of sharing in mother's powers. They must learn, gradually, and never without pain, to perceive her as an external object, that is, as a part of the world that is not the self, as an "other" who can depart, who can disappoint, and who can be lost. For mothers there is a correspondingly deep sense of loss at this stage, though it is often unrecognized and well disguised.

During the *practicing* subphase (about ten to fifteen months of age), the young infant's love for the mother is generalized into a grand passion—"a love affair with the world" (Greenacre 1971:490). Toddling now, children manifest elation, exuberance, and an urge to explore and discover all aspects of sensory experience. They often become so absorbed in their activities that they seem oblivious of the mother's presence. But this burst of ebullient autonomy is not the whole story, for these fearless young adventurers need to "check back" at periodic intervals that vary from child to child (and for the same child under different circumstances). They need not only to see but to establish intimate physical contact with mother and to return to her for emotional refueling.

This is the stage at which many children form an attachment to a particular object in their immediate surroundings, such as a soft blanket or a stuffed toy animal. They do this both to protect them-

selves against loss and to preserve the special quality of relationship with the mother that they are in the process of relinquishing. This object, importantly, is a part neither of the infant's nor the mother's body but something else ("not-me"). It nevertheless possesses certain soothing qualities (partly because it is imbued by the child with such qualities) that enable him or her to use it as a bulwark at times of stress and loss (e.g., at bedtime).

Winnicott (1953), who labeled this phenomenon and described its psychological significance, included in his notion of such "transitional objects and phenomena" the category of *sounds* initiated by children. Youngsters' impulses to babble, croon, and chatter to themselves before falling asleep serve a dual function, as they both make and hear these sounds. By initiating, replicating, and elaborating on previously heard phonemes, they practice newly developing vocal skills. At the same time, hearing these sounds serves as an ongoing source of comfort.

Rapprochement, the next subphase, lasts from roughly sixteen to twenty-four months of age. It coincides with the maturation of the central nervous system and thus with a spurt in the child's cognitive faculties. (Language acquisition is extraordinarily rapid during this period.) Endowed now with a multidimensional and therefore acute awareness of separateness, the child makes abortive attempts to reestablish symbiosis with the mother. Wishes for reunion with her conflict, however, with fears of engulfment and with pride in newly acquired skills and feelings of independence. Ambivalence, therefore, characterizes this stage. Toddlers often alternate between shadowing their mothers and darting away from them, and the young child's autonomy is usually defended by a strident negativism.

Mahler speaks of a "rapprochement crisis"—that point when the child comes face to face (quite dramatically in some cases) with the devastating realization that his or her love objects are, inevitably, separate from the self. Each young person must experience in a unique way a profound sense of loss, vulnerability, and alienation that will remain forever inseparable from, and indeed constitute, his or her human subjectivity. Concomitantly, children awaken to a clearer realization of the *triadic* drama into which they are cast. The death of one phase heralds the birth of the next (and yet they overlap). Highly charged dyadic relations are now expanded and reworked in the newly perceived triadic relations between father, mother, and "me." Desire begins to replace primitive demand. The chosen love of separate individuals with different and unique voices

begins to replace the fused, dependent love of early infancy. The ache, the mourning for oneness, however, survives. Great myths like that of the Garden of Eden stand as testaments to the undiminished regressive power of primitive symbiosis.

With this theoretical background, we turn now to the music. My intent has been to work as lightly as possible with the theory— keeping it as a tacit framework while the music is described. For *Ancient Voices of Children*, as a work of art, clearly transcends any particular theory that can be brought to bear upon it. Richly, it melds together, condenses, contrasts, and reveals, rather than unfolding in a simple linear sequence. In juxtaposing psychoanalytic developmental theory with *Ancient Voices of Children*, my purpose is not to reduce the latter to some musical version or illustration of the former but, rather, to endow the listener with a frame of reference that "expand[s] the field on which attention rests" (Isenberg 1973:52).

The full title of George Crumb's 1970 composition is *Ancient Voices of Children: A Cycle of Songs on Texts by García Lorca*. The piece was commissioned by the Elizabeth Sprague Coolidge Foundation in the Library of Congress and was first performed by Jan deGaetani, soprano, Michael Dash, boy soprano, and the Contemporary Chamber Ensemble conducted by Arthur Weisberg on October 31, 1970. Actually, it fuses several art forms into one, since its performance involves a special arrangement of instruments onstage, the strategically timed entrances and exits of certain performers, and the occasional vocalizing of instrumentalists as well as, in some cases, their changing of instruments during the piece. Consequently, as in the parallel case of an opera, not even the finest recording (*Ancient Voices of Children* has been recorded on a Nonesuch stereo disc, H-71255, featuring Jan deGaetani) can do justice to the full range of expressive possibilities offered by the work.

Ancient Voices of Children is scored for soprano, oboe, mandolin, harp, electric piano, and assorted percussion instruments, including antique cymbals, tambourine, maracas, Tibetan prayer stones, sleighbells, and five Japanese temple bells. Its oversized score is a work of art in its own right, a festival for the eyes, with notes, markings, and poetic text that dance enticingly helter-skelter over its pages (figure 6.1).

Although the actual sounds of the Spanish words are inextricable from their musical effect, I have, owing to complications of rights, quoted the Spanish texts more sparsely than I would have liked. My

warrant for providing translation comes directly from the score (Edition Peters No. 66303), where Crumb has clearly indicated his desire that the meaning of the text be understood by all his listeners. He states: "N.B. Both Spanish and English texts should be printed as part of the program notes." The translations are from Federico García Lorca, *Selected Poems* (1955).

The chosen fragments of García Lorca's poetry are strung together into a five-part cycle by Crumb, who assimilates and recreates the text into a new totality of his own making. The result is a transformation and transcendence of the original poetry in ways impossible in earlier conventions governing the setting of poetry into song. The composer creates a synthesis of music and language —sound and voice—that embodies new meanings, reveals new interrelationships and sequential significance beyond those inherent in the original poetry. By so doing, he participates in the recent tradition of breaking up verbal texts into phonemes and thereby abstracting them into pure sound. Parenthetically, the number of twentieth-century composers who have treated texts as phonemes is enormous; some of the most well-known of these composers are Luciano Berio, Gyorgy Ligeti, Karlheinz Stockhausen, and Daniel Lenz.

Crumb has, as I have suggested, given to his work a strong, almost choreographic visual aspect by carefully designating the position of all instrumental groups onstage and by directing his performers to move about as they prepare to play different instruments. They turn away, depart to perform offstage, or come onstage after having been totally invisible to the audience. In fact, the entire piece possesses a theatrical aura, and the score actually states that it can be adapted to choreography or even to mime (see Crumb's Performance Notes in the published score of *Ancient Voices of Children*).

From the psychoanalytic developmental perspective I have adopted here, one feature emerges as momentous. There is onstage from the beginning both a grand and a toy piano, and the visual relations (as well as the musical relations) between these instruments serve to underscore as well as to mirror the similar relations between the adult woman and young boy soprano who perform the central roles. As elsewhere throughout the piece, contrast and continuity are stressed by being presented in not merely one but at least two sensory modalities. Their intensity is magnified in a way reminiscent of the "coenesthetic" experiences of our earliest (ancient) moments, described first by psychoanalyst and infant researcher René

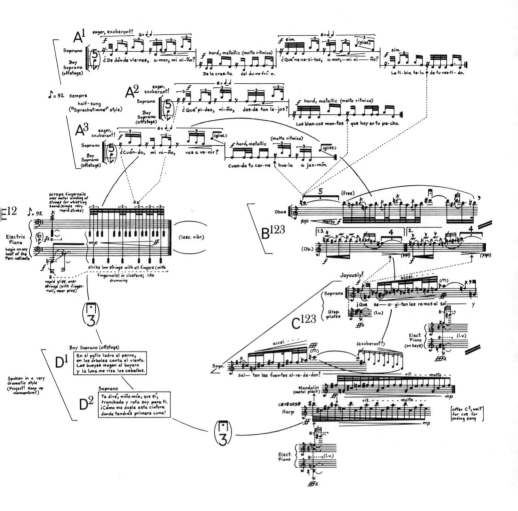

Figure 6.1. George Crumb, "Dance of Sacred Life" (detail) (1971).
From *Ancient Voices of Children.* Copyright © 1971 C. F. Peters Corporation.

Spitz (1965) and more currently by Daniel N. Stern (1985). These authors have described the "cradle of perception" in early infancy as prototypic for our later experiences in the realm of the aesthetic. Sensations, perceptions, and impressions are cross-modally reinforced; the infant simultaneously touches, tastes, smells, sees, hears, and feels in a primitive state before perception is localized and mediated by semantic symbols.

Ancient Voices of Children thus juxtaposes our notions of silence and absence. Our notions of consonance and dissonance find a parallel in the congruence and incongruence of sizes, shapes, sexes, and generations. This is accomplished through an interweaving of unusual musical elements with poetry that has been partially broken up into its phonemic components, and with visual counterparts including both objects and movements in space. The piece presents us with an experience in which the "primary illusion" (Langer 1953) is musical. The music is heightened, however, by a drama that envelops us by engaging us cross-modally, as do perhaps not only the earliest but all the most intense dramas throughout our lives.

Importantly, the dramatic action of the piece explores not only the perspective of the child but that of the mother. Insofar as the mother–child relationship is paradigmatic, the piece becomes a complex metaphor for the varying degrees of alternation and simultaneity that characterize all human relationships. As a work of art, *Ancient Voices of Children* confronts us additionally with the problem of relating ambiguities inherent in aesthetic experience to other important ambiguities. It challenges us to consider how it is that our experiences in the arts derive their power to move us so profoundly.

As a title, *Ancient Voices of Children* seems puzzling, even paradoxical. How can the youthful voices of children be called ancient? The composer unravels this riddle by revealing that, for each of us, the old or former or ancient self is indeed that of a child, inextricably bound to the voice with which we once spoke. It is an ancient voice that we are fated to lose and mourn, along with all the quality of life and human relationship that once went with it. Yet sometimes we can rediscover it in the voices of other children, perhaps especially our own. Through his art George Crumb has fixed the central message of Margaret Mahler's insights.

Ancient Voices of Children is about the power, magic, ambiguity and range of the human voice. It is about sounds created by human beings: what they can be, what they can do, and what they can

mean. The piece gives us two human characters, a woman (soprano) and a boy (soprano), who represent—at times consciously, but on a deeper level unconsciously—a mother and her child. We are led by them to explore through the medium of voice, but also through anthropomorphic instrumental sound, the dimensions of their changing relationship. The anthropomorphism here moves characteristically back and forth. The voices of the two pianos take on the personae of adult and child, and the plaintive oboe imitates the human voice. On the other hand, the soprano, while vocalizing into the amplified piano, prefigures the sounds of the Tibetan prayer stones with her clicking tongue. This intimacy and intermingling of human and instrumental sound characterizes the piece, reinforcing its evocation of the ancient and the primitive.

Voice reaches out in all directions as a vast bridge across primal separateness. It is a mother calling ("¿Cuándo, mi niño, vas a venir?"—"When, my child, will you come?"), trying somehow to establish contact with the child within her body, with a child out in the world, and with the child who is her own partially forgotten self (". . . que me devuelva / mi alma antigua de niño."—". . . to give me back / my ancient soul of a child.") But voice is also an affirmer of self, a confirmer of identity and self-sufficiency ("El niño busca su voz."—"The little boy was looking for his voice."). And these two ways in which the human voice functions can be in painful conflict, as we hear in the occasional abrupt contrasts, juxtapositions, and interpenetrations of the music.

The painful separations of birth ("Te diré, niño mío, que si,/ tronchada y rota soy para ti."—"I'll tell you, my child, yes, / I am torn and broken for you.") and death ("todas las tardes se muere un niño."—"a child dies each afternoon.") lie at the extremes of the spectrum of partial separations described by psychoanalytic developmental theory. But separation can be partially overcome by music and the magical power of voice, which interpenetrates that surface between self and outer world ("como me pierdo en el corazón de algunos niños."—"as I lose myself in the heart of certain children."). Thus, this music, "with a sense of suspended time," according to the score, momentarily arrests our sense of life's evanescence.

The piece begins with the soprano entering the stage and walking over to the piano. Standing beside the great instrument, she is dwarfed by it, as our fleeting consciousness is dwarfed by the cavernous recesses of the unconscious. She bends over and begins to

sing into the body of the piano. Her voice induces sympathetic vibrations in the piano strings. Rich vowel sounds ("a-i-u-a-i-u-a-i-u-a-i-u-a-i-u . . . ka-i-o-e-a-i-ai-u") vibrate and resonate throughout the hall as though in waves spreading from her, echoing and reechoing. She is searching, exploring, questioning, exulting in what her voice can do. She does not turn to the audience, but seems to sing into the depths of her own psyche—letting the sounds of her own voice bring messages to her. She makes a compelling visual image, leaning over the piano as if it were a pool of water, an ocean, or a vast nothingness. She is perhaps the pregnant mother calling to and listening to the unborn child within her who is still a part of her own body.

She sings sounds at this point: not words, but the "inside stuff of words"; sounds that suggest language unfettered to specific meanings; sounds evoking warmth and color, unconstrained by outline; sounds like those with which the young infant practices, experiments, and plays repetitively, joyful in his burgeoning power both to make and simultaneously to respond. In this opening section, by taking not words but the sounds of letters inside words as musical elements in his composition, the composer delves into the expressive tonal qualities of language—its internal value of sound. He isolates vowels, consonants, diphthongs. With this exploration, a vast richness of meaning opens, and associations multiply.

While Mahler described the symbiotic orbit that envelops infant and mother in the first stage of their relationship, she did not stress the powerful regressive pulls that this relation exerts upon the mother. This aspect of the dyadic drama is, however, elaborated in *Ancient Voices of Children*. From the very beginning, we are absorbed into the "shimmering aura of echoes" produced by the soprano's vocalise (see score, *Ancient Voices of Children*, inside front cover). The primeval quality of her voice, as she renders these sounds loosened from word-shells, is enhanced by the apparent freedom, spontaneity, and intense self-absorption with which she performs this opening section. Paradoxically, although the experience she conveys is almost improvisational in character, its every nuance is notated with consummate precision. This marvel, a score that specifies every subtlety and yet engenders a performance that conveys the very essence of spontaneity, recalls the following lines by William Butler Yeats (1960) from "Adam's Curse":

A line will take us hours maybe;
Yet if it does not seem a moment's thought,

Our stitching and unstitching has been naught.
Better go down upon your marrow bones
And scrub a kitchen pavement, or break stones
Like an old pauper, in all kinds of weather;
For to articulate sweet sounds together
Is to work harder than all these, and yet
Be thought an idler by the noisy set
Of bankers, schoolmasters, and clergymen
The martyrs call the world.

Although the words are not heard until later, the title of the first movement reads, "El niño busca su voz" ("The little boy was looking for his voice"). The voice of the adult woman soprano merges in the listener's fantasy with the inarticulate experimentations of the small child too young as yet to form words. And then, as if in confirmation, the child's own voice is heard remotely offstage at the close of the passage. Further fantasies evoked by this movement (which is marked "very free and fantastic in character") include the expressive vocalizations of an adult overwhelmed by extreme emotion into incoherence; the strange and unpredictable sounds of ancient tribal music that might thus link the early history of mankind with that of individuals; the delirious liberation of sounds from binding constraints of meaning; or the unfamiliar noises of some language that one cannot comprehend.

As the music evokes such fantasies as well as the underlying human drama of fusion and separation, its breaking down of verbal sense and orgy of primitive play may cause a struggle in its listeners against regressive pulls. Like young children caught in their own developmental thralldom, listeners may find themselves similarly caught, for if they can permit themselves to resonate with the magic of this music, they will gradually be engulfed by its reverberations—deeply stirred and compelled by the ancient powers of their own psyche.

García Lorca's text continues:

(The king of crickets had it.)
In a drop of water
the little boy was looking for his voice.

The soprano clicks her tongue intermittently, flutters it, works with open and closed sounds (full-throated and nasal), varying dynamics and tempi. Perhaps she is pretending to be the cricket king who has tried on a human voice, exploring all its possibilities, not

certain what to do with it. Simultaneously, in these passages, she becomes the child trying to find his own voice, tentatively emerging from the fetal drop of water. She merges with and evokes the experience of the young toddler who tries on different pitches and rhythms like costumes to discover which feels comfortable, startling, useful, horrid, becoming.

She becomes the child seeking a separate and unique identity in sound, a distinct voice of his own. This theme is developed by the lines of the boy soprano's "after-song," rendered softly through a cardboard speaking tube offstage:

> I do not want it for speaking with;
> I will make a ring of it
> so that he may wear my silence
> on his little finger.

To find one's own voice is also to be able to choose silence. It is to be able to make the ring of inclusion and the ring of exclusion in the dyad, and thus, to make the little finger independent—independent of the mother. Apropos of this, a Lacanian perspective may be helpful in locating the place of the cricket king who *has* the little boy's voice. According to Lacan, it is the father ("le nom/non du père") that intervenes and ruptures the child's symbiotic ("imaginaire") relation with the mother. In symbiosis, no symbolic communication is necessary. It is thus the (phallic) father principle that, in severing the bond with the mother, initiates the child into language, symbolized here perhaps by the "king" who has the voice of the child (see Lacan 1977).

There are associations with later developmental stages as well: A boy is changing, on the brink of manhood. He looks into the water, his memory, the sounding board, and he feels the vibrations of his past. He is seeking his former voice, since his present one has grown unpredictable and strange. The soprano's voice represents, perhaps, that for which he is searching, that for which he will continue to search in all his subsequent relations. As her voice reverberates in ever-expanding echoes, our own awareness of the possibilities of vocal sound expands. We become conscious of the multiple meanings released by this freeing of language from word and sound from poetry and enter aesthetically into the recurring and layered dramas of early human development.

The piece continues with an instrumental interlude, "Dances of the Ancient Earth," for oboe, harp, mandolin, and percussion. Although the composer denies that this section is a commentary on

the text (see Crumb, *Ancient Voices of Children*, score, inside front cover), the overarching theme of the human voice is developed and expanded here as the various instrumentalists vocalize in occasional shouts and whispers. As in later movements, the sounds made by the instruments themselves are often reminiscent of human voices—the raw wailing of bow on metal saw in section II, the antique toy piano's suggestive tinkling in section IV, the many different bells and touches of vibraphone, and, above all, the oboe's haunting abortive melodies that recapitulate qualities of the soprano's voice in section V. In this interlude and throughout the piece, the warmth and vitally personal quality of the human voice is present.

In section II, the soprano moves to center stage, and facing her audience with cupped hands, she proceeds to whisper the following lines of poetry, as if telling a secret:

> I have lost myself in the sea many times
> with my ear full of freshly cut flowers,
> with my tongue full of love and agony.
> I have lost myself in the sea many times
> as I lose myself in the heart of certain children.

These lines, not sung, but spoken quickly, quietly, confidentially, form almost a commentary on the preceding section as well as a further thematic development. We are, they suggest, always open to sound—to voice. Our ears are perpetual receptors unlike our eyes, and therefore we can be engulfed by sound; we can "lose" ourselves in it, for it has the power to surround and invade us. Music fills our ears with "freshly cut flowers," with notes or words that have been spoken or sung and that die soon or change once they have passed the lips of the singer.

The irony of these lines is further expressed by the juxtaposition of "love" and "agony." Voice creates an illusion of bridging the gulf between self and other—between mother and child. A mother hearing her newborn infant's cry or an infant sensing mother's voice and bodily sounds feels a powerful urge to be reunited in a symbiotic prenatal and postnatal union that must dissolve. The soprano's whispering of words between cupped hands—words spoken but not sung—reminds us that the transforming, reuniting magic of voice is but illusion. They remind us of the paradox that to hear another's voice as one's very own (like "freshly cut flowers") is to be at once united and inexorably separate; hence, "love" and"agony" together.

The next movement of the composition, "¿De dónde vienes,

amor, mi niño?" ("From where do you come, my love, my child?"),
is its centerpiece, musically, temporally, and even visually, in terms
of the score itself. Its text, a block of richly imagistic poetry, comes
from the song of Yerma—García Lorca's unforgettable Yerma, the
barren wife, who longs so desperately to bear a child. Her words
become now a musical dialogue between the two soprano voices:
the one, adult, female, and present; and the other, youthful, male,
and absent. The child, whom we have already heard offstage in
section I, continues to remain far away, remote and invisible. Incor-
porated into this section are the bolero rhythms of the "Dance of
the Sacred Life-Cycle" (see figure 6.1), which is scored in the shape
of a ring on the page (reminiscent of the "anillo" of voice and
silence). This dance closely follows the structure of Lorca's poetry
with the mother's repeated (slightly varied), yearning questions, the
child's vividly sensual and pictorial responses, and the thrice-re-
peated chorus. Against the rhythms and repetitions of this move-
ment play a rich variety of background accents produced by inge-
nious combinations of instruments and the composer's exploitation
of their potential for creating new sound.

Visually and auditorily, the instrumentalists become almost a
family to the major participants in the dialogue here, as awareness
of setting becomes more prominent both in the text and in the
drama that is unfolding between mother and child and between
mother and self. As background becomes foreground in the instru-
mental interludes, we grow more sensitive to the way in which all
the noises that surround us—including those internal to us—have
significance and hitherto unrecognized value. We begin to perceive
these noises as relating us to life around us and to our intrapsychic
and bodily selves.

Section IV is preceded by a silence. Brief but deeply signifying,
this silence symbolizes death (the final and irrevocable absence),
but it also offers respite. It prepares us for the complex and highly
emotional threnody to come:

Todas las tardes en Granada,
todas las tardes se muere un niño.

Each afternoon in Granada,
a child dies each afternoon.

Dominated by slow, unmeasured rhythms, this climactic move-
ment evokes the death of children—not loss of life alone but the
death of childhood itself.

In the first song, the little boy was heard offstage speaking of

wanting his voice not to talk but to make a "ring of silence." It is *this* silence, this distance, that the mother mourns here, although the literal death of children remains a viable interpretation. The toy piano's *perdendosi* rendition of Bach's "Bist du bei mir" ("Be near me") addresses the theme of loss and separation with special poignancy.

That the actual death of children is lamented also is made patent in the brief transition, aptly named "Ghost Dance," as well as in the final movement, "Se ha llendo de luces mi corazon do seda" ("My heart of silk is filled with lights"). Here the composer directly quotes in his plaintive oboe solo a melodic line from the final movement, "Der Abschied" ("The Farewell"), of Gustav Mahler's *Das Lied von der Erde* (1908), a piece written by that composer upon the death of his own five-year-old daughter and originally published in 1912. Mahler's elder and beloved daughter Maria (Putzi), who had been named for the composer's mother, died of scarlet fever on July 5, 1907 (see Feder [1978] for a sensitive discussion of the effect of her death on her father). This child's death coincided not only with artistic conflicts that led to Mahler's resignation from the Vienna Opera but with the diagnosis of the valvular heart disease that, four years later, claimed the composer's own life. As the first sketches for *Das Lied* were made in the summer of 1907 and its first title was *Das Lied vom Jammer der Erde* ("The Song of the Sorrow of the Earth"), we may assume some connection between the events of his life and this piece in which, as Alma Mahler writes, "He expressed all his sorrow and dread" (see Mitchell 1946:139).

As the music evokes our sense of loss in these several dimensions, it conveys especially that mourning for a special kind and quality of relationship that must irrevocably pass, and yet which is, evanescently, recaptured in our aesthetic moments with music.

Finally, in this concluding section of *Ancient Voices of Children*, we hear voices—both human and instrumental—reaching with a progressive sense of urgency. The soprano sings of traveling "farther than those hills, / farther than the seas, / close to the stars," to span the distance—to close the gap between herself and her "ancient soul of a child." It is here that the oboe player, after performing his soulful motive, slowly rises and leaves the stage. Later, we hear him again, the oboe muted, distant, and somehow reminiscent in feeling of the soprano's voice. The oboist's physical departure is essential here. It enables us to experience fully and cross-modally the illusion that voice reaches across the landscape with power to heal the terrible anguish of separation.

Then, after the last words of the poem are sung, the child comes onto the stage for the first time. The "ring" is now closed as the soprano walks toward him, and standing together in an exquisite cameo, they perform a series of wonderful, wordless sounds—a recapitulation of the first moments of the piece, but infused this time with shared serenity, joy, and resolution.

By the conclusion of *Ancient Voices of Children,* we have relived our own ancient cycles of symbiosis and separation-individuation. Associations, impressions, partially formed ideas flood consciousness. Through the process of searching within herself for her own "ancient" childhood, a mother may ultimately find her child in a new way. There must be death, but there is also regeneration. There is agony and yet love. The *uncanny* quality (Freud 1919) of the music fascinates and attracts us, inviting us to expand our sense of what music is and can be, just as it stretches and strengthens our sense of the open-ended possibilities of human relationship. Hearing this music with the insights into the dawning phases of human development that are provided by modern psychoanalytic theory, we may feel that the intense pleasure it affords us derives in no small measure from its power to awaken in us that archaic experiential world of infant and mother, duality and union, that lives on in the unconscious.

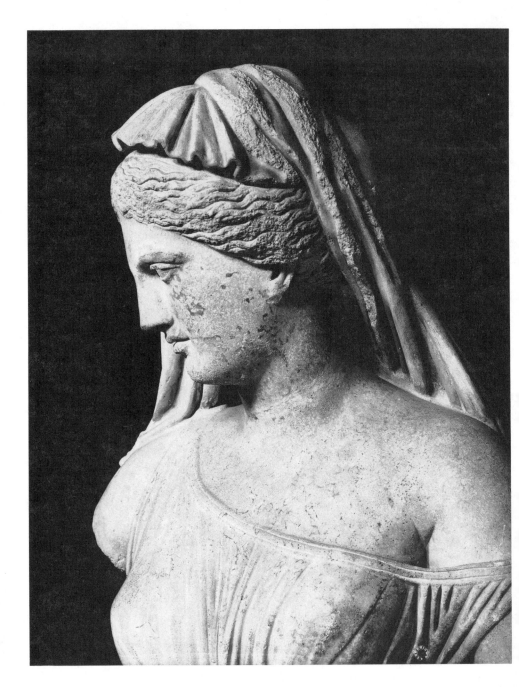

Figure 7.1. Farnese Melpomene (Muse of Tragedy) (A.D. first century).
Terme Museum, Rome. Photo cr.: Alinari/Art Resource, New York.

The Inescapability
of Tragedy

This short chapter grew in part out of my teaching of the
humanities in medical school settings—specifically of Greek
tragedy to psychiatrists, psychologists, and psychoanalysts both at
the Columbia Center for Psychoanalytic Training and Research
and at the New York Hospital–Cornell University Medical College
Department of Psychiatry, Westchester Division.

Symptoms, we hope, will succumb to the power of good clinical interpretation. Great myths and works of art, on the other hand, work the other way. Surprisingly, they thrive on interpretation. With it, they survive, flourish, and gain significance. Without it, they perish. Thus to participate in the tradition of interpreting tragedy and myth is to preserve that very tradition. At the same time, it is to recognize ourselves as inhabiting, with Freud, an inexorable afterlife of the classical epoch. Therefore we should cherish not only the contributions to this genre but also, and especially, the disparities among them, for it is precisely their variations in emphasis that keep the hermeneutic project in play.

As happens in the annals of scholarship, both because of and despite the so-called "anxiety of influence" (Bloom 1975), this chapter was sparked by a series of recent articles and books on the subject of Oedipus (Bettelheim 1982; Edmunds 1985; Leavy 1985; Loewald 1985; Michels 1986; Pollock and Ross 1988; Rudnytsky 1987; Segal 1978; Simon 1984). My emphasis here is on the ineluctability of tragedy in human life—a viewpoint that surfaces repeatedly in Freud's *oeuvre* and unites his own monumental achievement of psychoanalysis with that of his deeply valued predecessors, the literary tragedians of classical antiquity.

As embodied mind, the human being is trapped in contradiction, enmeshed in riddle and paradox, caught in a disquieting state that we struggle endlessly to evade through knowledge, revision, tran-

This chapter is reprinted with permission from *The Bulletin of the Menninger Clinic* 52 (5):377–382, copyright © 1988, The Menninger Foundation. I wish to express my indebtedness to Thomas E. Feigelson, whose senior essay (Yale University, 1984), inspired aspects of it and to Robert Michels, M.D. (1986) for his deeply suggestive meditations on Oedipus and insight.

scendence, and doomed efforts to reduce body to mind, or mind to body. This viewpoint, fundamental both to the Greeks and to psychoanalysis, gives rise to an interpretation of Oedipus that differs from some readings, especially those that deploy psychoanalytic theories of development and character pathology. I am referring to traditions of interpretation that hinge on what is taken to be the partiality of Oedipus' insight; for example, the notion that although Oedipus learns the terrible facts of his birth and faces the reality of his parricide and incest, he fails to come to grips with his character pathology—that is, with his impulsivity, his predisposition to narcissistic rage. Such interpretations, although persuasive and textually responsible, evade the essentially tragic nature of Oedipus' fate. They imply that somehow, with fuller knowledge, tragedy might have been (and, by implication, could be for all of us) averted.

When, on the other hand, interpretations emphasize the process of acquiring insight—which is, after all, the narrative thrust of Sophocles' play—rather than the nature or extent of any specific knowledge gained, they point directly to the ineluctability of tragedy. For, as the blind seer Teiresias warns, deep human knowledge not only cannot serve to evade, but must always be gained at the price of, suffering (likewise a central theme in the Judeo-Christian tradition).

I would suggest that, in part, interpretations that use notions of character pathology lean heavily, although perhaps unwittingly, on the critical tradition of *hamartia* often translated as "tragic flaw," which has been invoked, since Aristotle's *Poetics,* as an explanation for Oedipus' acts. However, from a more sophisticated psychoanalytic point of view that takes into account the history of criticism, this perspective may well be understood as having served an important defensive function. The notion of "tragic flaw" or character disorder serves, after all, as an "out"—a means of distancing both critic and spectator from the horror of the Oedipal tragedy. Surely to understand the defensive role played by this critical concept is to help explain its longevity and popularity.

My claim is that to attribute the crimes of Oedipus either to contingent contextual factors (such as his parental abandonment, mutilation, or failures in nurturance, cf., Bettelheim 1982; Rank 1914/1959) or to contingent character traits (Michels 1986) is to bypass, or at best to downplay, the central element of tragedy. The notion that somehow we can understand and account for behavior that Oedipus (and Sophocles) cannot is not only presumptuous but also betrays the very reasons for which Freud chose this story as the

cornerstone for his theory of psychic life. The mere fact that we, as audience, know what Sophocles' character does not is illustrative only of the principle of dramatic irony. It cannot explain tragedy— the essence of which lies in precisely its obverse. That is, the tragedy of Oedipus is exactly the inescapable reading of ourselves as spectators into his situation and plot (i.e., into his subjectivity) —a reading-in based on our own unconditional acceptance of his fate.

The often-overlooked point that Freud's version of the Oedipus story is but an interpretation of Sophocles' play *Oedipus the King* —which itself presents but a selection of elements from a complex myth—is, when noticed, sometimes compensated for in the literature of psychoanalytic criticism by the reintroduction of elements suppressed by both these texts. Generally, however, the factors reintroduced are only those drawn from the mythological *ancestry* of Oedipus and his early life history. However, to privilege these antecedents ought not to preclude a consideration of the rest of the myth nor of the other Theban plays—which, it can and should be argued, psychoanalytically, cast light backward on the preceding events.

Oedipus at Colonus, for example, was written by Sophocles at the age of 90 as a final commentary on the myth with which he had already struggled. In its central project—which is to establish the innocence of Oedipus—it clamors to be heard, to be readmitted (not banished) from the purview of such discussions. Even without a detailed analysis of *Oedipus at Colonus*, a point or two may serve to buttress my theme. (I should note that, although psychoanalytic studies of *Oedipus the King* abound, both *Antigone* and this final Theban play have escaped extensive psychoanalytic scrutiny; for valuable exceptions, see, however, Rudnytsky 1987).

First, however, I want to turn briefly to *Oedipus the King* and consider the climactic moment of self-blinding. To pursue more fully the implications of an elegant excursus on insight as a double metaphor (Michels 1986) and to apply what is developed there to the reading of this play, we might choose to explore the multivalent *symbolic* meaning of the self-blinding of Oedipus rather than emphasize only its impulsive, masochistic, self-punitive aspects. What the latter obscures is the triumphant element of this act—its meaning as a victory of self over self—a terrible conquest of Oedipus over his former, inward blindness. Whereas concrete, character-ological readings produce an Oedipus who has become, by the end of the play, a pitiful and maladapted figure, a failure, the symbolic

reading, on the other hand, preserves his stature as king, as tragic hero, and performs for us the uniquely tragic quality of the play.

I say "performs" here because to read the play symbolically is actually to replicate Oedipus' own process of self-discovery. It is to undergo the insight-acquiring process that leads him to self-knowledge. This process, however partial in its results, acquires significance precisely as inquiry and method rather than as end or product. And the character of this method of self-discovery is precisely that of symbolic reading conjoined with powerful rhetoric. Thus we as spectators are implicated rather than distanced. Only through such symbolic readings—that take as given both the innocence of Oedipus and his yoking of self-knowledge with pain—can we fully encounter this drama of self-discovery that opens on tragedy.

Oedipus at Colonus is Sophocles' final, radical revision of *Oedipus the King*—a mighty effort to establish beyond all question the essential innocence of his hero. Masterfully, this project develops through a series of scenes that mount progressively, like orchestral crescendi, to a climax in the final apotheosis and redemption of the aged king. In his famous speech to the vilifying and accusatory Creon ("O arrogance unashamed!"), Oedipus rehearses all the polemical arguments in favor of his innocence: He suffered against his will; his acts were ordained by fate; they were caused by the gods' pleasure due perhaps to some insult by his race before his time; they were the inevitable result of oracles and prophecies; he did not know whom he had killed at the crossroads; neither he nor Jocasta knew . . . ; and so on. Suddenly, however, in the midst of these arguments, he erupts into a burst of rhetoric that directly addresses the audience and draws us in. He almost literally forces us onto the tragic stage with him:

> Just answer me one thing [he asks]:
> If someone tried to kill you here and now,
> You righteous gentlemen, what would you do,
> Inquire first if the stranger was your father?
> Or would you not first try to defend yourself?
> I think that since you like to be alive
> You'd treat him as the threat required; not
> Look around for assurance that you were right.
> Well, that was the sort of danger I was in,
> Forced into it by the gods. My father's soul,
> Were it in earth, I know would bear me out.
> > *(Oedipus at Colonus* 11.991–999,
> > Grene and Lattimore 1954;124–125)

To experience this passage in the fullness of its power is to be brought face to face with the paradox and horror of the Oedipal tragedy. Conveyed doubly through its form (a rhetoric that compels self-consciousness) and content (the invocation of split consciousness), this doubleness sets up an ambivalence that we feel at each point of climax in the Theban plays—an uncanny sense of exhilaration and doom. Such a reading of Oedipus invokes not a particular father, not the flesh-and-blood Laius, but the dead father, the "father's soul." This invocation speaks to the fundamental issue here —that humankind is, from generation to generation, irrespective of particular circumstances, under subjection to the law of tragic misprizal, enactment, and pain.

In *Oedipus at Colonus*, the aged king, in a stunning series of reversals that betoken radical self-reinterpretation, curses and banishes his son, Polyneices, as he himself was formerly cursed and banished. Likewise, he abandons his daughters (to Theseus' care) as he himself was once abandoned (to the shepherd's or Polybus' care). Reading these cursings, banishings, and abandonings as a radically courageous, albeit destructive, reworking of Oedipus' own self-representations, we can reflect back on the blinding scene in *Oedipus the King*. From the vantage point of the latter play, it seems even more valid to take this act likewise as symbolic—as a deed of radical self-revision and reinterpretation rather than merely of maladaptive self-mutilation.

That self-knowledge is bought, inevitably, at the price of self-destruction is tragedy. That it is vindicated and universalized is the message that comes at the end of the Oedipus myth, where blindness is transformed into a mysterious, ineffable, and forbidden sight —a phenomenon that those of us in the psychoanalytic world may wish to contemplate. For in my view, a sensitive and persuasive interpretation of this final scene has yet to be written.

Figure 8.1. Head of Demeter (sixth century B.C.).
Greek. Terracotta. Freud Museum, London.

Mothers
and Daughters

Ancient and Modern Myths

While I gazed one afternoon at a photo of a small terracotta head of Demeter from the Sigmund Freud antiquities collection, it occurred to me that psychoanalysis has tended, in its discussions of entanglements between women, to weight negative aspects— recalcitrant guilt, envy, and rage. This chapter seeks to redistribute that balance by adding to the scales a goodly measure of the strength that derives from female-to-female intergenerational bonding. The following pages are dedicated to one regal grandmother, two wise daughters, a stepmother who never quite realized that she had become a real mother, and a very real mother who died too young but whose articulate voice can still be heard, softly modulated, throughout these pages.

As ivy clings to oak will I clasp her.

—Euripides, *Hecuba*

Inspired by a small head of Demeter in Sigmund Freud's collection of antiquities, the following pages offer a "thematic" reading (Spitz 1985) of the ancient myth of Demeter and Persephone with the interpolation of selected texts of contemporary fiction that also foreground the relations between mothers and daughters. These include: *The Joy Luck Club* by Amy Tan (1989), *Annie John* by Jamaica Kincaid (1983), *Lovingkindness* by Anne Roiphe (1987), *A Raisin in the Sun* by Lorraine Hansberry (1959/1987), and *The Shawl* by Cynthia Ozick (1989). These texts were authored by women of varied racial and ethnic backgrounds, and my aim here is in no way to flatten out the many differences between them nor between them and the ancient texts in which the Demeter/Persephone myth is inscribed. Rather, I have created a bricolage, an intertext, that not only *uses* but also occasionally *challenges* psychoanalysis, art always being, as Freud (1907) said, in the avant garde of theory, rather than the other way around, raising more questions than it answers.

Freud, having read Ovid, clearly knew the story of Demeter and Persephone at least in its Latin version. Yet, although in all its

A version of this chapter was read to the Washington Society for Psychoanalytic Psychology in September 1989. Several sections, in an earlier version, appeared as "Psychoanalysis and the Legacies of Antiquity," in *Freud and Art: His Personal Collection of Antiquities*, Lynn Gamwell and Richard Wells, eds. (New York: Abrams, 1989). It will also appear in *The Journal of Aesthetics and Art Criticism* (1990), vol. 48, no. 4. Grateful acknowledgment of support is due to the Fund for Psychoanalytic Research of the American Psychoanalytic Association and to the Getty Center for the History of Art and the Humanities.

For their generous and insightful readings, I wish to thank Professors Mary Ann Caws and Helene P. Foley. For valuable discussions that contributed to earlier versions, I wish to thank Professor Marilyn Arthur, Dr. Muriel Gold Morris, Dr. Ruth F. Lax, Dr. Helen Abramowicz, Joanna B. Strauss, C.S.W., and Lisa Burkhalter of the Getty Center for the History of Art and the Humanities.

forms it addresses the theme of mother-daughter relations—which Freud eventually came to recognize as central to female development, for he asked in 1931, "What does the little girl require of her mother?"—he never chose to interrogate this exemplary myth in terms of his own important question. His scattered references to it curiously bypass its central motif. He refers to Demeter only with regard to an incident that occurs in her daughter's absence (1916) and to Persephone with no mention of her relationship to her mother (1913). Freud's failure to address the bond between the two women —which is the subject of the myth—suggests that it may yet prove a rich source for the current psychoanalytic exploration of this theme. In this spirit, I offer the following retelling, an amalgam and an abridgement, which draws on two principal sources—the ancient Greek Homeric *Hymn to Demeter* and Ovid's tale, "Calliope tells of the rape of Proserpine," from the *Metamorphoses*.

In relating a mother's search for her lost daughter, the story of Demeter and Persephone gives priority to one role, namely, that of the mother, over that of the daughter. Yet, its fabric importantly suggests that daughter and mother are *one* and that their experiences both reciprocate and replicate each other. This is a point that pervades Amy Tan's recent best-selling novel, *The Joy Luck Club* (1989), which is dedicated "To my mother/ and the memory of her mother." A finely brocaded work, this text explores spatiotemporal and cultural continuities and disjunctions between four sets of Chinese-American mothers and daughters, and it offers a moment when one daughter, still a young child, suddenly reencounters the all-but-forgotten mother who had been wrenched from her in her earliest childhood. Despite the years of separation, however, this mother proves to be no stranger. At the moment of meeting, An-Mei Hsu, trying to recapture it years later for her own daughter Rose, says: "I tried to keep very still but my heart felt like crickets scratching to get out of a cage. My mother must have heard [in other words, heard *into* the little girl's heart], because she looked up. And when she did, *I saw my own face looking back at me.*" (p. 45, my italics) Later, this same character An-Mei Hsu describes, again for the benefit of her own daughter, a scene in which she watched transfixed as her mother took a knife and cut a piece of flesh out of her arm and, bleeding and crying, put it into a soup to feed to her own aged, dying mother in a desperate attempt to prolong her ebbing life.

This focus on the immediacy, intensity, and physicality of iden-

tifications is central also to Jamaica Kincaid's *Annie John*, where the title character, growing up on the island of Antigua in the Caribbean, describes her discordant, indissoluble bond with a mother who has exactly the same name as her own:

> Something I could not name just came over us, and suddenly I had never loved anyone so or hated anyone so. But to say hate —what did I mean by that? Before, if I hated someone I simply wished the person dead. But I couldn't wish my *mother* dead. If my *mother* died, what would become of *me?* I couldn't imagine my life without her. Worse than that, if my *mother* died *I* would have to die, too, and even less than I could imagine my mother dead could I imagine *myself* dead." (Kincaid 1983, my *emphasis*)

Such passages, besides scoring deep and ambivalent congruities, also connect, as does the Demeter-Persephone myth, the theme of death with that of the mother–daughter relation—a link with many layers of meaning to which we shall return.

Demeter, goddess of fertility and the harvest, thus a *mother* par excellence, adores her beautiful daughter Persephone who, while gathering flowers with other young girls in an idyllic landscape, plucks a fateful narcissus. This detail, the narcissus flower, is of interest because it recalls another comparable and contrasting myth that also juxtaposes death and sexuality—namely, that of an ill-fated male adolescent, the youthful Narcissus who fell in love with his own reflection in the water and thereby perished. Thus the flower may be seen as emblematic of self-involvement, of the girl's pleasure in her own loveliness, but also, perhaps, of her desire to *add* something to it. In evoking its namesake, it alludes both to convergences and to discontinuities between the bodily and developmental experiences of the genders.

According to the text, this sweet-smelling flower, the narcissus, is placed before Persephone as a lure by her father Zeus on behalf of his brother Hades, god of the underworld, who had seen the girl playing and developed a passion for her. As Persephone plucks the flower, the earth gapes open, and grim Hades appears in his golden chariot (the Homeric *Hymn*) drawn by deathless horses. Panic-stricken, the young girl cries out to her mother (Ovid) and to her father (the Homeric *Hymn*) to save her. Her entreaties are in vain. Zeus, merely a regal figurehead here, maintains his distance from her throughout the story, and, by staging her ravishment, may in

fact be seen as enacting by proxy his own incestuous wishes toward her. Never is he portrayed as having direct contact with her; her entire filiation is bound up with her mother.

Thus, on this "oedipal" level, the plot follows the paradigm articulated by Lévi-Strauss (1969) who, in addition to analyzing the structures of myth, theorized kinship as casting women in the role of a medium of exchange between men—a perspective that Freud himself did not precisely adopt but which might have served him well. (In the "Dora" case, as has been much remarked, his lack of attention to this dimension of the material caused him to become in fact one of the very men among whom Dora was passed. (See *In Dora's Case*, Bernheimer and Kahane 1985.)

For our purposes here, therefore, it is worthwhile to consider— but to *resist overemphasizing*—the implicitly triadic structure of the mother–daughter relation. Clearly, initiation into heterosexual relations comes in this myth by means of trickery, violence, and betrayal by the father. But interestingly, this betrayal is considered as such *only* from the point of view of women. In Ovid, Zeus (or Jupiter as he is there called) protests Demeter's complaints that their child has been pirated. He claims, on the contrary, that his brother's deed "was no crime, but an act of love" (p. 130), and he staunchly upholds the lord of the underworld as a fitting husband for her. (For a further political interpretation, see Clay, 1989.) According to him, even if Hades has no other qualities to recommend him, he is still, after all, a brother! Thus, the father rationalizes and reveals, possibly, his own vicarious pleasure in colluding with the scene of sexual violence.

Demeter's response to Persephone's disappearance has, on the other hand, elements of both narcissistic and object loss: she becomes by turns sorrowful, depressed, and bitterly indignant. Wandering over land and sea in an effort to discover the whereabouts of her beloved child, she enacts a sequence that uncannily prefigures the stages of mourning and melancholia Freud outlined in 1917. Turning aggression inward, she tears the covering on her hair, refuses both food and drink, and ceases to bathe. This self-destructive behavior continues, fascinatingly, for precisely nine days—thus, symbolically, she replicates and magically undoes the nine months of her pregnancy. Upon learning finally that Zeus was party to the rape, her grief reaches fever pitch. Cutting herself off from all company of the gods, disfiguring herself, she assumes the appearance of a decrepit old woman whose childbearing years are over.

Shortly after this, in the course of her wanderings, however, she

manages to "adopt," as it were, another woman's child. Partly to deny her loss and symbolically to recover Persephone, she "becomes" a mother again. Yet the child this time is a boy, and the incident has disturbing overtones. That a male child is chosen for the replacement suggests that Demeter, having once been forsaken by a daughter, must now ward off repetition of that loss by acquiring a new child of the opposite sex. She "steals" him, as it were, from his own mother. By breathing on him, clasping him to her bosom, and placing him each night in a fire in order to turn him into a god, she seeks utterly to possess him—and thus to separate him irrevocably from his own mother. In this way, under the guise of beneficence, she gives rein to aggression. Turning passive into active, she relives her own trauma in reverse by inflicting it on another woman. Furthermore, she attempts to acquire a divine male child who can attack the father (Clay, 1989).

Ovid, in his more florid Roman style, also dramatizes this cameo. Here, we find Demeter given a sweet barley drink by a woman who takes pity on her in her grief. When, however, this woman's young son taunts the goddess with being greedy (a suggestive detail), Demeter turns upon the boy and, enraged at his insult, rewards his mother's kindness to her by hurling the drink into the child's face, thereby setting off in him a grotesque metamorphosis. As his mother watches in horror, her child's skin puckers, spots develop, and legs sprout on him where arms had once been. As she reaches out to touch him, he shrivels up into the form of a loathsome lizard and slithers away to hide, leaving her to tears of grief and astonishment. Thus, here too, Demeter causes another mother to suffer a loss comparable to her own.

It is possible as well to read this incident as revealing by displacement the depths of Demeter's unacknowledged ambivalence toward Persephone—not only, on the oedipal level, her jealousy toward the girl as the (incestuously) preferred object of the father and her envy for her "flowering," her burgeoning fertility, but also, on a deeper level, Demeter's wish to appropriate unto herself *all* the prerogatives of motherhood. On this reading, the boy child, arriving on scene subsequent to Persephone's abduction, can be seen as representing in Demeter's fantasy her own daughter's future child—a child whom she wishes to appropriate and possess. Furthermore, this boy child may, it has been suggested, represent to her the treacherous male world that has so recently betrayed her (Arthur 1977).

The intensity of Demeter's commingled sexuality and aggression

toward this "new child" are, however, spied out by the boy's real mother, and a confrontation between the two women occurs. This is the sole moment in the narrative where any aggression *between women* is represented. Direct relations between mother and daughter are, as we have seen, portrayed *only* as loving while aggression is projected outward on to the predatory males. Here, however, in the frame within the frame, a catalytic moment of open anger toward another woman seems to release Demeter from her depression (Arthur 1977). She now reveals herself in all her glory as a mighty goddess and, rejecting the substitute child, simultaneously throws off her melancholy disguise. "Thrusting old age away from her," goes the text, "beauty spread round about her and a lovely fragrance was wafted from her sweet-smelling robes . . . golden tresses spread down over her shoulders" (Homeric *Hymn*, p. 309).

Vehemently now, having regained her royal status, she redirects her wrath outward. In order to punish Zeus, she plays power games with him by withholding her fertility. Permitting nothing to grow on earth, scourging the land with a cruel famine, she coerces him finally into returning Persephone to her. Meanwhile, the girl, pining for her mother among the dark shades of the dead, rejoices when Hermes descends, at the bidding of Zeus, to rescue her. Hades, however, has managed meanwhile to slip some pomegranate seeds into her mouth, the pomegranate being (among its many meanings) redolent of heterosexual union with its seeds and blood-red juice; thus, furtively, he has bound her to him forever.

The myth, as is well known, is resolved by compromise: Partially restored to Demeter, Persephone, because she has tasted the fruit, cannot fully sever her ties to her husband. According to different versions, she spends two thirds or one half of the year with Demeter and the other half or third in Hades. During the seasons when mother and daughter are reunited, they are portrayed as radiantly happy, and the earth regains its fertility: "So did they then, with hearts at one, greatly cheer each other's soul and spirit with many an embrace: their hearts had relief from their griefs while each took and gave back joyousness" (Homeric *Hymn*, p. 321). By contrast, when Persephone returns to Hades, "her expression and temperament change instantly: [she becomes] so melancholy as to seem sad to Dis [Hades] himself" (Ovid, p. 131); while, in spite of this, she reigns as honored Queen of the Dead.

One further detail must not be allowed to escape notice: Final reconciliation between daughter, mother, and Olympian Zeus is brought about through the agency of another goddess, Rhea, the

mother of Demeter and grandmother of Persephone. Rhea's role is to ask her daughter to forgive her husband and to return with her to him and to the other gods at Olympus. For Demeter to acquiesce in this request, therefore, is to obey her own mother. Appearing thus as a crucial agent at the very end of the story, Rhea represents the fertility of the previous generation. Her presence bears special meaning for our theme because it marks a crucial axis of the myth —namely, a powerful matriarchal lineage—an axis of *intergenerational gendered bonding*—a line that may, in fact, be read as *the spine of the story*, etched fossil-like into the softer ground surrounding it. It is a line, moreover, that may easily escape those focused only on an oedipal reading.

It is the selfsame line, however, evoked by Amy Tan, when she writes as follows in the persona of her character An Mei Hsu: "even though I taught my daughter the opposite, still she came out the same way! Maybe it is because she was born to me and she was born a girl. And I was born to my mother and I was born a girl. All of us are like stairs, one step after another, going up and down, but all going the same way" (1989:215). This wonderful, only apparently paradoxical image from *The Joy Luck Club* uncannily conveys the repetitive perpendicularity of Persephone's movements as she mounts and descends between Hades and Demeter, the worlds of darkness and of light.

This power of a mother's mother over both death and life and her sudden appearance as "dea ex machina" at the end of the myth is a feature also of *Annie John*, where, late in the action, the young protagonist, now entering adolescence, falls ill with a malady that responds neither to conventional nor to island remedies. Unexpectedly, yet as if fated, her grandmother materializes magically from the neighboring island of Dominica and remains with her own daughter and granddaughter on Antigua until the child's recovery is secure: "[she] would come into my bed with me and stay until I was myself . . . again. I would lie on my side, curled up like a little comma, and [the grandmother] would lie next to me, curled up like a bigger comma, into which I fit" (pp. 125,126).

Many questions come to mind at this point, and, as with all art and myth, psychologically valid interpretations may logically contradict one another. How might these texts both illuminate and complicate Freud's own question as to what a little girl requires of her mother (and vice-versa)? Does the ancient story represent or teach

us anything about what we have come to call normal or pathological relations between a mother and a daughter? Does it offer some layering and combination of these? In celebrating the enduring power of the mother–daughter bond at the apparent expense of joyful heterosexuality, does it endorse its own solution or express wishes and fears—or fears of wishes and denials of fears? Precisely what wishes and fears are at stake? What developmental levels of fantasy are addressed? Does the myth correspond to female or to male fantasies or to both? The aggressive bridegroom figures clinically, for example, in dreams of both genders, and the fear of doing or experiencing damage in the act of intercourse is pervasive.

In order to focus on the mother–daughter dyad, the myth, as we have seen, relegates its male characters to the periphery, and this is likewise a feature of contemporary novels that treat the mother–daughter theme. Take, for example, Anne Roiphe's recent *roman à lettres, Lovingkindness* (1987). Here, a feminist scholar with a name strangely similar to Jamaica Kincaid's heroine (she is called Annie Johnson) struggles with herself over her mothering of a twenty-two-year-old daughter, Andrea, who, when the book begins, has not communicated with her mother for five months. Ideology and intellectualism have long served defensively to hide from this mother her own failure to provide boundaries for a child who now, after years of wild, self-destructive behavior, has suddenly telephoned collect from Jerusalem to announce that she is embracing a new lifestyle, namely, that of ultra-orthodox Judaism. This choice on her part represents, of course, a rebellious repudiation of her mother's feminist principles, but it also betokens a deeper need—an urgent need for external limits and values that might compensate adaptively for intrapsychic structures that have never fully developed. Fascinating here is the paradox that, because on a deep level, this mother and daughter *are* importantly connected (as is Annie Johnson with her own ambivalently devalued mother), Andrea's rejection of Annie's manifest (feminist) credo is precisely what makes possible at some point in the future (beyond the text of the novel) an identification of the two women *as mothers*. Such an intimation is made explicit by Annie's fantasy in the closing paragraphs that she will one day have a granddaughter who will come from Israel to visit her: a *granddaughter*.

Early on in this book, however, the husband and father of Annie and Andrea is summarily introduced and immediately eliminated. Described as an ineffectual character, he walks out of a penthouse

window in a state of extreme inebriation, and, although his ambiguous, surreal demise continues to haunt the text, it works strategically to free the author to treat mother and daughter exclusively as a dyad. Similarly, *Annie John*, while not eliminating its husband/father character totally, relegates him to a clearly subordinate status. Described as shorter than the mother physically, he is of decidedly lesser stature than she in the eyes of their preadolescent daughter and plays only a minor role in her life. In her words: "When my eyes rested on my father, I didn't think very much of the way he looked. But when my eyes rested on my mother, I found her beautiful" (p. 18).

Likewise, the death of Lena's husband occurs before any action takes place in Lorraine Hansberry's play, *A Raisin in the Sun* (1959), which is dedicated "To Mama: in gratitude for the dream." The absence of the husband and father here leaves the stage open at the end of Scene One for a uniquely powerful moment in American theater:

Beneatha, fiercely independent, headstrong, and twenty, having just treated her mother to a typical adolescent barrage on her inalienable right to express herself, culminates with the statement: "God is just one idea I don't accept" (p. 51).

The ensuing stage directions read:

> (MAMA *absorbs this speech, studies her daughter and rises slowly and crosses to Beneatha and slaps her powerfully across the face. After, there is only silence and the daughter drops her eyes from her mother's face, and Mama is very tall before her.*)
> MAMA: Now—you say after me, in my mother's house there is still God. . . . *In my mother's house* there is still God. (1988: 51, my emphasis)

Well-acted, this scene conveys the sheer weight of ongoing maternal presence as it shapes the consciousness of a daughter. With keen insight, Lorraine Hansberry crafts Lena's contrasting behavior toward Beneatha and toward her son Walter Lee. Innately in tune with the headstrong young premed student who is obviously a second edition of herself, Lena readily guides, disciplines, supports *and opposes* her; she knows she can count on Beneatha's strength, just as she can count on her own. With Walter Lee, on the other hand, her interventions falter and misfire, and she comes only painfully, and after loss, to a rapprochement with him.

In marginalizing triadic elements, therefore, both the Demeter-

Persephone myth and its modern counterparts force us to recognize the power of *gendered sameness* and of biology—to see, in other words, that, because the girl *is* a second edition of her mother, their object relations are deeply structured by this sameness. Brilliantly, the ancient myth evokes this bodily identification through its cyclical content and its solution—which takes the changing and repeating seasons of the year as a figure for the periodicity of the female reproductive system.

Washing, water, and the female body figure prominently in both ancient and modern myth. Persephone is pictured near a deep lake of gliding waters (Ovid, p. 126) "playing with the deep-bosomed daughters of Oceanus" (Homeric *Hymn*, p. 289) when she is abducted; as we have seen, Demeter refuses to bathe when she realizes she has lost her child; she searches over the seas; and (in Ovid) she learns the truth of Persephone's ravishment from a water nymph who has been changed into the water of her own sacred pool. All the contemporary novels cited here take ocean as a metaphor for psychological distance between mothers and daughters (in *The Joy Luck Club*, it is the Pacific; in *Lovingkindness*, the Atlantic; and in *Annie John* it is both the Caribbean Sea and the Atlantic), and dreamlike mother–daughter scenes of bathing and swimming are likewise featured. In each of these instances, external waters serve both to connect and to divide the women—and thus they serve as metaphors for the inner amniotic waters that originally united and divided the pair.

"My mother and I often took a bath together," writes Jamaica Kincaid in the mesmerizing voice of her young Antiguan heroine.

> Sometimes it was just a plain bath, which didn't take very long. Other times, it was a special bath in which the barks and flowers of many different trees, together with all sorts of oils, were boiled in the same caldron. We would then sit in this bath in a darkened room with a strange-smelling candle burning away. As we sat in this bath, my mother would bathe different parts of my body; then she would do the same to herself. (Kincaid 1983: 14)

Anne Roiphe begins a passage, "I had been named Annie after my dead grandmother, Ann. My grandmother's picture was in a jade frame near my mother's bed" (p. 20). Thus, she evokes the presence of a matriarchal lineage that itself becomes the frame for a scene in which her protagonist, as a little girl, sits waiting outside her mother's bedroom for her to wake up:

I would lie on the carpet and put my face next to the crack at the bottom of the door. . . . I could stay in that position a long time. . . . I learned how to float with time as if on a raft in a becalmed sea. My mother's late sleeping habit had the effect of teaching me how to lie like a lizard waiting for a passing fly. It also taught me how to love through a closed door. (p. 22)

Not insignificantly, as we have seen, this same little girl grows up to become a mother who, when *her* own daughter loves *her* through a closed door (by not communicating, for example, for months at a time or by loving through the closed doors of the Yeshiva Rachel), she struggles intellectually to make it somehow all right. The text continues: "Sometimes [my mother] would let me in the bathroom with her. I would sit on the toilet as she soaped in the tub. A small woman with soft folds all over her body" (p. 23).

This passage, by juxtaposing images of grandmother, mother and daughter with a small girl's feelings of loneliness and ambivalent attachment and the physical intimacy of beholding the mother's naked body (which is, of course, a future version of her own body), overlaid with the rich metaphor of the bath, when read alongside other, similar passages from related texts, seems to tap a kind of organic memory (figure 8.2).

And, finally, from *Annie John*, a section that seems designed to tell Persephone's side of the ancient myth:

The only way I could go into the water was if I was on my mother's back, my arms clasped tightly around her neck. . . . It was only then that I could forget how big the sea was, how far down the bottom could be. . . . When we swam around in this way, I would think how much we were like the pictures of sea mammals I had seen, my mother and I, naked in the seawater. (p. 42)

The passage goes on to describe the mother swimming by herself, leaving the little girl to play and watch on shore. Suddenly, however, the child realizes in terror that she has lost sight of her mother:

My eyes searched the small area of water where she should have been, but I couldn't find her. I stood up and started to call out her name, but no sound would come out of my throat. A huge black space then opened up in front of me and I fell inside it. I couldn't see what was in front of me and I couldn't hear anything around me. I couldn't think of anything except that *my mother was no longer near me.* (p. 43; my emphasis)

This episode, virtually a rewrite of Demeter's mythic loss and separation but from the daughter's viewpoint, ends, as does its prototype, with a reunion that is only partial and with a permanent rift having opened up between mother and daughter. Interestingly, it is at this point that fantasies of *mother and father together* emerge in the text, as do similar fantasies after the comparable bathing passage in Roiphe.

One of the points I wish to stress here is that psychoanalytic theory, by structuring the relationships between women so exclusively around the pivotal figure of a male (or, in some accounts, the male organ) desired by both women (i.e., the oedipal paradigm: mother and daughter vying for the attentions of a husband/father), has tended to miss and to dismiss the intense, ongoing intergenerational relations among women inscribed by the texts I have quoted here—texts written within the past thirty years by gifted women both of color and of varied cultural background. Each of these texts, by temporarily assigning its male characters to the background or the wings, forces its readers to gaze fixedly and not without discomfort at the female-to-female bond *as a primary structure* placed stage-center and under bright lights.

Classical psychoanalytic theory has posited the little girl as necessarily turning *away* from her mother. While acknowledging the intensity of early ties, Freud (1931) states: "[the girl's] attachment is forced away from her mother" (p. 235); "the turning away from her mother is an extremely important step in the course of a girl's development" (p. 239); "the attachment to the mother is bound to perish" (p. 234). Our texts, however, indicate that daughter and mother, on the contrary, continue to search for each other throughout their lifetimes.

Current psychoanalytic literature (e.g., Herman 1989), while it does not deny "the centrality of the girl's long dependence on the mother," frequently characterizes it with extreme negativity and expatiates on its "tenacity," "difficulty," "hostility," and "sadism" (Dahl 1989). Its accounts, frequently drawn from the associations of patients who have had "deeply unsatisfying relationship[s] with their actual mother[s] . . . in which the daughter experienced her mother as withholding or withdrawn and as hostile and destructive . . . [yet] found herself, to her continual unpleasant surprise, still seeking her mother's love and approval" (Dahl 1989: 268; see also Young-Bruehl [1989], who writes fascinatingly about her search for Anna Freud's mother), tend occasionally to disregard the rich preserves of strength, wisdom, self-affirmation, and challenge that in-

Figure 8.2. Harry Callahan, *Eleanor and Barbara, Chicago* (1954).
Gelatin silver print 6 15/16 x 6 13/16 in. J. Paul Getty Museum.

here in the mother–daughter relation—qualities which, however, in some case histories, are transferred to the patient's new relationship with a female analyst. Without hope, without promise, however, no conflict can maintain its claim; thus, paradoxically, it is precisely the image of good mother–daughter relations (inscribed on one level of reading by the Demeter-Persephone myth) that keeps both conflict and communication in play.

Fortunately adult women, both growing and aging, and young girls in various stages of development can and do cherish ongoing meaningful relations with each other while simultaneously nurturing precious ties to fathers, brothers, male lovers, husbands, and sons. The Demeter-Persephone myth, however, in dramatizing its version of this state of things, ends *manifestly* in a compromise, but in fact offers a stark either/or solution that can be seen as the simple inverse of the classic psychoanalytic position, which, in its most extreme form, seems equally stark.

Whereas the latter has tended to conceptualize the mother–daughter bond as archaic and atavistic, a stage in female development that must be superseded and "left behind"; the myth, on the other hand, portrays it (manifestly) as ongoing but uncomplicated, as thoroughly tender, loving, and fulfilling. Neither view is adequate, for, as our rich literary texts teach, the bond can be understood neither *only* as a positive source of continuing strength *nor only* as a regressive pull or unpleasant site of conflict throughout the individual life history of women. In fact, it is all of the above.

Dreading her loss of self and of object, a mother goes, as we have seen, in search of a daughter whom she must keep. What does this mean? At what price is Persephone rescued from Hades and returned to earth? An all-too-obvious psychoanalytic reading might cast Demeter as an omnipotent *preoedipal* mother, more powerful than all males, or perhaps a narcissistic mother who, under the pretext of salvation, sacrifices her child in order to maintain hegemony and control (see Miller 1981).

On this reading, Persephone reverts to her mother merely to gratify the latter's need. Not only barred from achieving loving heterosexual relations, she does not within the mythic narrative become herself a (biological) mother. On this moot point, it is possible however to privilege the allegorical nature of the text and interpret Persephone's participation each spring in the refertilization of the earth as a species of symbolic motherhood. In any case, the negative reading offers us a Demeter who only superficially

rescues a cherished and victimized child; in fact, she herself becomes the victimizer, using and abusing her daughter for her own ends. By retrieving Persephone and taking her once again to her bosom, she asserts her eternal and *exclusive* prerogative to *be the mother*. (One conjures images here of little girls "playing house," vying with one another as to who will "be the mother.")

To interpret thus, however, is to do so *against the grain* of the manifest content and tone of the myth. It is to deny the fact that Persephone's initiation into heterosexuality comes via rape and perhaps even weakly disguised incest and to misprise the very mood and language of the originary texts, which clearly exalt the symmetry, mutuality, and tenderness of the mother-daughter bond. Idealization may, however, serve to defend against underlying pathology, and so-called "unconflicted" love cover a tragic inability to separate.

What all these texts teach, however, is that on some level mother and daughter *do not and cannot ever separate*. Rather, they portray deeply felt needs for maintaining ties that the changing conditions of social reality have not significantly altered. Clinical evidence, moreover, reveals that women require not only stable maternal introjects but ongoing contact with primary maternal objects—especially at moments associated with fertility—at menarche, marriage, pregnancy, birth, and the nurturance of children.

The ancient myth, which tells its story manifestly from the mother's side, stresses Demeter's desire to be available as an ongoing presence in Persephone's life, to play an active role and to foster identifications between her daughter and herself, but this is equally true in reverse. It relates the suffering attendant upon their inevitable separations and the gradual acceptance of changes in their relationship. Mothers and daughters who reestablish rapport after the discord of adolescence stand to discover more fully their own unique capacities for nurturance—a point underscored in the myth by the presence in the end of the grandmother, as well as by the closing pages of Anne Roiphe's book where, as we have seen, the mother becomes in fantasy a grandmother herself.

Cynthia Ozick, interviewed recently on the subject of her tragic masterpiece, *The Shawl* (1989), a savage tale of a mother who survives at the price of sanity the murder of her infant daughter in a Polish concentration camp, recalled the memory of her own grandmother. In trying to answer the interviewer's questions about why she, an author who never experienced the Holocaust, chooses to write about it, she evoked an image of her grandmother "weeping

and beating her breast" upon learning of the British White Paper in 1939 (an act that cut off, for German Jews, all hope of escape from the Nazi terror). " 'Maybe I was born to be a witness,' she said. 'I got it from my grandmother. I grew up always as a witness.' " (Bernstein, *New York Times,* 10/3/89).

While the ancient myth associates youthful innocence in an enclosed female space with playfulness and freedom from care, marriage, on the other hand—in the form of Hades—is equated with brutality and death. For Persephone, the joys of marriage and heterosexual love are apparently absent. Despite her restoration to mother, her sacrifice continues, and she fails, as queen of another realm, to establish a satisfying existence there. This dark parallelism of nuptials and death evokes other Greek legends inscribed in the tragedies, such as that of Sophocles' Antigone, who, as she is led to her death in the cave, is said to be "marry[ing] somebody in Hades," and Euripides' Iphigenia, the pitiable daughter of Agamemnon and Clytemnestra, whose father, after agreeing to have her throat cut so that the winds may blow and the ships set sail for Troy, laments that Hades will marry her before long.

Thus, *sacrifice, marriage, and death* are interwoven if not equated in ancient Greek culture (Loraux 1987), and shards of such beliefs continue even in our time to appear in fantasies and to deform the feminine psyche. Fed by pervasive visual and literary tropes, and simultaneously denied by overidealization in the form of other widespread myths exemplified by such tales as "Sleeping Beauty" and "Cinderella," where to marry is "to live happily ever after," they deserve to be more widely addressed by contemporary clinical writing on women's anxieties and conflicts.

It would be inaccurate to say that Freud evinced no interest in these complexities. Yet, despite his many references to Greek culture, his theoretical attention remained riveted on the towering figure of Oedipus whose tale, he firmly believed, could stand alone as a paradigm to which all others—even when the protagonists were female—could be referred if not reduced (Freud 1913). We have seen here, however, that the image of Demeter, mythical mother, symbol of the harvest, wandering land and sea in search of her daughter (who is also herself), offers another paradigm that cannot be mapped directly onto or equated with the Oedipus myth.

Among the prominent motifs that have emerged in this chapter are: first, the deep bodily identification of mother and daughter—

which weaves a cord between them that, though it may at times rip or fray in both pain and anger, can never be completely broken; second, the importance to a woman of becoming, being, and remaining a mother (a desire that may, in contemporary culture, find many diverse paths of sublimation); third, the wish to possess in perpetuity the power conferred by this role, a power that then encompasses in fantasy both birth and death, which are, in the unconscious, equated (here, on the subject of motherhood and death, I wish to quote a passage by Cynthia Ozick, who writes in *The Shawl*, "Motherhood—I've always known this—is a profound distraction from philosophy, and all philosophy is rooted in suffering over the passage of time. I mean the *fact* of motherhood, the physiological fact. To have the power to create another human being, to be the instrument of such a mystery" [p. 41]—is thus to triumph over death); fourth, a recognition of a mourning process on the part of both mother and daughter as they experience the inevitable changes in their relationship; and finally, the significance of intergenerational gendered bonding, of a matrilineal filiation, which deeply etches itself into the lives of women and affects them in ways underexplored by psychoanalysis and structuralism, theories content for so many years to construe women as a variant on, as complementary to, opposite of, even occasionally as inferior to, the male as both model and norm.

Thus, to ponder the myth of Demeter and Persephone in the light of recent literature by and about women is to grasp its significance, longevity, and power and to open rich possibilities for the further elaboration of feminine psychology.

One classicist (Burkert 1979) writes of the myth as encompassing a circularity, a self-containedness that excludes man, and by this, he of course means *mankind* as opposed to the *gods*. But the interpretation of gender works as well. Demeter and Persephone being doubles, mother and maiden, each contains the other within herself. Descending and retreating, the tale moves within a closed system, like the generative earth, with man ploughing and playing in it a crucial rather than a central role.

In closing, I wish to share a more general reflection: Psychoanalysis is a study not merely of the ways in which the past constructs the present but of the ways in which the present constructs the past. As such, it offers hypotheses rather than conclusions. Its hypotheses, however, exactly like the great myths, have power to exert far-reaching influence over human lives, both now and in the future. For this, each one of us who works with its ideas must take

serious responsibility, and to do so fully means not only to "use" theory but to reflect critically on it, to continue to reinterpret it, to be able both to understand and to imagine alternatives—to exercise that freedom of mind, that openness to possibility which, as I have tried to demonstrate here, is fostered by our contact with the very real, invented worlds of the arts.

Cat. No. 12, detail, p. 16.

Figure 9.1. Pentheus and the maenads attributed to Douris (as painter),
Red Figure cup (c. 480 B.C.)
Collection of Elie Borowski.

Meditations on the Smile of Dionysus

Representations of Perverse Fantasy in Euripides' *Bacchae*

Inspired by an unforgettable performance of the *Bacchae,* this chapter analyzes that masterpiece of Euripidean theater in terms of its construction and deconstruction of perverse imagery. In autumn 1980, an English version of the play was presented in New York at the Circle in the Square, with Irene Papas in the role of Agave. Onstage throughout, a great bronzed disk caught and reflected the lights. Continuously in view, it glowed, glowered, leered, grinned, and grimaced at both audience and players. Seductive and unsettling, its haunting presence seemed to blur comedy and tragedy. Meant perhaps as an amalgam of the two suns over Thebes, it seemed to figure the diabolical smiling mask of Dionysus.

Go, O Bacchus . . .
with smiling face cast your noose;
under the deadly herd
of maenads let him fall!

—Euripides, *Bacchae*, lines 1020–1022

Tragedy, like therapy, has to do with the project of attempting to wrest meaning from the ambiguities, arbitrariness, and devastation of human life. Thus, it seems worthwhile to retell its tales and to reinterpret them in each generation according to changing priorities and frames of reference (see Segal, 1982, 1986; Simon, 1978, 1988; Spitz, 1989). Just as the dramas of the ancient Greeks inspired Freud in his day (see Rudnytsky 1987), so they continue to retain and possess an enduring power to enrich clinical understanding. In addition, they enable clinicians both to locate their endeavors on a continuum that reaches back into historic time and to continue to elaborate themes of ongoing theoretical interest.

Among the extant masterpieces of Greek tragedy, the most fecund and explicit in its representations of perverse fantasy is the *Bacchae* of Euripides. Here, bisexuality, cross-dressing, humiliation, voyeurism, orgiastic revelry, and mutilation are dramatized through spectacle and spoken word. Thematizing the figuration of the perverse in this play, I shall, in this chapter, offer a series of meditations with several foci of interest. First, I shall consider the *Bacchae* as reflecting a world in which cultural upheaval engenders

Except where otherwise indicated, all line references are to the *Bacchae* by Euripides, translated by Geoffrey S. Kirk (Englewood Cliffs, N.J.: Prentice Hall, 1970). Chosen for its fidelity to the original Greek text, this translation was recommended by Professor Lowell Edmunds, Department of Classics and Archaeology, Rutgers University, who kindly read this paper and offered a number of valuable suggestions. A version will appear in *The Perverse and the Near Perverse in Everyday Life*, Gerald I. Fogel and Wayne C. Myers, eds. The permission of the Yale University Press is gratefully acknowledged. My research was supported by a grant from the Fund for Psychoanalytic Research of the American Psychoanalytic Association. I am indebted to Professors Peter Jelavich, Helene P. Foley, and Charles Segal for their generous and illuminating readings of versions of this essay. I also wish to thank archaeologist Claire Lyons of the Getty Center for her help in locating illustrations.

perverse enactments as attempted solutions to the paradoxes of human sexuality and generation—a theme that can be explored through its repetitive images of doubling, overturning, and falling. Second, I shall read key scenes in the play as perverse scenarios that recapitulate a violent birth trauma that is evoked in the opening lines of play and referred to throughout. Central to this theme are issues of identity, disguise and méconnaissance (failures of recognition)—especially within the mother/son dyad. Third, as a *leitmotiv*, I shall reflect on the trope of visualization that figures so prominently in this play as it does likewise in the perversions generally, where staring, furtive glancing (see H. Meyers, 1990) revealing, and concealing are often implicated and where the sight of the phallus (or lack thereof) may carry overwhelming signification. As a part of this third theme, I shall consider choices made here as to the relative merits of representation by spectacle and onstage enactment versus representation by word alone (see Aristotle, *Poetics* 1455a, lines 23–37; see also Fried 1980; Fried's argument considers visual art in terms of theater and I have reversed the terms; however, his work has stimulated my thinking with regard to this issue).

Because my critical discussion meanders, I shall begin with a focused summary of the dramatic action and offer details from certain background myths that are alluded to within it and relevant for what follows. The following precis draws heavily on Rose (1959) for mythological background and on the commentaries of Kirk (1970); for a later comparative retelling in Latin, see Ovid, *Metamorphoses*, Book III.

Background and Argument of the Play

Dionysus, god of theater, festival, wine, and revelry, has returned to Thebes, site of his birthplace. Standing before the Theban palace, he speaks his first lines directly to the audience. Even before hearing him, we notice he is young, beardless, effeminate (almost hermaphroditic) in appearance, with long golden curls, a fawn-skin, and that he wears (and will wear throughout the play) a smiling mask. This emblematic mask evokes uncanny feelings, for it appears grotesque in a context so redolent of catastrophe—a stage set where a ruined, still-smoking house and vine-covered tomb are displayed (Kirk 1970). Thus, before words are uttered, theater works through visual spectacle to create strange juxtapositions and omi-

nous forebodings. This aspect of the drama bears stress with regard to our theme, for spectacle is likewise often central to perverse experience.

Dionysus, soliloquizing, identifies himself immediately as the son of Zeus but then says that he is in disguise as a mortal, a foreign stranger. Significantly, he immediately tells the story of his traumatic birth, an event that, as I shall show, haunts the entire play. In the account, Semele, his mother (a daughter of Cadmus the dragon-slayer, founder of Thebes), because she was beloved and impregnated by Zeus, brought down upon herself the jealous wrath of Hera who, in disguise as an old woman, teased and cajoled her into asking the sovereign god to reveal himself so she might *see* his splendor and thereby ascertain beyond all doubt the divine identity of her lover. Semele did so but, as Hera had foreseen, proved unequal in her mortal state to the revelation. She was destroyed by the Olympian thunderbolts of Zeus, and her fetus, snatched up from her ashes, was implanted by him in his own thigh and delivered therefrom after the full period of gestation (*Bacchae* lines 88–93). Thus, Dionysus is a male born from a male, a child in fantasy abandoned and unrecognized by his mother, a son whose father has destroyed his mother, a male deeply scarred by a perverse birth, a child humiliated *in utero* by a murderous and powerful female (Hera), a persona of complex and bewildering identity.

Dionysus informs us that he has come to Thebes in mortal disguise (paradoxically) in order to legitimize himself as a god, for his identity has (also) been publicly challenged. Rumor has it that his mother Semele, in fact, cohabited not with Zeus but with another mortal and contrived the story of Zeus as a front; her death then is explained as a punishment by him for her falsehood (lines 26–31). Manifestly, therefore, Dionysus returns to establish his patrimony, to insist on (dramatize) his identity as son of Zeus (line 1), and to institute his rites of worship in Thebes. His obvious opponent in all this is Pentheus, his antagonist in the play, son of another of Cadmus' daughters, Agave, and brash young ruler of the city, who has not only neglected his worship but condemned it and denounced him as an imposter.

Beyond the manifest content here (the wish to be recognized and affirmed), the psychoanalytically minded reader can discover other levels of meaning for the return of Dionysus to Thebes. One particular motive, which organizes on a fantasy level the action of the plot and bears directly on clinical notions of perversion, is the powerful need of a traumatized child to replay his trauma, often by

staging a series of scenarios through which, by displacement, reversal, and projective identification, he can simultaneously identify with and triumph over its original participants (see McDougall 1986). This will be one of the frames through which I shall examine key scenes of the *Bacchae*.

Pentheus, having declared Dionysus an imposter, rages that the women of Thebes, under his corrupt influence, have flocked to the hills to engage in frenzied Bacchic orgies. Unable to prevent them, he plans to use military force to return them to the city. When Dionysus arrives in his disguise as a Lydian stranger, Pentheus has him captured, manacled, and arraigned before him, then, despite warnings by his grandfather Cadmus and the blind seer Teiresias, cast into the palace dungeon. In an apocalyptic scene, which I shall discuss below, the "stranger" (Dionysus) is miraculously delivered, destroys the palace in a thunderous explosion, and appears to the frustrated Pentheus as a bull.

Chastened but unyielding, Pentheus again confronts Dionysus who, still in disguise, actively and with ironic delicacy begins to direct his diabolical play within the play. Masterfully, he seduces the young ruler into abandoning his regal interests and following out the perverse implications of his own unacknowledged erotic desires. Persuaded to disguise himself as a woman, Pentheus willingly goes to spy on his mother, his aunts, and the other Theban women in order to see for himself what actually transpires in their secret rites (to "see the maenad's shameful deeds," as he puts it, line 1061; see also Segal 1986: 311) on the mountain beyond the city walls.

Through back alleyways (Foley 1985), lest he himself be seen, the costumed and excited Pentheus is led by Dionysus to a tall tree in which he can hide and watch the women. A fateful reversal, however, thwarts this voyeuristic plan. Alerted by Dionysus, the women— the bacchae—instead behold him in his exposed perch against the sky. Crazed, they fall upon his tree, pelt him with branches, shake him down, rush frantically upon him, and rend him limb from limb —his mother playing the role of principal assassin.

Gradually, in an exquisitely crafted closing scene (discussed below), Agave is brought by her father's gentle words to a recognition of her deed and to a state in which she can lament the death of her son and her own terrible part in it as well as other losses—the fall of the house and extinction of the line of succession, the impending familial separations, and their retaliatory banishment from Thebes by Dionysus.

Background Myths

Before turning to commentary, I wish to supplement this retelling with several details from background myths that bear on what follows and provide a fuller familial context for the tragedy. Cadmus had, according to myth, four daughters, two of whom we have met. In addition to Semele and Agave, there are Autonoe and Ino, both characters mentioned in the *Bacchae.*

Autonoe is the unhappy mother of Actaeon who had angered the chaste goddess Artemis either by spying on her at her bath, by boasting that he was a better hunter than she, or by proposing to marry her after bringing offerings to her shrine (we can trace all of these alternative themes in the narrative of the *Bacchae;* on hunting, see Vidal-Naquet 1986). In her fury, Artemis changes this young man into a stag; whereupon, he is felled in a ghastly scene and dismembered by his own hounds. Thus, Autonoe's story prefigures that of Agave and Pentheus, but with greater displacement. The murder here is performed not by the hands of the mother herself but rather arranged by her proxy, another (in fantasy) chaste and, to the son, unavailable woman. This barely disguised theme of erotic and murderous relations between a mother and son is thus deeply implicated in the drama of the *Bacchae* and also treated parenthetically by Euripides in two earlier, closely related plays, *Hippolytus* (step-mother and son) and *Medea* (on *Hippolytus,* see, among others, Segal 1986; for a psychoanalytic commentary on *Medea,* see Simon 1988).

Ino, the fourth daughter of Cadmus, has an analogous albeit more complex history, again with several alternate versions. As sister to the dead Semele, Ino was called upon to nurse the infant Dionysus. In the meantime, however, she was married and bore two sons of her own. Hera, enraged at this latest subversion of her plot for the total destruction of Semele and her offspring, takes revenge now on Ino by driving her mad. Ino, apparently, disappears, and, in her absence, her husband believes her dead and remarries, siring two more sons by his second wife. Discovering at length, however, that Ino is still alive, he brings her back with her children; whereupon, his second wife, Themisto, plots secretly to kill these stepchildren who pose, as she believes, a threat to her own sons.

The detailed narrative of this attempted slaughter is interesting because it sharpens the theme of mother/child violence and nonrecognition that etches so deep and lasting an imprint on the play.

Themisto, the would-be murderess, arranges to have her own children dressed in white and those of Ino in black so that she can tell them apart in the darkness of night. Learning of this, however, Ino reverses the colors. Thus (prefiguring Dionysus' role in the *Bacchae*), she arranges for Themisto to destroy her own children; whereupon, the latter, horror-stricken, commits suicide. Hera now reenters the tale and finishes things off by again inducing madness (another prominent theme of the *Bacchae*), this time in both Ino and her husband. The latter (anticipating Agave's role in the *Bacchae*) mistakes one of their two remaining sons for a deer or a lion and kills him; while Ino, in order to escape his unreasoning violence, clasps her remaining child in her arms and races to a nearby cliff whence she leaps into the sea, thus destroying both herself and the only remaining child. Clearly, this story foreshadows Euripides' narrative not only in the *Bacchae* but in *Medea* as well. In both of these dramas, however, infanticide by the mother "comes out," so to speak, and parades itself in all its perversity on the open stage—a macabre theme for blatant enactment sans disguise, displacement, or substitution.

Commentary

To meditate on the action of the *Bacchae* is to experience a kind of vertigo—almost as though the very notion of perversion (from the Latin, *peruertere* "to overturn") were turning itself upside down. I mean by this that, whether we choose to conceive of perversion as an opposition of the presumably unnatural to the natural or the supposedly immoral to the moral, the invented world here permits no stable referents. Again and again, the play shows us a convergence between apparent opposites and offers images of irony and contradiction that leave us uneasy: ("do not be too confident that sovereignty is what rules men," line 310; "this beast we found was gentle," line 436; "he who talks wisdom to an ignorant man will seem out of his senses," line 480; " 'this male womb of mine'," line 527; "Am I to stop being a man and join the ranks of women?" line 821; "You will be hidden with the hiding that is appropriate/ for one who comes as a furtive spy," line 955; "the god has ruined us, justly, but to excess," line 1249). Riddling and prodding, it addresses with uncanny urgency our modern conscience.

The *Bacchae* reflects a turbulent moment in ancient history when the Peloponnesian War was causing a violent upheaval in

established customs and beliefs (see Harsh 1979; Fine 1983; de Romilly 1985). Participating fully in the tempestuousness of its epoch, the play with its ambiguities brings to mind a thoughtful passage by Ernst Kris, who speaks of art as being characterized by greater ambiguity during periods when "systems of conduct ideals are in doubt or social values are in process of transition" (1952: 262). Art produced under such circumstances reflects, he suggests, "the uncertainties and equivocations in the culture of which it is a part" (1952: 262), and his own era, he indicates, is one of this kind. Thus, the *Bacchae* speaks to us across the centuries as we grapple today with the disorientations of our own time and the fluctuations in our mores and values. For us as well as for Euripides, stable notions are suspect, and the referents for our most cherished shibboleths cast in doubt. Yet my approach here is neither historical nor fully ahistorical, for I seek to consider the *Bacchae* psychologically as a work for our time rather than to locate it within its own epoch or remove it from history altogether.

The play makes its impact directly on us through its panorama of sliding signifiers; its images shift as readily as does Dionysus himself, who, though sporting only the one smiling mask, appears in many guises: as an ambiguously gendered stranger, a roaring and thundering god, a clever sophist and seducer, a theatrical director, a bull, a snake, a lion, and finally a terrible avenger. The *Bacchae* defies fixity. It is given over in large segments (both concretely and metaphorically) to movement and to dance—to turnings, twistings, and fallings—its rhythmical coda ("Many are the shapes of things . . . ," line 1387) valorizes unpredictability and a bewildering plurality of signification.

Generating classical commentaries that have sprouted as lavishly about it as the ivy and vines sacred to Dionysus himself, the *Bacchae* was written, as it is thought, in the seventh decade of Euripides' life. It forms a place in his canon comparable to *Oedipus at Colonus* and *Oedipus Rex* in the oeuvre of Sophocles—to the former by virtue of its having also been produced at the end of the author's career when he was in exile and first performed posthumously (within a few years of the *Bacchae*), and to the latter because of its consummate artistry and obvious parallels, both structural and thematic. Elusive and complex, the *Bacchae* distills culminating reflections by its master on themes that had engrossed him in earlier works, particularly, as noted above, in the *Medea* and *Hippolytus*—namely, themes centering on the erotic and hostile attachments between mothers and sons, a pronounced motif in the

clinical literature on male perversions (see, among others, Chasse-guet-Smirgel 1985; Stoller 1985). Beyond this, its preeminent stage-ability has given it the magnetism of a lodestone, attracting reinter-pretation not only by scholars and literary critics but by directors and performers.

Mimicking, however, the partial blindness figured in its text, interpretations have occasionally fallen to one side or the other of a false divide (Harsh 1979). They have, on the one hand, envisioned the play as principally a glorification of Dionysus and all he appar-ently stands for (theater, ritual, festival, wine, voluptuousness, tran-scendence, reunion with nature) and, on the other, privileged a condemnation of the above, with the additions of licentiousness and brutality—this latter position being supported by the final scenes in which the tragically linked fates of Dionysian victims Pentheus and Agave are rendered with pathos and empathy. It is worth noting, however, that the exaggerated character traits of both Pentheus and Dionysus create a partial disidentification between each of the protagonists and the audience such that a kind of mu-tual exculpation results. Thus, as in a typical perverse scenario, neither of the parties—indeed, no one who has colluded in the event (including here the audience)—need feel guilty or be judged so by the end (see Arlow, 1990).

In what follows, I shall press for an attempt to hold both such positions in place without losing grip on either, for to do otherwise would constitute, in my view, a seduction by partial elements of the play; whereas, to follow through on the doubling devices that riddle its text and keep ambiguity alive without giving up on no-tions of frame and boundary is, rather, to engage interpretively with a central problem posed by the play as a whole—namely, the inti-mate relations of paradox to perversion.

To experience the *Bacchae* is to be struck by a strange thought: namely, that paradox—both emotional and intellectual—can be conceived as the underlying traumatic state out of which perversion crystallizes. For perversion, distinguished by mechanisms of split-ting and doubling, engenders, at least here in the Euripidean text, a dazzling repertoire of failed attempts to master paradox—paradox understood, however, not (solely) as aberrant but as deeply intrinsic to the human condition and as horrifyingly obdurate to more than momentary hallucinatory solution.

Early in the action of the play, Pentheus rails at his grandfather Cadmus and at the aged seer Teiresias who form a twosome (line

198) to join the Dionysian revels the young king overtly despises but covertly envies and desires. Enraged, he threatens to punish Teiresias by "turn[ing the latter's throne] upside down [and] mix[ing] everything up in utter confusion" (lines 347, 348). This wishful punishment, however (turning things upside down and mixing them up) is concocted out of a desire to set things right in the face of Dionysian madness, which he considers perverse. Yet the punishment precisely recapitulates the very dynamic of perversion (Chasseguet-Smirgel 1985). Thus, the penalty Pentheus conceives for Teiresias is identical to the crime of which he accuses him, and here, as elsewhere in the tragedy, Pentheus conflates weapon with enemy and means with end. This is supremely so when eventually he goes garbed as a woman to spy voyeuristically on women (lines 821–839). Unwittingly, he colludes with and is coopted by what he professes to despise. Such mergings, as they occur throughout the play, problematize the notion of perversion by revealing that norms are often indistinguishable from what apparently deviates from them.

To confuse implies a contrasting state: namely, one of clarity or distinctness. To overturn or turn away (pervert) implies a right side up or a baseline. But it is precisely such "normal" states—of rectitude, stability, reliability—that the *Bacchae* calls in question. Deeply hidden within the notion and experience of negation lies, as Freud (1925) taught us, affirmation. Similarly, couched within the notion of perversion are implicit sexual (and social) norms upon which its meaning depends (Freud 1905; Stoller 1985). Thus, in the double sense that negation is both the obverse of affirmation and simultaneously equatable with it, just so, perversion may be seen not only as an overturning of sexual (and social) norms, but likewise, in a different sense, as equatable with sexuality itself (Bersani 1986). This doubling, a recurrent feature of the Freudian text, is anticipated in the Euripidean text of the *Bacchae*, where, as we shall see, it figures as a major trope. To foreground the proliferation of such doubling devices in the play is thus to observe the way the very notion of perversion is both explored and at the same time rendered problematic.

Reversals, ironies, and transformations abound. Dionysus, although purposing to prove his divinity, disguises it. Appearing first as a Lydian stranger, "his hair all fragrant with light-brown tresses,/ with ruddy cheeks and the charms of Aphrodite in his eyes, who daylong and nightlong mingles with young girls/ holding out before them his rituals of holy joy" (as described by Pentheus, lines 235–238), he later on becomes a raging bull. Pentheus, however, intent

on hiding fatefully from himself, fails totally to penetrate either of these ruses (lines 501–506). This is so because of and despite the fact that bull and curls are symbols that unite the two young men.

It was as a bull that Zeus had raped Europa, sister to Cadmus, grandfather of both protagonists, and it was as an outcome of Cadmus' search for his sister that eventually the dragon seeds were sown and Pentheus' father Echion (snakeman) sprang from the earth. Thus, in taking on the shape of a bull, Dionysus "becomes" his bestial rapist father and instantiates that animal part of himself which Pentheus must so strenuously deny. Likewise, the curls, symbolic of the flagrant bisexuality of Dionysus, both tantalize and repel Pentheus—annoy him by preventing him from a successful evasion of his conflicted sexuality.

Dionysus, in the scene where he has become prisoner to Pentheus, asks: "Tell me what I must suffer—what is the dreadful thing you will do to me?" Pentheus replies, "First I shall cut off your delicate locks" (line 493)—a wish that can be read in its double sense, paradoxically, not only as castrative but also as an effort to foreclose doubleness by attempting to force Dionysus into a strictly masculine gender role.

Next, Pentheus commands Dionysus to hand over his thyrsus (ivy-tipped wand), and it is at this point, with the other's response, that the brilliant seduction begins. For Dionysus says: "Remove it from me yourself" (line 496). In so saying, he implicates Pentheus in the latter's own disavowed desire, forces him to play out actively his own forbidden wish. *He refuses him a place outside the action*, prohibits him from disowning his own lust. Silently, as Pentheus takes the thyrsus into his hand, the roles reverse. (It is important to note, however, that although this action is implied in the text, it is ultimately a performance decision.) From this point on, it is Dionysus who commands and orchestrates and Pentheus who must unknowingly obey. By handling the thyrsus, he is now in the hands of Dionysus. Although he has gloated earlier that, when he finally captures this sensual "worshipper of Dionysus," he will "cut his neck clean off from his body" (line 241), it is Pentheus himself who in the end appears onstage as an impaled and severed head. Thus Euripides creates chilling ironies that overturn the expected.

This centrality to and inextricability of paradox from perversion characterizes both actor and spectator in the *Bacchae*. Its protagonists, Pentheus and Dionysus, though manifestly human and divine respectively, are perceivable as *doubles* (Fóley 1985). Youthful cous-

ins, their ill-fated mothers, Agave and Semele, were, as we have seen, sisters. Heirs, therefore, to a bizarre and intertwined genealogy, the two young men seek to establish and secure a stable identity despite family histories tainted with repetitive blots of rape, murder, infanticide, and suicide. Paired in their mutual acts of sadism, they seek to humiliate each other and by so doing to replay and repair their own past wounds. Colliding and merging, their enmity figures a twinship that is revealed paradoxically through role reversals that occur both within their individual personae and in the libidinized and hostile (sado-masochistic) relations that obtain between them.

Pentheus, the hunter, for example, swiftly becomes Dionysus' quarry; Pentheus, the keeper, is metamorphosed into Dionysus' prisoner; the would-be observer of perversion becomes an actor in it, fully costumed and implicated; this "actor" is quickly transformed into an "actress," and the one who most rigidly defends his boundaries of self, a victim of *sparagmos*—of violent physical dismemberment and death. Like the matched groups of women, the onstage chorus of bacchae from Lydia and the offstage Theban bacchae in the hills outside the city, the god Dionysus and his doubles are participant-observers.

Similarly, we, as audience to the *Bacchae,* are compelled to participate with its characters in an observing that is simultaneously an enacting. Always potential objects to ourselves, we are fated to seek, rediscover, and lose, both inside and outside their intense theatricality and perversity, the double vision of our own human condition.

The genius of the play, therefore, lies at least partly in its brutal insistence on the necessity for, but the utter impossibility of, some species of double vision. Relentlessly, it parades before us the disasters attendant on our penchant for the unilateral and the polemical, the too sharply delineated, the logically bounded or statically conceived. Pentheus's deeply felt human need, for example, to wall things off (line 653), to demarcate by means of chains (lines 356, 444, 446, 644) or by fastening down with iron nets (line 231) figures a type of partial blindness we can find in ourselves. When, however, he relinquishes the walls of Thebes and, following Dionysus, plunges "in drag" into a hallucinatory maelstrom outside the seven gates, we almost lose him. Clutching arrogantly at his prerogatives of masculine gender and socially conferred power but betraying latent bisexuality and infantile passivity, he forfeits the narrowly conceived identity to which he has previously clung and, venturing out

beyond civilization, is threatened with, and suffers, annihilation. These extremes are the choices dramatized by the *Bacchae*. They are extremes meant, however, to be experienced by us as our own.

In the *Bacchae*, the centrality of double vision to perversion, though continually evoked, leaps into full awareness at the moment when Pentheus is dressed as a woman and led by Dionysus to his death at the hands of women (lines 1911–976). The rigidly tyrannical young king, his fiercely guarded identity now thrown visibly into question and eager, as Dionysus ironically hints, to see what he should not see (line 911), suddenly exclaims:

> Look—I seem to myself to see two suns and a double Thebes, a double seven-mouthed fortress; and you appear to lead on ahead of me as a bull, and on your head horns seem to grow! Were you a beast before? For you are certainly a bull now! (lines 918–922)

Thus, the male who dresses in female garments doubles his identity, instantiates his bisexuality, demonstrates in his person the central paradox of gender and of human sexuality. Replaying with erotic excitement a primal and possibly on some level universal trauma of passivity and humiliation at the hands of woman, Pentheus enacts a fantasy of identification and aggression, while, under the disguise of the castrated image, he preserves his intact phallus and masculine persona, of which however, he is only intermittently aware. This point is conveyed in lines 924–963, where he first asks, "What do I look like, then? Do I not seem to have Ino's way of standing, or that of Agave, my mother?" But then, moments later, he commands: "Convey me through the middle of the Theban land—/ for I am the only man of them to dare this deed." Such oscillations between knowing and not-knowing impart a tension and suspense, a thrill of anxious pleasure, an intermittent sense of mastery and terror—one doomed in the end, however, to be ephemeral, tragic, even fatal.

It is fascinating that, to Pentheus' hallucination of the double image, Dionysus, now his torturer in earnest (though still himself disguised) responds, "Now you see what you should see" (line 923). Thus, the bifurcated, dissociated world of perversion—where one fixed set of images is hyper-idealized at the expense of another set that remains too dangerous to contemplate—stunningly erupts in this scene. The audience, through spectacle and onstage enactment, experiences a kind of dual transvestism in the twinned figures of the disguised young men barely distinguishable now except for

their antithetical masks—one smiling and the other unsmiling (tragic) (Foley 1985); while speech and language simultaneously exhort us to share in their diplopia.

Dissociation of imagery is, however, nowhere dramatized with more consummate impact than in the final scenes of the *Bacchae* where the crazed Agave, having murdered her son, is brought to awareness by the words of her grieving father. Here we see the Euripidean overturning—the equation between madness and sanity, deviation and norm—as Cadmus, understanding not only that his grandson has been murdered but that Agave, having committed the act, does not comprehend her deed, must choose between allowing her to remain in her manic state or help her to one that can only be more painful than her present condition. He speaks as follows:

"O sorrow unmeasurable and *beyond seeing"* . . .
Alas! If you all [Agave and her sisters] realize what
 you have done
you will grieve with a dreadful grief; but if to the end
you persist in your present condition,
though far from fortunate, you will think you are free
from misfortune. (line 1244, my italics; lines 1259–1262)

Taking the role of the good parent (or therapist, see Devereux 1970; Segal 1982), he accepts the responsibility *to make her see,* to bring her dissociated worlds of imagery together, to return her to what will be for her forever a tormented world. And here, as elsewhere, we hear the *leitmotiv* of seeing and knowing, image and word. Agave, believing she has hunted and destroyed a wild beast and is holding its head in her bloody hands, must come to recognize this object as the severed head of her beloved child. Cadmus, in helping her achieve this, does so by *directing her gaze.* Thus, he concretizes the metaphors that link vision with knowledge:

CADMUS: *(pointing)* First turn your gaze on this sky above.
AGAVE: There: why did you suggest I look at it?
CADMUS: [*Asking her to monitor the alterations in her perceptions*] Is it the same, or does it seem to you to be changing?
AGAVE: [*Turning symbolically from the benighted vision, the dream, the hallucination, to the light of daytime and of commonplace reality*] It is brighter than before and shines with a holier light.
CADMUS: [*Asking her to become aware of her changing affects as secondary to her changing perceptions*] And is this passionate excitement still in your heart?

AGAVE: I do not understand this question—and yet I am somehow becoming in my full senses, changed from my previous state of mind.

CADMUS: [*Calling upon her faculties of reason, her ego functioning*] So you could understand a question and give a plain answer?

AGAVE: [*Her altered state of consciousness dissociated now from the more normal state*] Yes, except that I have forgotten what we said before, father.

CADMUS: [*Reconnecting her with her past history, with the flow of sequential time, a dimension absent in her former manic state*] To what household did you go at your marriage?

She responds appropriately, and Cadmus asks her what child she bore.

AGAVE: [*Remembering but still dissociating this thought from her perception*] Pentheus, through my union with his father.

CADMUS: [*Now making the final move of reconnecting thought with perception*] Whose head, then, are you holding in your arms?

AGAVE: [*Denying by avoidance, by not looking*] A lion's—at least, so the women hunters said?

CADMUS: Now consider truly—*looking* costs little trouble. (my italics)

AGAVE: *(violently agitated)* Ah, what do I *see?* What is this I am carrying in my hands? (my italics)

CADMUS: *Look hard at it and understand more clearly.* (my italics)

AGAVE: [*Describing her affect before being able to connect it with her visual perception or to pronounce the name of her child in this altered context*] What I see is grief, deep grief, and misery for me!

CADMUS: [*Reminding her of her former hallucinatory perception which has now become dystonic*] It does not seem to you to resemble a lion?

AGAVE: No, but it is Pentheus' head I am holding, unhappy woman!

CADMUS: Yes, Pentheus', bewailed before you recognized him!

Thus, Euripides, with a sensitivity to psychological process that annuls the passage of time, implicates us in a scene of recognition that is not described but enacted onstage before our eyes. It is a scene again, like that of Pentheus "in drag," that confronts us with the double vision of the human condition, a double vision intensi-

fied by the perverse scenario but by no means peculiar to it. Agave must go on to face herself as the unwitting agent of her child's death and to learn that she will be separated not only from him but from her father and her birthplace.

I should like to comment on the fact that these two scenes—Pentheus led into the perverse scenario and Agave being brought out of it—are enacted onstage rather than retold and described to us. That this is not the case with other major scenes in the drama, such as the bacchic orgy on the mountain and the death of Pentheus is worth consideration despite the fact that it represents a long-standing theatrical convention. Speculating on this choice between representation by spectacle versus representation by word alone, a point summarily addressed by Aristotle in the *Poetics*, I would suggest, in accordance with the interpretive frame of this essay, that when the scene occurs *within* the perverse fantasy per se, Euripides has chosen narrative, whereas when the scene involves *moving* from one modality or state of consciousness to another, he has favored enactment plus word. Thus, in the moments located within the perverse fantasy, each member of the audience is given more freedom and privacy to imagine the scene according to individual need as well as to deny it (for example, Pentheus and the maenads on Mount Cithaeron), whereas the representation of passage from one state or mode to another is rendered, vis-à-vis the audience, with greater precision. Made intuitively, such artistic decisions have counterparts in clinical practice, where different modes of intervention are likewise chosen and matched with levels of material presented. One wonders further as to the etiology of such choices beyond the clinic in the realm of perverse psychopathology per se—where words and images are often used to achieve similar effects.

Dissociation and splitting continue to be developed in the *Bacchae* by a doubling in the characterization of women. In a series of passages given to numerous speakers including the chorus, images of women in the daytime, at home, under their roofs, seated quietly at their looms, are contrasted with images of women at night, in the hills, women in motion, shrieking, dancing, or running.

The Theban women on Mount Cithaeron, for example, abandon their looms and roofs (line 38) to roam the hills outside the city. Their behavior—both literally and figuratively—is out of bounds (in Pentheus' words, their madness "exceeds all bounds," line 785). Having transgressed the limits of the seven gates, they loosen their

hair and perform orgiastic revels that include the imbibing of wine, milk, and honey—a reversal of the usual feminine role as provider to others of such nourishment. Tapping magically with their thyrsi, they elicit these liquids from the earth and voluptuously suckle young deer and wolf cubs, thus violating the boundary that separates human from animal. At a certain point, sensing ambush by the followers of Pentheus, they, like Pentheus and Dionysus, suddenly "fall" and, yet again, turn "everything / upside down" (lines 753, 754). Inverting their previous nurturant behavior, they pounce on live animals and tear them to pieces, snatch children from their homes (lines 735–755), and transform themselves from magical imbibers and providers with powerful phallic appendages into monstrous predators. Bearers and givers of life, these women are seen, by the spying males, as wanton slaughterers. Thus, they prefigure the scene of Pentheus' death. The description of them ends with snakes licking drops of blood from their cheeks.

Paradoxically, however, this entire scenario (Messenger's speech, lines 677–769) begins with an emphasis on the women's orderliness: They are "a miracle of discipline to behold,/ women young and old and girls still unmarried" (lines 693, 694). Thus, just as Pentheus in the name of order threatened to overturn Teiresias' throne at the beginning of the play, so here, states of rectitude or propriety against which confusion can be measured turn into their opposite. The seemingly composed bacchae disorganize; pattern erupts into anarchy; apparent structure proves a deceptive veneer for chaos.

Such portrayals of women cannot be left unconnected with Semele, the dead mother, whose onstage presence is evoked by her burned house and tomb. Dionysus, in returning to Thebes, has returned to his mother in the form of this tomb, and, in so doing, must relive the trauma of his birth. Reading the narrative of the *Bacchae* this way, we see in it a turning of passive into active by Dionysus who, having suffered a perverse birth, here foists a similar but more ghastly return upon his cousin Pentheus. For Pentheus too, by the end of the *Bacchae*, is made to reencounter the scene of his birth— which also now becomes a tomb, namely, the person of his mother Agave, and a maternal bereavement. In Dionysus' restaging of the trauma, however, it is not a live son who returns to the tomb of a dead mother but rather a live mother who is forced to contemplate in horror the body of her dead son. Thus, by masterminding and directing this perverse scenario, Dionysus revenges himself both on

his enemy Pentheus (who had refused to recognize him) and on his mother, Semele (who died before recognizing him), and identifies both with his father Zeus, (through powerful acts of sexualized violence and destruction), as well as with Hera, the aggressor par excellence, while, as a double for Pentheus, he also experiences, via this proxy, his own victimization and maternal abandonment.

Thus, though his divinity *had* truly been called in question by Pentheus and a prevalence of rumors had accounted manifestly for his insistence on announcing himself as being beyond all doubt the son of Zeus, yet Dionysus has had all along a further agenda— namely, to master the outrage he has suffered *for the sake of his mother Semele,* to reenact their joint trauma by proxy. Thus, he has forced Pentheus to be outraged *by his mother.* In designing and witnessing this destruction of another son and mother (for Agave is, in the end, psychologically shattered), Dionysus momentarily redresses his own and Semele's still-smoldering humiliation.

Forsaken by the first woman in his life in a disaster plotted by another woman, Dionysus seeks vengeance on all females. At the same time, however, he is, with his Maenadic band, unique among male divinities in having an intense identification with women. This ambivalence, which operates for Pentheus as well, figures perhaps, on the two different planes of the divine and the human, a fundamental ambivalence of the male child toward the mother (Charles Segal, letter of 3/8/90). Maddening his followers, Dionysus enthralls them ("So them I stung in madness from their homes/ and they dwell on the mountains stricken in their wits . . . all/ of the women, I maddened" lines 32–36) as well as, by a more proximate displacement, Agave. Her misfortune is that she was born sister to the woman who not only deserted him but who did so blindly, that is, before affirming or acknowledging him as her child.

Recognition matters deeply here, for the theme of *recognition* is central not only to the *Bacchae* but to all tragedy (see Aristotle, *Poetics:* 1452, 1455). Without recognition, there can be no identity —no sexual or generational identity. Thus, Dionysus demands that the audience *recognize* him ("I have come, the son of Zeus, to this land of the Thebans, /I, Dionysus, whom once Cadmus' daughter bore,/ Semele, brought to childhood by lightning-carried fire," lines 1–3). His very compulsion to proclaim his identity in terms of both parents belies the confusion, puzzlement, and pain that underlie it —which he betrays by announcing that he has problematized his own identity by donning a disguise:

> Exchanging my divine form for a mortal one
> I am here, by the streams of Dirce and the waters of Ismenus;
> And I see the tomb of my mother, the thunderbolt-struck
> her by the palace, and the ruins of her house
> smoldering with the still-living flame of the fire of Zeus—
> Hera's undying outrage against my mother. (lines 4–9)

Thus, the (effeminate) disguise is linked with images of the dead mother, which kindles living rage within him, rage externalized by the ruins on the stage—signs given to the audience before we ever learn of his ostensible reason for the return to Thebes. The prologue also figures the reversal of infantile helplessness into divine potency: the infant lifted from the womb has now grown up and returns in mortal disguise to extract his fearful revenge (Segal, letter of 3/8/90).

These parental identifications with father and mother reverse themselves later in the play in the apocalyptic scene when, as prisoner to Pentheus, Dionysus causes the Theban palace to tremble and fall. Significantly exchanging the order of these first identifications, here, his mother's name comes *before* his father's ("again I speak,/ the son of Semele, the son of Zeus!" line 581). Thus, this catastrophic scene, read as a restaging by Dionysus of the primal scene, the paternal assault (also accomplished with pyrotechnics and thunder) shows us, if we focus on the reversed order of the referents, that, as a child of both parents, he must identify deeply with the destroyed as well as with the destroyer—that, indeed, it is as much his deeply felt congruity with the humiliated Semele as with the potent Zeus that has made him the cruel avenger he is.

Furthermore, in his initial scene of sadistic seduction, when he begins to lure Pentheus step-by-step to his death, Dionysus again brings issues of recognition and identity to the fore—identity and vision—twinning himself with Pentheus. For Pentheus, duped by his disguise, asks him at one point where Dionysus is (line 501). Ironically, he replies:

> DIONYSUS: Even now he is close by and *sees* what I suffer. (my italics)
>
> PENTHEUS: Well, where is he? *He is not visible to my eyes.* (my italics)
>
> DIONYSUS: Here, with me; but you, because of your impiety, *do not behold him. . . .*
> *You do not know what your life is—neither what you are doing nor who you are.* (my italics)

PENTHEUS: [I am] Pentheus, son of Agave and Echion as father.
(line 500–507)

Thus, identity is reintroduced and reproblematized here, its paradoxes brought home to the heart of the tragedy, juxtaposed with the vexed equations of vision with knowledge and blindness with ignorance. Foisting his own dilemma on Pentheus, Dionysus reveals their deeper twinship, for Pentheus, in fact, does *not* know who he is. Confined within his limited, overly defended persona—walled, like the city he rules—he is, as we have already seen, both inwardly and outwardly blind. Like Oedipus, he can recognize neither his interlocutor nor himself.

Identity and recognition, however, surge into preeminence almost unbearably in the scene in which Pentheus has fallen from the tree and is about to be sacrificed. Ripping off his feminine disguise, he begs Agave to acknowledge him as her child and to spare him. Touching her cheek, he pleads:

Look, it is I, mother, your child
Pentheus, whom you bore in the house of Echion!
Take pity on me, mother, and do not by reason of my
errors murder your own child!" (lines 1117–1121).

Like the dead mother of Dionysus, however, she cannot at this crucial moment *see* him. Her blindness and her inability to affirm him matter focally to the perverse scenario, for Dionysus' revenge must be taken not only against Pentheus but, on a deeper level, against the lost mother. Had she lived to know him as her son, her recognition and affirmation of him would have made it imperative (in fantasy) for Pentheus and others to have done likewise.

Exploiting, at key moments, the trope of falling, the *Bacchae* presents a world in which moderation appears only as a chimera hallucinated by the chorus, while its principal human subject plummets from extreme to extreme, living out with erotized intensity the paradoxes of his mortality.

Descending images abound, only culminating in Pentheus' final fall from the treetop (lines 1111–1112), but we may take this one as a stunning metaphor for libidinal regression—regression as applied to the fate of Pentheus in his participation in the Dionysian trauma. Hurtling from his phallic tree, he is propelled into a sadistic orgy of dismemberment and then, at the very end, exposed to one horrible moment of primitive oral aggression when his deranged mother

actually suggests that he be eaten ("Partake then of the feast!" she says, holding up his impaled head, line 1184).

From the start, falling figures as a trope. Worrying that it might be topsy-turvy for old men like himself and Cadmus to join the young at their bacchic revels, but pointing out that Dionysus makes no distinction between the generations (line 206), Teiresias requests his friend to "support my body, as I will yours./ It is shameful for two old men to *fall*" (lines 364–365, my italics). Thus, falling, perceived as disaster, can be momentarily averted by the device of doubling—a point echoed later, ironically, when Pentheus perceives the two suns over Thebes.

Furthermore when Dionysus, in imitation of his father, demolishes the palace (lines 585–607), the female chorus is awestruck by his display and, in their terror, replay vis-à-vis him the role of Semele to Zeus: Like her, they fall to the ground (lines 600–611). Thus, in this scene as well, the infantile trauma is reenacted. Pentheus, stumbling helter-skelter in helpless confusion and bewilderment (lines 625–630), rehearses in this repetition of trauma the role of the child. Moreover, the palace, symbolizing "solidity," may be interpreted as figuring the secure adult self that collapses in ruins at this moment to reveal the helpless child beneath (Segal, 3/8/90).

Falling images figure physical disaster, grief, terror, even ecstasy, as when the frenzied bacchae are described as hurling themselves to the earth in the throes of their worship (lines 135–6). Thus, the world of the *Bacchae* is one of almost perpetual descent—even unto the final imagery, where the venerable but impotent Cadmus is transformed by Dionysus into a snake as a closing humiliation. Destined henceforth to touch the earth with all his body parts, he thus reverts to the chthonic being of the family ancestry, barred forever from siring future kings. His achievement as a civilizing hero is thus undone.

In meditating on such images, we realize that fear of falling is basic to the human species. The most primitive of all our fears, it is the one that causes every infant to grasp reflexively and against which every good mother protects by her holding hands and cradling arms. Adumbrated here throughout the *Bacchae*, this fear is actualized in a supreme moment of perversity. For Pentheus drops not *from* but *into* his mother's unsustaining, life-threatening hands. Losing his grip on the tree that supports him and reaching the ground, he is, as we know, deprived of life by the one who gave him life—rent in a total fragmentation of body and mind.

The male child, by achieving merger with and humiliation of the

mother through his cross-dressing and voyeurism, thereby relinquishes the masculine identity by which he can be recognized by her. In falling from his precarious phallic perch to the earth, he must be passively and violently undone. Nightmarishly, this scene enacts the deepest level of male fantasy—that terror of annihilation for which castration anxiety itself is but a façade.

Thus, to accomplish its overturning of the overturned, the *Bacchae* has, by its final choral piece, produced reversals, transformations, and violations of established boundaries. In what has transpired here, I have attempted to mirror the text by locating and dislocating several of the notions of perversion discoverable there. By pointing to specific types of imagery, I have demonstrated how one traumatic event, evoked in the first moments, spawns a set of new editions that both erupt into and propel the tragic action. I have indicated that, despite florid pathology figured in the story and its background legends, Euripides' tragedy speaks directly to us today.

Perverse solutions are attempted answers to riddles that compel, in troubling times and in fantasy, deeds of the uttermost extremity. To read or see the *Bacchae* is to confront ourselves; for Euripidean theater, like and unlike Artaud's, is a theater of cruelty—and a theater of truth.

TEN

Film as Dream

The French Lieutenant's Woman

As a special research candidate at the Columbia Center for
Psychoanalytic Training and Research in 1981, I longed for a venue
wherein to experiment with the explosive interpretive powers of
Freudian theory. The Reisz/Pinter film, screened that autumn,
presented itself as a ready laboratory of images with which to try
out key concepts. Thus, this essay, reprinted essentially as it was
written, represents my first steps in the direction of psychoanalytic
criticism. I have included it for the moment it captures—its
freshness of belief and animating wonder at the explanatory force
of psychoanalysis—an élan that contemporary revision
might easily ravish.

But all the story of the night told over,
And all their minds transfigur'd so together,
More witnesseth than fancy's images,
And grows to something of great constancy;
But, howsoever, strange and admirable.

> —*A Midsummer Night's Dream*
> Act V, scene i

The conceptual schemata originated by Freud in *The Interpretation of Dreams* seem particularly apt for application to the art of film. Among films in general, Freud's understanding of dreams may apply with special appropriateness to those created on the basis of preexisting literary texts. My claim here is that Freudian theory can illuminate the transformation from printed page to screened imagery and, by revealing certain characteristic types of ambiguity, help to explain the power of that imagery, particularly, its ability to convey economically a vast range of meaning. I shall attempt to show that Freud's theory offers insights into the nature of our response to the art of film as well as to filmmaking and provides a system of interpretation that can be meaningfully applied to individual works.

Clearly, no one conceptual framework fits precisely any given work of art; moreover, in the case of this essay, my presentation is fragmentary with respect to the film I have chosen as an example, a film that is contemporary and popular rather than classic. My purpose here is to demonstrate the merit, the desirability, of a psychoanalytic approach, not to claim exhaustive or exclusive prerogatives for it. My following discussion of *The French Lieutenant's Woman* should be taken therefore, as an example of method rather than as a critical reading (though, inevitably, it is that as well).

Dedicated to my daughter Jennifer Beulah, this chapter originally appeared under the title "On the Interpretation of Film as Dream: The French Lieutenant's Woman," in *Post Script: Essays in Film and the Humanities*, vol. 2, no. 1, pp. 13–29, 1982. Permission is here gratefully acknowledged.

I wish to express appreciation to Morton J. Aronson, M.D., of the Center for Psychoanalytic Training and Research, Columbia University, who generously read it in its earliest incarnation and encouraged me to develop it further.

At the outset I should like to note my indebtedness for inspiration not only to the film itself, to Freud's *Studies on Hysteria* as well as *The Interpretation of Dreams*, but also to a presentation by Dr. Leon Balter (1981) of a paper in which he analyzes the film *Cabaret*. In this paper, Balter utilizes the concept of multiple frames and levels of meaning, such as one finds in the structure of dreams, and especially Freud's notion of the meaning of the dream within a dream. This is relevant because the film with which I shall deal here, like *Cabaret*, makes use of the play within a play. Freud said that since the dream-work employs the device of dreaming as a form of repudiation ("after all, it's only a dream"), a dream within a dream must therefore constitute the strongest affirmation of reality, the disguise being already present (see *S.E.* 4:338). Balter uses this idea to show the way in which, in *Cabaret*, the innermost frame corresponding to the dream within the dream (i.e., the musical and choreographic numbers performed both in and outside the cabaret) serves to represent, condense, anticipate, and comment on the outer frames of the film (i.e., Sally Bowles' love story and the decadence of Berlin in the last years of the Weimar Republic). Balter's presentation—passionate, intense, personal as well as scholarly—provided much impetus for the following work.

The French Lieutenant's Woman represents an attempt to translate a prose text that is not a script into film, an art form that is preeminently visual. How does such a process occur? No doubt filmmakers who have essayed it could provide discussions of the ways in which they consciously work with their material. What I want to suggest here is that, granted that any creative mental act involves a largely unconscious process, the work of translation may be analogized to intrapsychic functions that operate in the transition from waking life to dreams, where, as Freud says, thoughts are transformed into pictures. Freud cites Herbert Silberer as describing this phenomenon, which occurs normally under conditions of drowsiness and fatigue (see *S.E.* 4:344). At such times, when one is thinking, the thoughts seem to escape and are replaced in the mind by pictures. One example Freud (*S.E.* 4:344) quotes is that of the thought of revising an awkward passage in an essay; gradually, this thought gives way to an image of planing a block of wood. In an analogous manner, I am suggesting, material can be viewed as passing from the Fowles novel into the Reisz/Pinter film, undergoing thereby a hallucinatory transformation that may be the hallmark not only of dream-formation but of certain aspects of film-

making as well. The material as it finally appears in the film thus moves in part regressively from verbal to visual, from symbolic to imaginary, from secondary to primary process organization, which is *pari passu* secondarily revised: idea becomes image. The film-goer's response also, conditioned by his being isolated and in darkness, can be likened to that in which dream-states, reveries, and hallucinations occur.

Fowles explores in his novel, which takes place in Victorian England and depicts the fate(s) of a young woman who has apparently been abandoned by her foreign lover, the possibility of writing, self-consciously, in the style of the nineteenth century. He draws his reader into a world of fantasy, creating the circumstances for a "willing suspension of disbelief," but interrupts his narrative from time to time to remind himself and his reader that, in fact, he and we are quite removed from that world, inhabitants of a later incarnation of the culture he is describing. Thus, rather than simply telling yet another romantic tale, he manipulates our aesthetic distance from his story and creates a tension between past and present, the fictional and the real, the work and the artist's craft; finally, to drive this home compellingly, he presents us with a choice of endings which, however, we must experience sequentially.

Pinter's challenge was, of course, to create both a visual and experiential counterpart for this shifting of perspective, these alterations of aesthetic distance which Fowles explores. His task in making the film was to give us what Freud (*S.E.* 5:534) has called the most striking characteristic of the dream, that is, the thought objectified, represented as a scene or series of scenes, and experienced by us as if it were really happening. Pinter's solution was to juxtapose the two time frames, nineteenth century and now, within the context of the film. Whereas in the novel, author and reader represent the touchstone of the present, in the film the two historical contexts are actualized. We see and hear the different sights and sounds: carriages and high-speed trains, tea gowns and blue jeans, the studied manners and the casual. The two worlds are telescoped together, as happens in the condensation of dream-work, in which aspects of our lives separated by many years are represented simultaneously.

Pinter's choice in creating parallel narratives conveys a meaning of which we are only gradually made aware. As the culture of Victorian England with its configuration of values, mores, and visual imagery, its "claustrophilia," which Fowles (1969:143) sees "so

clearly evidenced in their enveloping, mummifying clothes, their fear of the open and of the naked," is set alongside that of our contemporary international life-style, we see them first in contrast. Only slowly do we come to grasp that it is not two different worlds with which we are being presented here, but rather one cultural world that has altered through time. As infantile wishes live on in our adult selves, so the values, fantasies, wishes, and symbols of the nineteenth century live on in our world, even if, as the film seems to demonstrate in its final moments, we no longer (if ever we did) act them out except in dreams. The film stresses, in this way, our dependence on cultural inheritance; it instantiates Freud's claim that, culturally as well as genetically, the past lives on in the unconscious.

The French Lieutenant's Woman deals structurally with the making of a film in the context of a larger whole. We may choose to view the entire film as a dream in which the nineteenth-century story is a dream within a dream, or we may see only the film within the film as dream and the outer frame as "reality." In either case it is clear that it is the inner frame (i.e., the story of Sarah Woodruff and Charles Smithson) and not the outer one (i.e., the relationship of principal actor and actress, Mike and Anna) that focally engages us. The world of the past is in every sense the major story. Taking the second perspective I have suggested, we are, from the beginning of the film, in the world of the dream. Only occasionally do we awaken and perceive not only what has been producing the dream but also how the dream has been influencing the waking life. This alternation, shifting back and forth, achieves the titration of aesthetic distance that Fowles induces in his novel.

As we slip easily from the realm of fantasy and dream to the actors' "waking lives," we experience another mechanism of dreamwork, that of reversal; for, in the initial scenes of Mike's and Anna's waking life, they are in bed. Supine, vague, and fragmentary in their "real life," they awaken in their film. It is as if the dream (film) had more substance than the reality.

The investment of time, energy, and elaboration in the inner frame of the film reveals a major theme of the work, a statement about the relations between art and life, between fantasy and reality, the dream and the waking state. We might see it as a variation on the theme of Theseus and Hippolyta's brief dialogue in the beginning of the final act of *A Midsummer Night's Dream*, a play that is of course paradigmatic of the frame within the frame. Here, Theseus takes a Platonic view of art, suspicious of the poet's imag-

ination. Hippolyta, however, sees more deeply, discovering "a great constancy" in the varied stories of the night. For her, the minds transfigured by dreams bear witness to something "more" than "fancy's images," to something "howsoever, strange and admirable." And yet, as Puck reminds us in the end, we need not take any of it seriously, for it is, after all, "but a dream." The claim, then, is that there exists a truth more basic than any other that art (and dreams) are privy to but which, because of its "strange" nature, must be denied upon awakening. The word "constancy" in Hippolyta's speech indicates that Shakespeare sensed, like Freud, a certain uniformity at *bottom*, a constancy in our dreams, and that this is, perhaps, what causes us to resonate with works of art and enter them so fully. I believe a similar theme involving the relation between fantasy (dream) and reality (waking life) is explored in *The French Lieutenant's Woman*.

This theme is developed by the subtle ways in which the creation of character from script by the actor and actress (Mike and Anna) interpenetrates their "waking" lives and gradually affects and alters not only the nature of their "real" relationship but the outcome of their characters' story as well. This phenomenon, central to the film, of an actor's "becoming" in some sense the character he is playing, is familiar to us since ancient times. When, in the Platonic dialogue *Ion*, Socrates asks the actor whether, while acting, he feels he is among the persons and places of the drama, Ion responds in the affirmative and reveals to Socrates that his eyes fill with tears when he recites a piteous tale, that his hair stands on end and his heart throbs when he enacts a tale of horror. In the terms of our film—and of dreams—there is an interpenetration of present by past and a borrowing by the past from the present in order to create the drama.

If then, momentarily, we equate the artistic creation, the film, with dream-work, we see that what is presented is reminiscent of what Freud has described: the dream-work confers upon the trivial events of waking life an emotional power and rich significance through association with unconscious wishes. The rather insignificant story of Mike and Anna is transformed by its counterpart, the story of *The French Lieutenant's Woman*. By means of a variety of techniques including condensation, displacement, representation by symbol and secondary revision, the dream-work (here, the film of the inner frame) invests the residues of ordinary life with a momentous quality. This is why, in this film, we spend more time in the inner frame, the dream, and why we must begin and end with

it. Like Freud, the artist must on some level believe in the preeminence of the intrapsychic, in creation over imitation, in making before matching, though, always, the final product will be a compromise formation.

Thus, two major themes are evident in the film: the effect of past on present, as represented by the alternation of time frames, and the elaboration of fantasy, revealed through the structure of the film within a film. By choosing these ways of working with the material, Pinter has been able to solve the problem of the multiple endings: With two parallel lines of action, he has each story end differently. Hence, no choice is necessary. Again, the chosen mode is relevant to the oneiric for, as Freud pointed out, in dreams all possibilities are fulfilled and "either-or" cannot be represented. In keeping too with Freudian theory is Pinter's reservation of happiness and wish-fulfillment to the realm of the dream and his consignment of suffering and loss to the outer frame, to external reality. In the dream, the work of art, the satisfaction of desire, even forbidden desire, can occur, can be represented as attained.

At this point, I would like to turn to the film and examine its content more closely. My purpose in these next two sections dealing with the outer and inner frames respectively will be, as stated, to demonstrate an interpretive method based largely on concepts drawn from *The Interpretation of Dreams,* not to offer an exhaustive, fullfledged critical reading of the film.

Returning momentarily to Fowles' novel, it seems fairly clear that when the narrative is interrupted and the reader returned to the twentieth century, he or she experiences a distancing from Sarah's story. What happens here is interesting in that, because of Fowles' frequent intrusion of the commenting persona of the author, a bond is set up between reader and author that interferes, even conflicts with the intimacy between reader and characters. It is Fowles' manipulation of these identifications that, in my view, distinguishes this novel and marks it as worthy of note. However, in the film, the outer frame—the sequences with Mike and Anna—serves perhaps an even more complex function than the interpolation of the author's voice. The audience searches and scans these sequences intently, seeking to find clues, causal connections, links between them and the personae of the dream. In so doing, however, we imitate the philosopher who, as Freud says (*S.E.* 5:490), according to the "malicious" poet, seeks to patch over the gaps and disconnectedness of the dream with some model of intelligible experience. But the "logic" here is different; it is the "logic" of secondary

revision, which involves patterning *without* causal connection. We would do better, as Freud suggests, to dwell upon individual elements than to focus on apparent cohesion. Analyzed in this order, the principles of cohesion will ultimately reveal themselves.

Returning, for example, to the motif of the artist and his work, we are shown as the film progresses fragments of Mike and Anna's creative relation to their roles. At one point Anna, lying languidly on a bed, reads statistics about the number and origins of prostitutes during a given year in Victorian London; she thereby gains a sudden insight into one of her lines and an intensified identification with her character Sarah. Eventually, when the scene incorporating that line is played, we resonate with it in several modes: Not only do we understand its historical significance, but we now read its meanings both for Anna, for Sarah, and for Mike, whose passive presence is catalytic. Also, importantly, Charles's long nightmarish search for Sarah among the prostitutes is foreshadowed here. Thus, the outer frame has served to guide us to latent ambiguities with which a particular line, when repeated in the inner frame, is charged, and it has provided an idea, an image which, when linked (in our analogy) with unconscious wishes by the dream-work, produces a haunting sequence in the inner film: Charles's wandering among the gaslit streets of London in despair.

At another point in the outer frame, actor and actress rehearse a scene. Anna snags her skirt; she is caught; she extricates herself. The scene is repeated. We see Anna poring over her script. In the glimpses we have of them, both Anna and Mike are portrayed as having a waking life wholly subservient to the inner frame, the film. They are artists living *for* as well as *in* their work; even their sexual intimacy seems inextricably linked with the film that they are making. All aspects of ordinary life (home, family, lover) have been expunged as they incarnate their characters, projecting into the text of their lines their own possibilities and limitations, wishes and fears. As they identify with the text, they are in turn animated by it; its vicissitudes reverberate both on and off the set. Partly defined by their own dreams, they come to know themselves and each other, and we come to know them, wholly in terms of the shared dream, the content of the work of art. We realize anew that we are watching not two parallel stories but alternate aspects of one story; the structure of two frames compels our awareness of the meshing and dissolution of private dreams and of the oscillation between the realm of (endless) private dreams and that of (finite) public existence, a contrast which the film designedly blurs until the end, where the (happy) dream is portrayed as continuing and the

(painful) reality as terminating in despair. (For a related discussion of art-life interplay in terms of the writings of Otto Rank, see chapter 12.)

What is the nature of Anna and Mike's relationship? Its sexual aspect, with which we are immediately confronted, seems at first "strange," incomprehensible. Though casual and tender, it is unclear what bond or commitment underlies it. The early bedroom scenes confront us with an intimate sexual relationship for which no contextual material has been provided; consequently, they evoke feelings analogous to those of child-voyeurs, for whom adult sexuality appears exciting but incomprehensible. These feelings may be of vague confusion, arousal, and guilt. A sense of the uncanny, in fact, pervades the sexuality of the entire film, and I shall return to this point later on.

It is clear at any rate that Mike and Anna's "love" occurs solely within the context of their film and is inseparable from it. One way of understanding this convergence of sexualized love and work in the context of art is to refer to Phyllis Greenacre's (1957/1971) notion of "collective alternates" in her paper "The Childhood of the Artist." (For a discussion of this paper, see chapter 11.) By this term Greenacre suggests the artist's tendency to be drawn into intense relations with aspects of the environment that surround, are components of, and that may eventually supplant, the main object relationship. This concept can certainly work in reverse (as would be the case, for example, with a painter who falls in love with his model, as in Balzac's short story, "Le chef-d'oeuvre inconnu" [1831/1837]). Thus, taking it in reverse, we can use it to understand Mike and Anna's erotized alliance and, at the end of the film, to see their pain as due not only to their parting from each other but equally to their loss of the work of art that has sustained them.

Thus, at the completion of the film, they face a two-fold bereavement, determined in part by the emptiness and depletion that frequently characterize artists after a period of creative effort. However, Anna and Mike's final separation is necessitated not only by the tie of love and artistic work that binds them but by the illicit, incestuous substratum of this tie which must, in punishment, be dissolved. I shall try later on to show how this unhappy ending in the outer frame is compelled by the final union of Sarah and Charles in the dream.

It is not in the outer frame, but, as noted above, rather in the story of Sarah and Charles, in the dream *per se*, that the most vivid

images of *The French Lieutenant's Woman* occur. It is here that the overall hallucinatory quality of the film is at its height. Freud (*S.E.* 4:330) speaks of the most vivid elements of a dream as being those with the most numerous determinants, those formed by the greatest amount of condensation. He speaks of intense elements as "nodal points" in which we experience the confluence of affects from many sources, the starting point of numerous trains of thought. Particularly striking examples of such images occur at the beginning and at the very end of the film.

We see in the first of such images (figure 10.1) the French lieutenant's woman standing on a flooding sea wall. Wrapped by a hooded black cloak, her wild red hair escapes to the wind and rain; a violent storm rages around her, threatening her life. She is glimpsed at first from afar, mysterious, out of reach. The wall upon which she stands, symbol of invulnerability, is being overwhelmed by water; the black of her garment signifies death, mourning; her red hair unbound suggests wantonness, abandon, lust. Seen from a distance, her human form seems dwarfed by the storm with its surging waters, like that of a child caught in the tide of torrential passions. There is an ambivalence about the image arising from the condensation of these many elements, affects, ideas, upon which the aesthetic effect depends. The image both attracts and repels, inspires sympathy and shame. It evokes longing and fear, desire and punishment. Its threatening waters allude to the most primitive trauma, to birth, as well as to death.

Charles' immediate reaction to this image is to feel an urge to rescue the woman. Unhesitatingly, he leaves his intended bride and attempts to approach this stranger who exerts upon him an irresistible appeal. It is as though he is convinced that she is in need of him, that he must abandon all and save her. Freud (*S.E.* 11:166–174), in speaking of the special kind of object choice in which a man seeks a woman who is unavailable because of a previous relationship or who has a sullied reputation (apparently true here on both counts), traces the origins of this accompanying rescue-motif to its oedipal roots, explaining that the man who, in a dream, rescues a woman from water, signifies thereby that he makes her a mother, makes her, in fact, into his own mother. The mechanism of reversal is at work here with the trauma of birth being invoked both as the primal danger from which the child was originally saved by the efforts of his mother and as that which stands for the sexual act in which the mother is now given a baby like the child the man once was, thus enabling the man, via this rescue fantasy, to identify completely with his own father. Further on, I shall develop more

fully the oedipal structure of Charles's relationship with Sarah; what I want to demonstrate here is the way in which central images in the film visually condense multiple (unconscious) strands and to show that from this condensation they derive their power.

As the film ends, another image occurs, again condensed and magical, a contrasting image of undisguised wish-fulfillment: a scene in soft and muted colors of a man and woman moving rhythmically together in a boat over calm water. We view this image through a semirounded portal that, though in the lexicon of dreams may represent the vaginal orifice, here works also as an eye that opens onto both inner and outer space (fantasy and reality). This aperture, furthermore, presents us with a visual analogue for the multiple framing devices that, as I have tried to show, structure the entire film both psychologically and aesthetically.

The aperture offers an inviting vista that promises peace, harmony, union, but also the unknown. Hilltops rise in the distance; the presence of water surrounding the figures and enclosed in a rounded shape suggests a recapitulation here of birth fantasy beneath all developmentally later signification—a sense, perhaps, of being "reborn" through love. One sympathetic anonymous reader of my essay has observed that this egress from dark tunnel to clear water is reprised under the end titles but this time from a point at which the iron grate, which had been slowly raised during the couple's first exit from the darkness, is now raised out of sight. Thus, the juxtaposition of the two images suggest even more strongly the theme of parturition.

Throughout the film, as in these scenes, water plays a central role. Its color, pace and temperament change as the narrative progresses. In Sarah's first house with Mrs. Poultney in Lyme, she looks out over the English Channel whose waters are loud, dark, and turbulent. By the end of the film she inhabits another house which overlooks serene waters, cerulean blue and sparkling. In the outer frame there is a brief beach scene between Mike and Anna. As indicated, water often figures birth and has here the extended metaphoric significance of the birth of a work of art, the creation of a film. Freud has pointed out to us the use of reversal in terms of this symbol, where going out to water or going into water may stand for being taken out of the intrauterine waters (as in the story of Moses and Pharoah's daughter). Water may engulf internally as well as externally, as when Charles, after making love to Sarah and then losing her, goes up to his London club and attempts to drown himself in liquid (aqua vitae). An enormous bowl of champagne

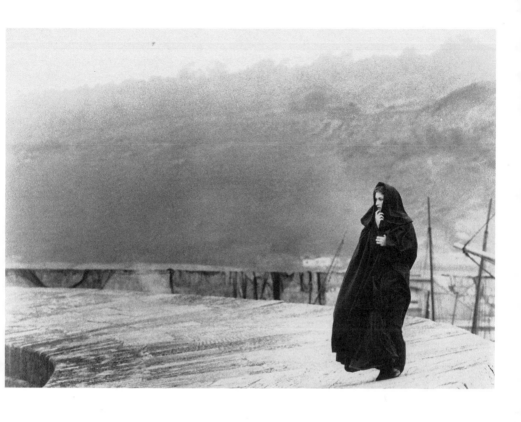

Figure 10.1. Scene from *The French Lieutenant's Woman* (1981).
Museum of Modern Art/Film Archives, New York.

punch fills the frame here, followed by bottles of claret, glasses of port. Charles falls, a victim of liquid taken internally. Having "saved" Sarah from drowning (on the sea wall, in her misery and degradation), he is engulfed by his passion for her and must, as Freud (*S.E.* 11:168) says, not give her up. From this point on, their roles are reversed. (For a related discussion of the significance of water in the mother–daughter relation, see chapter 8).

At this juncture, I would like to review the way in which the film presents the etiology of Sarah's melancholia and relate it to Freud's *Studies on Hysteria*. Initially, it is mysterious; when Charles, deeply distressed by her aberrant, reclusive and ritualistic behavior, consults a local doctor, he is told authoritatively that Sarah is known to be suffering from an obscure type of melancholia. This diagnosis is supported by the "evidence" that, though many women are abandoned after seduction, few, according to the doctor, react with such extreme anguish. Secrecy shrouds her as does her hooded cloak. We surmise only that some trauma or powerful, unfulfilled wish lives on in her mind, producing fantasy, reverie, a pattern of withdrawal from disappointing reality into the self.

When Charles finds her lying under a tree on the cliff overlooking the sea or, later, recumbent in the hay of the barn on the undercliff, she jolts as she is approached. We sense that she has been intensely absorbed, day-dreaming, withdrawn into an inner world of self, an altered state of consciousness more real to her than any other. As if to confirm this, she tells Charles explicitly that her only happiness comes in sleep. Again, if we make the momentary leap of equating sleep with dream and dream with work of art, we may read her statement as expressing a major theme (and problem) of the film: The gradual realization that, though dreams (art) can provide us with representations and thus with a certain kind of experience of gratified wishes, yet the human organism can be but temporarily satisfied by such solutions.

Finally, it is with her cry, uttered during the scene of passion when Charles, after climbing a flight of stairs, finds her in a shabby room in the Endicott Family Hotel in Dorchester, that the mystery of her melancholia is resolved. Hearing Sarah cry out, we understand at last that her longing for the French lieutenant had never been consummated. As in Freud's early hysterical patients, the story of her seduction turns out to have been a fantasy. We can discern here a parallel with Freud's theoretical progression from the seduction theory to the theory of infantile sexuality, as we understand Sarah's suffering now as emanating not from trauma but from

long suppressed sexual desires stemming from childhood, reawakened by the French lieutenant (and now by Charles) and frustrated with no possibility of external discharge. Her response, described in terms of Freud's early theory, has been regressive, a cathexis of hallucinatory wish-fulfillment that must, ultimately, fail. Art, in our analogy, cannot substitute except momentarily for life—which is, after all, what Puck actually reminds us in his closing speech about the offending shadows. To adapt, we must give up the dream, not take it too seriously perhaps, or somehow manage to integrate it, which is impossible for Sarah at least until her moment of sexual union with Charles.

This scene is also highly condensed: the confining, drab, impersonal hotel room, Sarah's foot swathed in bandages, the fireplace emitting dangerous sparks. Love and hurt, passion, pain, tenderness, relief, guilt and brutality come together in that confluence of affects Freud has described. The overall sense is, as I have suggested, that of the uncanny. Yet, the mystery of Sarah is solved in this moment, and from this time on she is in some sense freed. Her name, as we later learn, undergoes reversal after this time. From Woodruff, she becomes Roughwood, signifying an inner change perhaps from a passive (regressive) to a more active (adaptive) mode, and the kind of linguistic mirror reversal involved in this change characterizes primary process functioning both in and out of dreams. It is important to note here also that her subsequent abandoning of Charles after defloration may be interpreted in terms not only of the mechanisms of reversal, the turning of passive into active, and even of a certain identification with the aggressor, but also in terms of the bitterness Freud (S.E. 11:200–208) describes in his analysis of the repressed feelings occasioned in a woman upon the loss of her virginity.

Dream symbolism in the film is, as we have seen, unbiquitous. A felicitous example, besides water, is the garden. Both Ernestina, Charles' rejected fiancée, and Mike's neglected wife have gardens— cultivated, tended, orderly, and fertile. These gardens are abandoned in favor of brambles and thicket in the same way in which available women are passed over and neglected and the unattainable woman sought.

A consideration of this imagery—of gardens, woods, and unrequited love—links up again with A Midsummer Night's Dream and with the final point I wish to make here, namely, an interpretation of the uncanny feelings aroused by sexuality in this film. How can we explain Sarah's intense and persistent longing for a

French lieutenant who, as she plainly acknowledges, will never come back "because he is married?" Likewise, how shall we account for Charles' parallel yearning for her, for the French lieutenant's woman, who is so remote, inaccessible, and yet irresistibly attractive? What childhood wish persists with such vividness? Clearly, these inexorable desires may be identified as oedipal in origin. If we so understand them, we can then trace our sense of the uncanny to what Freud has called the "return of the repressed," that is, to the revival in the characters in the film of powerful childhood wishes toward their parents—the ultimate unavailable sexual objects—and to our unconscious identification (as members of the audience) with these wishes, which then suffuse the sexual scenes of the film with a pervasive aura of momentousness, strangeness, and confusion.

From this perspective, the two endings offered make psychic sense. They are complementary: they satisfy, in psychoanalytic terms, both ego and id. Instinctual wish fulfillment, however, is given the final say, the ascendancy which—in a work of art—is perhaps as it should be. The unhappy ending of Mike and Anna, analogous to Puck's disavowal, reminds us of our adaptive exigencies, our needs to renounce the dream and to return to the everyday world of logical (rueful) consequences where secondary process holds sway. The near simultaneity of the two endings gives us a sense of their interdependence, of the interpenetration of conscious by unconscious and a renewed awareness that in every act of art and life, the past informs the present and is in turn created by it. Reinforcing this interpretation, in one of the final moments of the film, inner and outer frames converge as Mike accidentally calls Anna by her stage name, "Sarah."

Freud (S.E. 4:283), discussing condensation, quotes several lines from Goethe and compares the dream to a "weaver's masterpiece," an infinite combination of a thousand threads and treadles. Because of obvious limitations, I have not in this essay followed all the threads of The French Lieutenant's Woman that might have been explored by the method I have employed. My purpose has been simply to demonstrate that method. I have tried to prove the relevance of dream interpretation to film analysis by taking as my example not a great film but a recent one, a film that had to be created by translating a literary work into visual terms and a film that utilizes the model of a play within a play so that we could consider this structure. Thus, we have been able to study the rela-

tionship of two levels of meaning as well as certain mechanisms of primary process functioning as they manifest themselves in the art of film. In addition to considering examples of condensation, displacement of affect, symbolic representation, reversal and the return of the repressed, Freud's theory about regression in hallucination from verbal idea to pictorial image has also been invoked as a model for understanding the unconscious processes involved both in making and in responding to film.

Like Puck, I should like to conclude with a demurral. I do not believe that any conceptual framework as yet developed can thoroughly account for a given work of art; rather, different schemata provide their own characteristic types of insight that may be judged as more or less relevant to specific media and works drawn, for example, from different historical periods. My claim here is simply that psychoanalytic theory, particularly as developed in *The Interpretation of Dreams*, has special applicability to the art of film, where it can, by revealing aspects of unconscious functioning, heighten our sensitivity to ambiguity.

New Lamps for Old?

Reflections from and on Phyllis Greenacre's "Childhood of the Artist"

This essay was written to fulfill the last request made of me by my mentor and colleague, Robert S. Liebert, M.D., whose pioneering work in psychoanalysis and the arts persuaded me that this could indeed constitute a legitimate field of inquiry. In our last conversation, he asked me to contribute to a panel on Phyllis Greenacre's study of the childhood of the artist. This is that essay, dedicated in gratitude and in sorrow to his memory.

In her sparkling paper on "The Childhood of the Artist," Phyllis Greenacre (1957, 1971) speaks of splits in the self-representation of the artist. First, there is what she calls the "freakish" persona of the artistic self versus a more conventional, ordinary citizen self; and secondly, there is an innovative, relatively unbridled risk-taker versus a sober, restraining critic.

This essay is an attempt to dramatize that split. First, the inventive side will be enacted in the form of an extended simile that juxtaposes Greenacre's ideas on the childhood of the artist with images drawn from the tale of "Aladdin and the Wonderful Lamp" from *The Thousand and One Nights.* Next, the sober side will stage a critique of Greenacre's paper from vantage points located outside psychoanalysis and will address a few relevant issues neglected by her text.

Just as the magical lamp of Aladdin was found among jewel-fruits of diamond, opal, moonstone, jasper, and carnelian, so Phyllis Greenacre's paper is to be discovered in a treasure trove—a group of brilliant essays on creativity in the second volume of her collected papers. This is an oft-neglected classic with untold riches not only for clinicians but for all who are at work, for example, on the biographies of artists.

My title is taken from the "Tale of Ala al-Din and the Wonderful Lamp," found in volume 3 of the Powys Mathers translation, *The Book of the Thousand Nights and One Night* (1972).

First presented in a panel sponsored by The Association for Psychoanalytic Medicine, New York City (October 1988), some sections were also read at the 1989 College Art Association symposium on "Art History and Biography," in San Francisco. A version appeared in *The Psychoanalytic Review* (1989) 76:557–566, published by The Guilford Press, and permission is here gratefully acknowledged.

In rereading these studies, I began to feel myself in the grip of a veritable Scheherazade who, again and again, just as morning—that is, light—began to dawn, would discreetly fall silent. Not that Greenacre willfully tantalizes her reader by witholding her insights. But, like the fabled favorite, gifted with the rarest of narrative skills, she enthralls her audience with the sense that there is always something more to come—more than is being uttered at any particular moment. And I hope by this analogy to convey the profound sense of humility with which she approaches her delicate subject; above all, to prize her refusal to bring her story to premature (theoretical) closure. As King Shahryar puts it on the seven-hundred-and-seventy-fourth night, Scheherazade inclines him to ponder her words while desiring her at the same time to go on.

My metaphorical gloss takes its warrant from Greenacre's own pervasive theme of childhood. For although my text, *The Thousand and One Nights*, was not written for children, it is in our childhoods today that we encounter Aladdin and the others, Ali Baba, Sindbad the Sailor, and so on. Furthermore, in developing her ideas for this essay, Greenacre drew upon her own previous work specifically on artists (authors) who wrote stories beloved by children. (I am referring, of course, to her analyses of Swift's *Gulliver's Travels*, Lewis Carroll's "Alice" books, and the nonsense verse of Edward Lear.)

Explicitly, I shall take Aladdin's tale as a prototypic saga of the gifted child. Impractical in the extreme, unpromising in his behavior, a rascal, Aladdin is strikingly handsome with magnificent black eyes and skin of jasmine (so goes the text). His development is traced in the tale that bears his name. Suffering in childhood the loss of his father, a poor tailor, he runs about the streets of an obscure city in China playing with other urchins until suddenly he is "discovered" in early adolescence by a disguised and evil sorcerer-Moor who marks him as special, gives him an enchanted ring, and initiates him into the cave of the lamp, thus sparking changes of far-reaching consequence.

Having obtained possession of the magic lamp and its powers, Aladdin grows in virtue and worldly knowledge. His strange and wonderful adventures include his bizarre courtship of and eventual marriage to the Sultan's daughter, Badr al-Budur, for whom he erects a splendid palace. After a long-delayed but final triumph over his enemies, Aladdin's story ends with his approaching fatherhood, a key passage being: "He who leaves a son does not die"—a message that binds the theme of creativity with that of procreation, an

important linkage insufficiently developed in Greenacre's paper. My purpose here, however, is not to retell the complex tale but merely to draw upon its imagery for the illustration of Greenacre's text.

The Jinni of the lamp can be seen as etymologically and conceptually related to the notion of "genius"—the avowed focus of Greenacre's paper, which she tends to characterize as "dazzling and mysterious"—terms equally applicable to a Jinni or an Ifrit (this is an Arabic term connoting "demonic," whereas "Jinni" means "out of the bottle"). Upon being summoned, the Jinni announces himself as "master of earth and air and wave." In the words of the text: "As soon as Aladdin had unwittingly rubbed [it, ring or lamp], he saw a great black Ifrit rise from the earth before him with red flaming eyes who [spoke] in a voice of thunder [and] Aladdin . . . [nearly fell] into a swoon"—a scene that extends the meaning by dramatizing another of Greenacre's theoretical constructs, namely, *awe*. Described as an experience of exhilaration and intense bodily sensation, awe is derived by Greenacre from the young child's initial vision of an adult tumescent phallus which, in the case of the gifted, is then readily transferred and extended to other phenomena in the external world.

Thus psychoanalytically, in Greenacre's terms, the notions of genius and Jinni are deeply linked. Importantly, the Jinni appears only when the boy rubs his magic lamp—an object of irresistible desire to another, older male (the wicked sorcerer-Moor) whose urge to possess it exceeds the price of treachery, deceit, and murder. This lamp is prototypic of the fetish-object Greenacre connects intimately, yet imprecisely, with art.

Especially compelling is that the triad (boy/lamp/Jinni) condenses both libidinal and object-related components of developing creativity, in Greenacre's terms. Enormous, potent, preeminently phallic, the apparition rises in smoke and, towering over the child, seems to embody his need for an "identification with a father—or with a specially powerful godlike figure"—a need that (in the case of unusually endowed children) crystallizes into an idealized imaginary being. (Parenthetically, one might compare the Jinni, viewed in part as a representation of Aladdin's lost, longed-for, feared, yet idealized father, with the powerful, wish-fulfilling fairy-godmother of the Cinderella story, who also emanates from the imago of a vanished same-sexed parent. Such an analogy, however, would reveal an unacknowledged gender-specificity in Greenacre's formulations and thus point to possible limitations in their applicability,

an issue I shall address later. For a gifted girl, in other words, it may be significant to evoke and tap into maternal powers rather than those exclusively of the phallic father in order to actualize her latent creativity.)

Greenacre speaks of a blurring of the libidinal phases in creative children and stresses an ongoing preeminence of anal themes (a major motif in her treatment of *Gulliver's Travels*). This close relation between anality and creativity has also been explored with great originality by Chasseguet-Smirgel (1985; see discussion in chapter 2). We find it here in the notion of "inspiration" (breathing in and out, air, gas, smoke, flatulence) associated both with genius and with Aladdin's Jinni, who "surges out of thin air . . . his black head scraping against the ceiling." Likewise, such associations are extended by repeated allusions to the blackness of both Jinni and Moor. The sooty lamp itself contains an oil that must be poured upon the ground before Aladdin can remove the lamp from the depths of the cave; concealed under his clothes, it slips round to his rear and, as he complains, actually hurts him. Ongoing anally derived issues of mastery and slavery are at stake here as well—both for the Jinni and for the boy.

Interestingly, there is one moment early in the story when Aladdin's mother (who plays a crucial but somewhat devalued role) decides to clean the lamp in order that it may bring a better price when sold. She herself rubs it, and suddenly the Jinni appears to *her!* Terrified at the sight, she freezes into immobility, "rooted to the floor with knotted tongue and open mouth, falling forward in a swoon." This is most interesting psychoanalytically, for it reverses the paradigm of Medusa: it evokes not the castration terror of the male upon beholding the genitalia of the female but rather a construction by a male of the female's terror at beholding the male phallus. Upon her recovery, Aladdin's mother begs her son to banish the lamp, calling it the "gift of devils." Aladdin, however, knows that it is indispensable to him. He tells her that it has saved his life and he cannot give it up but promises never to show it to her again. After this episode, true to his word, he hides it away and has recourse to it only in deserted places or in the seclusion of his own bedchamber. Later in the story, he does not rub it in the presence of his wife.

These details are highly suggestive in light of the place given to masturbatory fantasies in Greenacre's discussion of gifted children. They may also be related to a study of creativity reported in the *New York Times* (9/13/88) that emphasizes the need for privacy and

freedom from surveillance. Aladdin, about to use the lamp to com-
plete an architectural feature on his palace, tells the Sultan, "I
cannot bear to be watched while I work." Direct links, however,
between sexuality and creativity are completely absent from the
newspaper article. Greenacre to the contrary, prioritizes sexuality
(and aggression) but remains fully alert to their blending with ob-
ject-related factors. In so doing, she stakes out a rich and fertile soil
for psychoanalytic investigation in the future.

One might also interpret the amalgam of Jinni, boy, and lamp as
an instance of the split self-representations alluded to at the start of
these remarks, a paradigm of the intensely cathected projections
constitutive of that labile sense of reality peculiar to creative chil-
dren. Greenacre's murky notion of "collective alternates" is also
adumbrated here in the sense that Aladdin, through his Jinni, ring,
and lamp, is able, in fantasy and reality, to substitute for as well as
secure and repair his web of object relations, past, present, and
future.

Reverberating thus with Greenacre's key formulations concern-
ing creativity and the artist, Aladdin's tale explicitly dramatizes, for
example, bisexuality and impostership. One vivid instance of this
occurs at the very end of the story, when the Moor's conniving
brother, disguised as an old women, is decapitated by the fore-
warned Aladdin in front of the latter's horrified wife. Smiling, Alad-
din theatrically unveils to Badr al-Badur the severed head of the old
woman, revealing the face to be that of a hirsute male. Here (as
elsewhere) inventiveness fuses with erotized aggression, blossom-
ing in a polymorphous and perverse plasticity.

Family romance, the gifted child's elaborate fantasy of clandes-
tine illustrious parentage, is adumbrated here not only by Aladdin's
tale itself (as indicated earlier) but by the frame story of *The Thou-
sand and One Nights*, a plot of vengeful intrigue between the sexes.
Two brother kings have each been deceived by their wives. One,
King Shahryar, seeks revenge by beheading each new wife after
passing one night with her. After precisely three years of this, he
marries the apparently doomed but exquisitely artful and ulti-
mately triumphant Scheherazade, whose younger sister, her accom-
plice, forms a parallel in the story to the king's brother. Finally,
there are *hidden children!* For Scheherazade climactically produces
on her last night the three infant sons to whom she has secretly
given birth during her three years of story-telling. Here again, the
bringing forth of art is linked (problematically and mysteriously)
with the bearing and birthing of children—explicit male and female

roles, wills, and knowledge all left unaccounted for. Family romance at its extravagant best!

Greenacre's insistence on the gifted child's unusual capacity for response to intense and extended sensory stimulation is illustrated throughout *The Thousand and One Nights*. I shall quote just one passage to convey its ubiquitous sensuality—a description of Aladdin at the *hammam* (the bath):

> It was made all of jade and transparent alabaster, with pools of rose carnelian and white coral. The ornamentation . . . [a] pattern of large emeralds; the eyes and every other organ of sense rejoiced together in this place. . . . The air was of a delicate freshness . . . when the slave of the lamp had set Aladdin upon the dais in the entrance hall, a young Ifrit of immortal beauty appeared before the boy and helped him to undress . . . after reclining him upon a bench, [then] began to rub him and wash him with scented water of different flowers. They kneaded his limbs . . . and then laved them again with musk-scented rose water. Their skilled care gave his skin the fresh tint of a rose petal . . and he felt so light that he was tempted to fly like a bird. (cf., Greenacre, p. 529)

Finally, the frame story of *The Arabian Nights* can be read as an illustration of Greenacre's brilliant thesis that the artist's work product is always, on many levels, a "love gift." Addressed to a special audience, it is invested with high intensity, urgency, and often a sense of fateful pressure. Scheherazade knows that to live she must continue to invent, produce, and, above all, please the king. Thus she stands as a figure for the artist, whose continuing ability to produce successfully for *someone*, even a "phantom" internalized as an aspect of his or her own ego ideal, is experienced in exactly the same dire terms: art as a matter of life or death. Reversal of the usual gender stereotypes (male artist, female muse) seems wonderfully apt too in considering the work of a gifted woman analyst.

Now, turning away from metaphor to don the sober mask of critic, I shall comment on three issues, beginning with gender, from positions located outside psychoanalysis. The reference to Scheherazade is a reminder that although she and Greenacre are both women, "The Childhood of the Artist" is a paper that takes for granted from start to finish that the gifted child is male—a young Aladdin. In another study published immediately after this one, "The Family

Romance of the Artist" (1958), Greenacre limits herself likewise to masculine examples. Later, Greenacre *did* write a paper entitled "Woman as Artist" (1960), about which much could be said. This fact, however, serves paradoxically to underscore the gender bias in the present paper, for to juxtapose the two titles, "The Childhood of the Artist" and "Woman as Artist," is to emphasize the utter unself-consciousness with which the artistic subject is presumed to be masculine in the first.

Clearly, Greenacre's practice here reflects prevalent modes of discourse in the 1950s, but this fact does not give us warrant, over thirty years hence, to dismiss it. We might ask what is at stake here in terms of the limitations such bias imposes on the generalizability of her ideas. That it *does* impose some limitations is clear even from the intertextual reading I have just offered. From the perspective of contemporary interdisciplinary scholarship, this issue of gender is one that has assumed considerable importance. Feminist scholars, for example, would argue that such a text plays, in spite of itself, an ideological role. The unexamined assumption that an artist-genius is male works to reinforce cultural sterotypes and to perpetuate the very social attitudes that have historically retarded the support and recognition of female talent. To avoid criticism of this sort, Greenacre's paper on the childhood of the artist would need to announce in its title that it applies solely to male children or else would have to deal directly with issues of sexual difference and their impact on its formulations. It is crucial, however, to recognize that aspects of Greenacre's thought (such as the notion of the love-gift) *are* applicable to both genders. In fact, as my use of imaginative literature here implies, I believe a counter-claim might actually be made to the effect that, far beyond describing talent or genius, exclusively male or not, Greenacre, in deep and suggestive ways, illuminates the psychic lives of *all children* and, in so doing, of all of *us*. Thus, the opposing selves!

A second issue taken from a vantage point outside clinical psychoanalysis concerns cultural myths that surround art and artists. Inescapably, narratives about artists' lives enthrall the beholders of art. This fascination is fueled by awe, idealization, envy, and wishes for forbidden knowledge about the secret wellsprings of creativity. It motivates endless biographies of artists and stems in part from deeply imbedded Western mythologies about art—mythologies that, to some extent, have coopted Greenacre herself. She accepts, for example, the received notion of "genius" (p. 485) and attempts to probe it psychologically without calling it into question—without

worrying, for example, about the *social construction* of "talent" or "greatness" or the fact that the very positing of an autonomous heroic subject might itself be an issue for debate. By taking such myths for granted rather than interrogating them, her paper tends (as in the case of gender) to underwrite prevailing fictions rather than to unmask them, as does, for example, Roland Barthes in his book *Mythologies* (published the same year, 1957, as hers on the childhood of the artist).

Barthes shows that, because of our obligatory mystification in matters of art, our curiosity is not easily satisfied when biographers, for instance, endow a famous artist publicly with a good fleshly body and reveal that he (or she) likes dry white wine and underdone steak. Paradoxically, this type of information renders the artistic product even more (not less) mysterious. Far from bringing the nature of inspiration into sharper focus, the details of an artist's daily life can serve quite the opposite function, namely that of heightening an already present sense of mythical uniqueness. In worst-case scenarios, reader-beholders, titillated by irrelevant confidences or bombastic theories, simply lose touch with art. Biography and theory become substitutes for direct encounters with art objects. Greenacre, although she begins her paper with a long section on biography, discreetly falls silent on such matters.

Furthermore, although she addresses the plasticity of memory and the importance of agendas in both autobiography and biography, she never emphasizes that, like polyphonic scores, such texts always speak in many voices—historical, political, economic, critical, ideological, as well as psychological. Nor does she deem it important to mention that biographies can serve as agents for producing social change by inscribing the sagas of neglected artists. They can, specifically, expand the canon to encompass the oeuvre of artists previously excluded on the basis of gender, race, or class.

Finally, Greenacre concedes and even stresses the role of aggression in creativity and offers a lovely way of distinguishing it from hostility. In so doing, she valorizes it and encourages us to face whatever destructiveness may erupt in the creative process. She fails, however, to take into account the ethical fallout from her model. Having written elsewhere (see chapter 2) on the inextricability of making and breaking, I believe that the aggression of art, whether it occurs in the arena of physical objects or meanings or in the sphere of an artist's human relationships, can potentially disrupt existing order in ways that entail hard questions of means and ends. And I believe that these ethical issues are of great and ongoing

concern to many artists. Although it is quite true that, as Greenacre puts its, "the expansive aggression of growth of one organism [as of deer in suburbia] may be destructive to another without being hostile," the consequences for the environment can, nonetheless, be exactly the same.

Related to this is her suggestion that the unusually endowed individual may help us to understand sublimation in the less endowed individual. She speculates simultaneously that "in gifted people a process comparable to sublimation . . . does not [in fact] occur" (p. 497). Here again, she falls silent when one would wish her to go on. Does she mean by this that we should question the whole murky notion of sublimation? Her passage seems to foreshadow the recent work of authors like Bersani (1986) who have radically undercut it. As he describes it, sublimation is a paradox, multiplying and diversifying desire while at the same time substituting for it. His description construes sexuality as erupting in creative moments while being repressed and detached from such moments. Even if Greenacre would disagree with this formulation, nevertheless she herself, by denying sublimation to the very gifted, raises unanswered questions and opens up a close association theoretically between creativity and psychopathology—a problem raised also by her statement about the less decisive progression of libidinal phases in gifted children. She stops short of calling for a drastic rethinking of the fixedness of our stage theories altogether, but surely her best insights, if one takes them seriously, do point in that direction.

Earlier, I praised her discretion in refusing to offer theoretical closure; now, I seem to be criticizing her lack of comprehensiveness and follow-through. In playing out these opposing responses to her work, I am, as I suggested at the outset, enacting one of her own best insights and thus demonstrating in a quite personal way the power of her text. Greenacre, in guiding us into the dark cave of the artist's psyche, never leads us far from our own. Like the jewels and small copper lamp of Aladdin, her ideas sparkle, emitting rays and producing reflections that extend beyond the pages of her text. They promise wealth to all who would revisit there.

Conflict and Creativity

Reflections on Otto Rank's Psychology of Art

For various historical, political, and theoretical reasons, Otto Rank's work has been relatively neglected by mainstream psychoanalysis, and, undeniably, his prose is turgid. Yet, he has much to say to those of us who care about the arts, and this chapter is intended to kindle sparks of interest not only in his provocative contributions per se but in the intellectual shimmers they emit.

In the preceding chapters, I have attempted to demonstrate that experiences in the arts can deeply enrich the interpretive repertoire of mental health professionals and that, likewise, the concerns and experiences of clinicians may enhance the frames of reference of scholars in the humanities, of arts educators, and of amateurs. In this final chapter, I shall discuss the ideas of Otto Rank, a psychoanalyst in the early, turbulent days of the Freudian movement who sought to describe art-making and its attendant conflicts from a position that accorded them a priority rather than reduced them to a special case of more general theoretical principles. This is important because a characteristic *bête noire* of interdisciplinary endeavors is the simplistic reduction of issues in one field to the terms of another.

Rank's lifelong interest in the artist and in issues of creativity stem from his childhood (Eisenstein 1966). Born into a Viennese Jewish family of modest means, Rank (1884–1939) experienced a family environment in which his alcoholic father appears to have played a major role. In a climate of difficult daily interactions, Rank felt it necessary, by mid-adolescence, to take the radical step of breaking off spoken relations with his father and disavowing him by relinquishing the family name, Rosenfeld. In its place, he assumed the new name of Rank. This symbolic enactment of aggression and self recreation had longlasting repercussions. From the perspective of

Early versions of this chapter were presented at the American Art Therapy Conference, Los Angeles, 1986, and at a panel, "Art, Psychoanalytically Speaking," held at the School of Visual Arts, New York, December 4, 1986. A version appears in *The Journal of Aesthetic Education* (1989), vol. 23, no. 3. Permission is here gratefully acknowledged.

the present essay, it is of moment because it helps us grasp at least one source of Rank's interest in the self-making of the artist, his need, so to speak, to give birth to himself, albeit at great cost. Since to deny one's father is, on some level, to deny oneself, the story suggests that it might be worthwhile to inquire as to what aspects of the self any creative individual leaves or attempts to leave behind in enacting similar disavowals and reengenderings. In Rank's own case, his later developmental theory dethrones the father, who is, of course, enthroned by Freud as principal parent. This is so in the sense that the moment of birth, or primordial separation from the mother, is regarded by Rank as paradigmatic for all later losses and traumas rather than, as Freud had described it, castration at the hands of the father. Thus, in his theory, as in Rank's life, there is an (abortive) effort to leave the father behind.

It is interesting, as a brief digression, to speculate on the symbolic significance of the act in adolescence of the creation of one's own name. In many cultures this is an accepted mode of establishing independence from the nuclear family. On the contemporary American scene, one might cite the New York City seventies' graffiti artists whose spraypainted nicknames on subway cars are never given or proper names but rather "tags" that serve to symbolize the connection of these adolescents to street and peer group rather than to their families of origin (see chapter 2). Assuming a new name constitutes a kind of rebirth, and thus it is not without significance that Rank's major theoretical text, The Trauma of Birth (1929) was dedicated and presented to his mentor, Freud, on the latter's own birthday. It was this book that resulted in Rank's painful and irrevocable rupture with Freud who had by that time become to him a second father.

Erik H. Erikson, another distinguished psychoanalyst, similarly concerned with exploring issues of identity and creativity, also created his own name. Taking Homburger, his father's name, only as a middle initial, he entirely ignored his mother's maiden name, Abrahamsen. Thus, Erikson generated his own identity, doubly, in form and content. This act, along with the nidus of conflicts surrounding it, he then inscribed as a recurrent theme in his own theoretical writings (Erikson 1950). For Rank, the issue was more concretely the birth experience itself, but in both cases, assuming new names in adolescence prefigured later intellectual preoccupations.

Jacques Lacan, the French psychoanalyst, has also underscored the transcendent significance of names (Lacan 1977). Proper names,

he points out, are untranslatable from one language to another and both preexist the birth and outlast the death of the body. Names, unchanging (unlike faces and bodies), denote and survive us and are engraved into our tombstones (see Richardson 1985). To reject the name of the father is thus, according to Lacan, a profoundly significant act which, because of the *double entendre* of the French *(nom/ non)*, may be interpreted as a refusal of the symbolic order, a turning away from paternal law and prohibition altogether to an imaginary relation with the mother. Such a subversive or regressive move, it could be argued, is partially enacted in the case of Rank's own theoretical writing.

To speculate further on these connections, however, would be to digress from the main theme of this essay. Theory and art are never independent of biography. Having lacked, for example, a father with whom he could identify in a positive way, Rank's early readings in the available nineteenth-century literature assumed an aura of extravagant hero worship. Imaginary encounters with Ibsen, Dostoevsky, Schopenhauer, and Nietzsche set the stage for a lifelong fascination with the motif of the birth of heroes—both actual and symbolic—and with the extraordinary capacity of minds to originate and to conceive.

When Rank met Freud, he gave him, as mentioned above, an essay on the artist. Favorably impressed, Freud rapidly became Rank's patron and mentor: thus, in him, Rank acquired a new and idealizable father. Gradually mentorship evolved into collegial companionship, and Freud accorded Rank a place of honor in the coveted inner circle of Viennese psychoanalysis, while, on his part, Rank believed that Freudianism would provide the intellectual tools with which to probe the gnarled roots of artistic creativity. Having entered Freud's circle with virtually nothing but his own native ability, Rank must have felt that Freud had, in a very real sense, given him birth. Recorded instances of the younger man's servility to his benefactor stand as a testament to his feelings of indebtedness—a (not unconflicted) indebtedness that, as Rank pointed out later, often finds echoes in artists' highly charged relations with their teachers and patrons (see Roazen 1971).

The subsequent advent of Rank's own fatherhood provided an occasion for the act of originality on his part that precipitated his break with Freud. When Rank's wife Beata became pregnant in 1919, the event triggered profound emotional and intellectual repercussions as might have been expected in light of his early history. Thus, approaching parenthood impelled Rank to ponder not only

issues of creation but of procreation, and especially to consider the power of the first human relationship—that between mother and infant—a topic Freud himself had underemphasized. It was not however until 1923, when his small daughter was already a toddler, that Rank completed *The Trauma of Birth*. As mentioned, the book was dedicated to Freud who, at first, did not seem to recognize in it the apostasy he later decried.

Apropos the theme of conflict and creativity, it is worth noting that Freud's rejection of Rank was symptomatic of the complexity and ambivalence that infected his own collegial ties. Much as he cherished fine minds and enjoyed their presence, Freud was apparently incapable of tolerating their tendency to evolve in independent, original, and unpredictable ways. In instance after instance, he would appreciate and support a colleague up to but not beyond the precise point when that colleague began to develop in a direction Freud perceived as a threat to his own. Stemming, as he explained, from experiences suffered in his own childhood, these feelings and their origins were apparently easier to describe than to master (see Freud, *S.E.* 4:198). Thus, in uncharacteristically harsh ways, Freud did, on occasion, disavow and wound formerly esteemed collaborators; Rank was in distinguished company.

With his publication of *The Trauma of Birth* (1924/1929), it became clear that the nurturing, protective, powerful birth mother—relatively neglected by Freud—had moved to center stage in Rank's thinking. His thesis that anxiety stems from the trauma of birth, that is, from separation from this primal mother, dovetails with his sensitivity to artists' fears surrounding the birth (the making, completing, exhibiting, selling, giving up) of works of art. In his insistence that the event of birth is *the* crucial fact of life, we see parallels with his concerns about the conception of art works. Where Freud had placed the father at the core of emotional life, Rank now substituted the mother—an instance again of biography intruding into creative life.

In Rank's account of basic personality types, he accords the most advanced status to the artist, whom he identifies as that individual who can create by means of symbolic function a web of ever-expanding relations between his own inner and outer worlds. This is in contrast to less creative individuals who tend to identify themselves rather unreflectively with the outside world according to prevailing societal norms. A third type, the neurotic, is described

by Rank as a failed, frustrated artist, unable to endure intrapsychic separation from the objects of his earliest attachments. Thus, according to Rank, the symptoms of a neurotic are best seen as expressive of an inherent creativity gone awry (Schmitt 1975).

Rank's notion of the neurotic as a failed artist accords well with the work of certain other authors. D. W. Winnicott (1958) for example, has stressed with great poignancy and persuasiveness the self-curative aspects of symptoms and their inherent creativity. Both his and Rank's thought tie in as well with that of the contemporary French psychoanalyst Joyce McDougall (1980, 1982), who writes with empathy about the failed (maladaptive) creativity of her artist-patients. Likewise, Gilbert Rose (1978, 1987) has discussed what he calls the "creativity of everyday life" and comparisons between artistic and psychopathological processes.

After his rupture with Freud in the late twenties, Rank's move to Paris put him in contact with such figures as, for example, Henry Miller and Anaïs Nin. Thus, he had in this period ample opportunity to observe at close range (and in his consulting room) the workings of the artist's psyche. Stressing the possibility of creative integration of conflict, Rank held that Freud had erred by conceiving the ego as too passive. He adopted a more optimistic stance, encouraging individuals to discover their latent capabilities. The general tenor of his stance is revealed in passages by Anaïs Nin who wrote, concerning her analysis with Rank, that "what predominated was his curiosity, not the impulse to classify . . . [and that Rank was intent on discovering in her] a woman neither of us knew" (Nin 1966:272, 273).

Among Rank's direct contributions to the realm of the aesthetic mention should be made of a striking early essay entitled "The Myth of the Birth of the Hero." This piece contains his interpretation of the myth of Oedipus and offers psychological insights not to be found in the Freudian text.

In considering the mythic narrative that forms the basis of Sophocles' play, Rank focuses, in this case, directly on the father. He notes that Laius and Jocasta, parents of Oedipus, make a joint decision to abandon their infant—to dispose of him. As is well known, they arrange for a trusted shepherd to have his feet pierced and then to take him to Mount Cithaeron where, exposed to the elements, he will, as they purpose, die. The reasons for such unnatural parental cruelty is, of course, that the Delphic oracle has foretold that (in punishment perhaps for Laius' previous betrayal of

trust by the homosexual seduction of his friend's young son) he, Laius, will, if he bears a son of his own, suffer death at the hands of this son.

Freud's interpretation of this play and its centrality to his theory need no review. Rank's alternative interpretation focuses, fascinatingly, on the fantasies that the parents develop concerning their child—fantasies that, as the myth reveals, precede the actual birth of the child and profoundly influence the course of action adopted by them toward him. Such fantasies can be analogized with those experienced by artists during the gestation period of works even long before materials are actually taken in hand.

Laius, terrified by the oracular decree, seeks to avert it by abstaining from relations with Jocasta. He dares have no successor. He wants to become, rather, his own successor, to preserve himself indefinitely: to negate time. To decline fatherhood is to refuse, on some level, to accept the reality of one's own death. Thus, Laius denies the fundamental sociobiological givens of time and generation and of the mutual creation of new beings. That he refuses these basics of human existence is already prefigured in his wanton and impulsive seduction of a child. To refuse such realities is, inevitably, to incur tragedy.

Oedipus, as the son of a father who wants no successor must replicate the refusal of his own father by mating with his mother, thus also short-circuiting the inevitable flow of the generations and denying the finitude of his own existence.

By reading the myth in these terms, Rank focuses our attention on psychological issues quite different from those given priority by Freud. Rank asks us, implicitly, to take account of the complex meanings that children have for their parents even before they come into the world as well as, certainly, thereafter. What does each child signify to his or her father and mother? What, by analogy, does each work of art signify to its creator? What is imagined for him/it? What hopes and fears are awakened by his or her birth/its completion? In the case of Oedipus, there are in the literature some compelling speculations that, indeed, Jocasta and Laius may have had very different agendas where he was concerned and that Jocasta—out of her rage at being neglected by Laius—may have colluded with the shepherd to have the infant spared, taken into the care of King Polybus of Corinth in order precisely that he might thereby be enabled to grow up and to fulfill not only the vengeful prophecy of the oracle but her own vindictiveness as well (Stewart 1961). In analogies with art-making, it is interesting to speculate on the

complex meanings each project may carry—as gift, as threat, as dare, as entreaty—for and to its creator.

Rank's major text on the artist begins by stressing that artists do not simply create art; rather, they use art in order to create art (Rank 1968:7). Thus, artists and their work belong importantly to historic time—a point occasionally and conveniently overlooked by psychologists of art with universalizing tendencies. Rank, however, takes this as source of the inherent dualism of the creative process—a dualism that often proves agonizing and even paralyzing. The conflict he delineates is between the artist's need to use forms, materials, and techniques that stand ready to hand, that is, to participate in a tradition of some sort (be it technical, stylistic, iconographic, ideological, etc.) versus a powerful, contrasting wish to create that which is absolutely new and one's own (see earlier discussion of Oldenburg, chapter 2). The phenomenon is similar to what Harold Bloom (1975) has termed the "anxiety of influence," Bloom's argument being that new works represent systematic restructurings of previous ones—efforts to undermine the hegemony of the latter and to triumph over them. Melanie Klein's (1975) thought is also relevant here in that she has emphasized the inevitable envy of artists and their need to spoil and devalue as well as to appropriate the work of predecessors.

To speculate on this point, one might consider the highly conscious as well as unconscious dependence of the creative artist on art—on previous art, on contemporary art, on his or her own art, and on other artists themselves. André Malraux has, of course, addressed this issue extensively, though not precisely from the perspective of the psychological conflicts it may produce in the artist. In his 1983 study of Michelangelo, however, Liebert dealt with the element of conflict by tracing unconscious roots of certain of the master's iconographic choices and quotations made from the works of other artists, both ancient and contemporary. For Rank, this notion of using art to create art stands as *the* central, inherent source of splitting in the creative process and, stubbornly, he refuses to reduce it—or delimit it—or derive it—from either oedipal strivings, that is, fears of outstripping the father (as does Bloom) or from preoedipal dyadic struggles, that is, envy of the creative power of the mother (as does Klein). Rather, Rank gives it priority. In so doing, he inspires us to consider how it feels subjectively to the artist.

To defend against deep fears of isolation brought about in part by

his or her giftedness, the artist seeks to identify with teachers, mentors, and with artists of the past. Loyalty to these figures is, however, opposed by inner demands for loyalty to self-development. Creative impulses impel the individual into realms where traditions of the past cannot be adhered to and must in fact be abandoned. Then, in response to unconscious needs for self-punishment, he or she may suffer—not conscious guilt—but temporary blocks to further progress or other symptoms.

Of great interest here, a thought stimulated by Rank's text, is the relevance of the artist's own previous work to the ongoing creative progress. What is the nature of one's relation to that other artist— those other artists—who are also one's self? What does it mean, for example, to be surrounded in one's studio or at an exhibition by one's own works? How do such works function vis-à-vis the artist? As blandishments, as spurs, as goads, they may exhort to further productivity. They may represent split-off parts, old friends, beloved relics of a past life—tokens of passion, effort, or anxiety overcome. One's works can, at times, seduce one into self-plagiarism, lull one into complacency. Thus, contrarily, from time to time, and chronically with some artists, the old works must be bitterly repudiated—disdained, disavowed, even destroyed, as the terrible conflict between new and old is played out even in the context of one's own productions.

To create is thus always, on some level, to disavow, and to disavow is, almost inevitably, to beget guilt and to provoke punishment—punishment that appears in infinite guises, sometimes within a work itself in terms of form or content (as Bloom would have it) and sometimes in an artist's ambivalence about accepting or owning the work, finishing it, repeating (or refraining from repeating) aspects of it, or, in pervasive, crippling blocks against the possibility of new work altogether. Thus, to be an artist is to be locked in struggle, in veritable war, with casualties, wounds, and losses, between self-creation and self-negation. To abjure one's past is to forswear oneself—and yet, to be an artist is, somehow, to take hold continually of a new self, a new identity.

What then about life and work? Rank boldly brands all attempts of psychoanalysts to "explain" an artist's work by examining his life as misguided (1968:49, 50). Artists, he points out, often regard their work as more important than all the rest of life, which may be experienced (both consciously and unconsciously) as but a means to production—almost, in fact, a by-product of it. Thus, subjectively, the artist stands in a relation to the events of his life radi-

cally different from that assumed by many psychoanalytic authors who, failing to perceive this skewed relation, fail likewise to analyze its profound effects on the psyche. The failure is to see that life experience can, in a sense, be created as raw material for art—that, for the artist, it is art (rather than other areas of function and involvement, including even human relationships) that constitutes life's most central and intense adventure (see chapter 5).

Frequently, discordant loyalties are engendered by this asymmetrical relation between life and work. Efforts to balance compelling desires with irresistible demands may give rise to skirmishes between art and sexuality, art and morality. Focused and global clashes often occur between work and human values, between aesthetics and ethics, even between art and life taken in its most primitive sense as survival—survival not only of the artist but of those around her. Such conflicts though underexplored by psychoanalytic authors (or attributed disparagingly to the ever-expanding category of narcissistic pathology), are no news to artists themselves. Such struggles have been continuously dramatized in the arena of theater, in visual arts, literature, and music; they have been represented with pathos, with irony, even with self-contempt.

Consider, for example, Chekhov's unforgettable character Trigorin in *The Sea Gull*. The quintessential artist, he lives his life for the sake of his art. Unlike his youthful foil and counterpart, Trepliov, who cannot—despite himself—suborn his life for the sake of art and thus, unloved, must destroy himself, Trigorin is obsessed with turning life into art and, in so doing, destroys others. A writer, Trigorin walks about with a notebook, recording his life as he lives it. Chekhov satirizes him without mercy: this Trigorin who tells us that when he sees a cloud shaped like a grand piano he knows immediately that he must put it into some story or other, that every word and sentence uttered must be locked up in his literary pantry, that he yearns to exchange places with the young Nina Mihailovna just for one hour so that he can better create her as a character in the novel he is writing.

Guiltlessly, he seduces and abandons her. Possessed by art, he literally forgets the seagull—symbolic of his failure to experience life as responsibility to other beings. Fishing, his only competing passion, is yet another guise for the predatory cast of art toward life. *But*, Trigorin speaks also, just once, of pain—of the pain of devouring his own life for the sake of the honey he gives to others—of "despoiling my best flowers of their pollen—[of] plucking the flowers themselves and trampling on their roots." Narcissism alone

cannot adequately explain these inversions of art and life—which Chekhov's caricature serves to illuminate both because and in spite of his efforts to disavow them with parody and contempt. Driven by his art, the artist's life is distorted by it.

"Creation," claims Rank, "is itself an experience of the artist's, perhaps the most intense possible for him" (1968:384). If this is so, the phenomenology of this experience should be of paramount concern—an area once again underexplored by psychoanalytic discussions of the artist. How is it, for example, that, even at its most controlled, the process of creation erupts with surprise? That a work in its making, like an adolescent or a loyal disciple, can suddenly veer off on an errant path, leaving the artist then to survive anxiety and, by integrating the unpredictable shifts of force and direction, transform them into art?

In *Death in Venice*, Thomas Mann explores the ethical implications of this tendency of one's lived life to be subsumed by one's art. Wrestling with Aschenbach's desire for Tadzio, he implicitly asks: How *can* the artist live as a moral agent when his daily experience is continually in the process of transformation into art? Noted infrequently by psychologists, such themes are perennially addressed by philosophers, but clearly, as Rank points out, they engender psychic conflicts of proportions that can scarcely be overestimated.

What about the paradoxical and pervasive struggle of the artist *against* art? This is a battle, as Rank describes it, that crystallizes around resistance to the fragmentary and fragmenting quality of everyday existence. Shattered and inundated by stimuli, by the disjunctions, flux, and inexhaustibility of ordinary life, the sensitive artist may feel a compelling need to focus and concentrate his or her energy and total personality on a single task, a detail, no matter how seemingly insignificant. One thinks, in passing, of Italo Calvino's brilliant portrayal in *Palomar* (1983) of the eidetic artist *manqué*, as he tries to isolate the individual wave or star. However, the impulse to flee from life into creation—to immerse the whole of oneself, so to speak, in one's work—introduces new dangers. The flight itself becomes problematic. Having fled into creative effort in order to preserve the intactness of self in the face of multiple distractions, the artist now may feel engulfed and overwhelmed by the very totality of the developing creation. Her own productivity, in other words, may begin to constitute as great a danger as the everyday realities from which she originally sought refuge.

Hence, the artist begins now to struggle against her own creation. In an effort to avoid being submerged and dominated by the work, she seeks escape from it. To diffuse anxiety, for example, she may choose to work simultaneously on more than one project, dividing her attention among them. She may, perhaps, begin a second piece at a point when work on the first threatens to become all-absorbing. And, although this second piece, on superficial inspection, may appear unrelated in style and character to the first, it is often, on a deeper level, a continuation.

Without such a second focus, an artist may succumb to periods of depression, lassitude, even physical illness. Rank has stressed the point that, although such symptoms are commonly interpreted as the consequences *of* mental and physical exhaustion, they may, on a deeper level, represent precisely the reverse—namely, a flight *from* exhaustion (or annihilation). They may, in other words, function unconsciously as strategems of self-protection.

Rank also mentions time conflicts—notorious difficulties around beginnings and endings. Artists experience not only needs to escape threatened domination by the work in progress but wishes to hold back as long as possible from initiating it. Rank views these inhibitions as a further defense against being consumed by the creative process, and he derives the underlying anxiety here from more basic fears of both life and death—which in turn fragment the self and produce a desire for externalization in works. Paradoxically, however, whereas a completed work, in the sense that it can survive one's death, may serve as a comforting symbol of eternity, it may also signify death in that, as a completed thing, no longer in process, no longer growing or changing, it may itself seem dead and thus need either to be mourned, discarded, idealized, or enshrined. One thinks here of the enormous range of attitudes that characterize artists as they confront their completed pieces—from Albert Pinkham Ryder, for example (figure 12.1), who could not endure parting from his paintings, for years fussing and brooding over them continuously, to René Magritte, who could not separate quickly enough from each of them.

In addition, the creative process may itself be experienced as an analogue of death, involving, as Chekhov points out in Trigorin's earlier-quoted lines, exhaustive output and depletion of self. Thus, while the artist is driven by an irresistible impulse to externalize, to engender and to bring forth, he is simultaneously checked and caught by contradictory impulses stemming from fears of annihilation. Thus, Rank's larger theory of procreation conflict dovetails

with his theory of artistic creation. With undeniable intensity, life invades art: biography interpolates theory.

The relations of male artists to women are often discussed under the heading of the Muse. Rank makes the point that a chosen woman may serve as the single person for whom or in whose presence, about whom, or in opposition to whom, a male artist creates. In such a case, the artist's relationship with this woman becomes an integral part of his creative enterprise. Conflicts may intensify as the artist plays out through this beloved woman both in life and in art his inner struggles. The woman may become for him a symbol of an ideology that he once espoused but no longer finds adequate, an ideology that she may have helped him to create but that he now feels must be discarded. Thus, unable to create without her but at the same time prevented by her presence from further progress, he is torn. Although temporary restraints on abandoning her may seem predicated on guilt, such restraints may, in fact, be grounded more firmly in intrapsychic needs that concern his own development than in ethical principles or genuine concern for a once-loved companion. One thinks in this context of the troubled and mercurial relations that Picasso, Gauguin, and countless other painters experienced with the women in their lives.

For Rank, the Muse is the woman upon whom the male artist projects his bisexual creative fantasies—his desire to bear as well as to beget. Thus, each successive Muse may represent a partial replicative transference from the primordial mother—a symbol of eternal parturition and rebirth.

Thus, the male artist's fight with art is fought on many fronts. He struggles against the traditions out of which his art is made, contends against the dynamism of the work itself, and, finally, strives against its completion—lest he undergo an analogue of postpartem depression, terror, and loss—loss, that is, of himself.

In this manner, Rank reveals his exquisite sensitivity to the subjective experience of at least some working artists. Not content merely to reduce it to a special instance of more general phenomena inferred at higher levels of abstraction (i.e., sexuality and aggression), he invites us to focus on the nuances of its manifestations. As indicated, Rank's own early life significantly fired his desire to make sense for himself of various creative processes (biological, psychological, and intellectual) and to come to terms with latent fantasy. I have attempted to demonstrate both subtle and overt

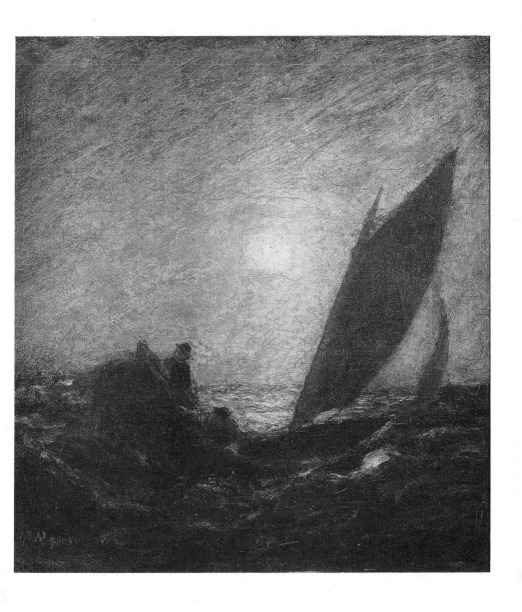

Figure 12.1 Albert Pinkham Ryder, *With Sloping Mast* (c. 1880s).
Canvas mounted on fiberboard 12 x 12 in. National Museum of American Art, Smithsonian
Institution, Washington, D.C. Photo cr.: Howard Jensen/Scala/Art Resource, New York.

links between his emphasis on birth and artistic creation. Hard-won, his ideas still possess a freshness and power to challenge us as we carry on the tradition of humanistic endeavor to which he also was so profoundly dedicated.

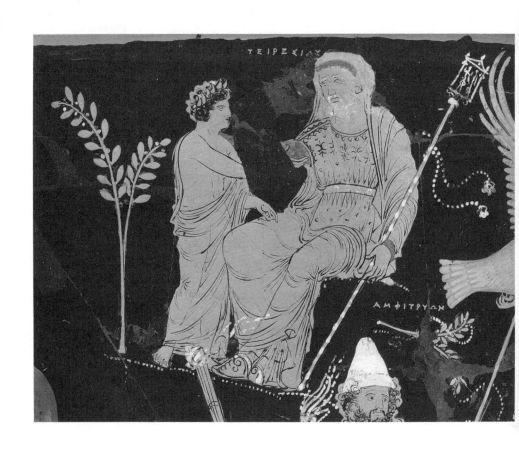

Figure 13.1. Teiresias.
Apulian Red-Figure Calyx-Krater c. 335–325 B.C. (detail). Attributed to the Darius painter (South Italian Greek). Ceramic. Museum of Fine Arts, Boston.

EPILOGUE

Hands, do what you're bid:
Bring the balloon of the mind
That bellies and drags in the wind
Into its narrow shed.

—William Butler Yeats

Struggling throughout this text to fix elusive notions of image and insight, I have been haunted by a strange figure—an androgynous seer who appears in many guises—benevolent and yet ominous, leering albeit paternal, wise but also absurd. As in my Preface, he seems to be Teiresias, the blind prophet of Greek mythology, a symbol for the many varieties of doubling that have surfaced here (figure 13.1). Not only a sightless man who "sees," Teiresias is an old man who in some respects plays or remains young, and, uniquely, he is a human being who has experienced life as both male and female. According to the ancient myth, after having observed two snakes coupling, Teiresias killed the female and was, temporarily, turned into a woman. Queried later by Zeus and Hera as to his then well-informed opinion about which of the sexes obtains the greatest pleasures in love, he responded unhesitatingly "the woman" and was punished by Hera with blindness but compensated by Zeus with gifts of prophecy and longevity. Thus, Teiresias, taken as an interpretive metaphor, might well serve as a primary signifier for a host of dualisms in our constructions of both art and psyche.

In these closing pages, I shall, very briefly, explore this metaphor as an interpretive strategy. Despite a long tradition that has associated creativity, artistic products, and the reception of art with notions of "wholeness," I have argued in the first chapter of this book that to do so might be considered a denial of "the most unkindest cut" of psychoanalysis. For, to accept any construct of artistic creativity or aesthetic receptivity that rests uncritically on such notions as the "wholeness of individuals" (except to do so ironically or perhaps in the psychoanalytic sense of the "imaginary") would be to risk misprising the most radical implications of the ubiquity of

the unconscious. Relentlessly, psychoanalysis, by demonstrating to us the infiltration of our reason by unreason, has rent our cherished cloak of wholeness and exposed it as a fiction. It has shattered even our supreme fiction of "a unified self." Like androgyny, "wholeness," *qua fantasy*, has been revealed by psychoanalysis as a cover for gaps, a bandage for wounds, a triumph over loss, and a denial of all those separations that paradoxically structure our very humanness.

Creativity, on the other hand, consists not only in covering, filling, constituting and completing, but also in displaying rupture and even occasionally in acting violently to isolate and to break, a topic I have broached in chapters 2, 9, 11, and 12 of this text. *Genesis*, our most tenacious and ambivalently cherished creation myth, describes the very making of the world as a series of magnificent separations. To link, therefore, fantasies of wholeness and androgyny with creativity, we must, as Euripides does in the *Bacchae*, make them count at least double. Momentarily androgynous (playing at being female), Pentheus learned to his tragic horror, meant being emphatically *not*. It meant being not only not male but not whole. It meant, in his case, not being: dismemberment and final blindness.

A Teiresian art criticism that privileges doubling and dialectic might therefore stress the bifurcations that flourish both in works of art and in our perceptions of them. It might work to prevent shortchanging the resistive density of the arts. Counteracting approaches that reductively shrink complex visual dynamics to mere emblems that "stand for" prefabricated formulae, it might generate narratives that have the potential to become critically relevant, that participate in genuine connoisseurship and figure non-reductively in the field of beholders (I recall with mixed emotions my interlocuter at the Magritte lecture, see Preface above). A Teiresian art criticism might address not only blatant/latent androgynous figuration in painting, say, but also its formal qualities—wildly exciting colors, perhaps, or serenely decorative patterned surfaces. It might emphasize an almost palpable or masked *aggression* that occasionally pervades such formal elements—and likewise the strained *containment* of that very aggression. It might give voice to silent dialogues that recur between works of art and their co-determining sociocultural, political, and economic matrices. To work well, however, such an approach would have to be capable of generating interpretive moves to which art itself, as subject and not merely object, could yield, resist, or in some way respond dialectically. If

not, it would offer us merely another example of verbal text laid neatly beside artifact in a hierarchical and/or sterile parallelism.

In his recent work on the painting of Courbet (see chapter 1), Michael Fried has spoken not only of the merging of masculinity and femininity in ways that challenge our conventional constructions of gender but has focused on the very act of painting itself which, *as intense bodily experience,* may actually figure in resultant imagery and in the experience of beholders. This vital notion, underexplored in psychoanalytic and other forms of artwriting, is addressed in my text in chapters 2, 5, and 12, and holds out intriguing possibilities for future critical work in both the visual and performing arts.

How else might Teiresias figure as a reference point around which to organize psychoanalytically fertile masses of data on artists' lives and work—vast primary sources swelled by thousands of pages of commentary, written texts as well as imagery in many media? One answer lies in allowing the metaphor itself to expand and proliferate. It might, for example, operate like a powerful lodestone, creating and delineating a magnetic field. As such, it could serve to draw details, as if they were particles, out of the art to an attractive surface.

Urging this image for a moment, I would like to extend it— spreading, as it were, its field of force: Imagine a bar magnet. Now, take this bar magnet and pass it slowly over the corpus of an artist's oeuvre. What you may begin to notice is that one form of doubling, say, plasticity in sexual identification, keeps company with a host of other conflicted dualisms. Conflation of maleness and femaleness may link by analogy with a range of problematic opposites so that, if we conjure up a body of well-known painting, we may catch on to a dialectic between visual details that relate both by opposition and by mirroring: dream and waking states, interiority and exteriority, substance and transparency, the human and the supernatural, living and dead, activity and inertia, duplicity and sincerity, versions of religiosity and their constructions of paganism—a tissue of uneasy couplings dramatized and merged by stunning colors that mask and betray a seething anxiety that stays choice. Our Teiresian bar magnet attracts sights where in art and life, artists (and beholders) struggle to achieve, evade, obviate, or transcend closure.

Yet, such criticism, while opening fields for both reflection and perception, entails its own species of blindness. For, despite our longing to experience simultaneously image and insight, the out-

ward and the inward gaze, we are chastened by the myth. It warns us that these modes are possible in sequence only and never without peril. Even as I write these words, however, moved by memories of the ancient tradition that inspires them, I sense that today, as this turbulent century draws to a close, those memories are fading. And to sense this is to ponder the limitations attendant on any (psychoanalytic) criticism of the arts: It is to wonder, quite radically perhaps, whether it may in our time prove necessary to reinvent not only the arts themselves—new ways of making and experiencing them—but also new ways of representing our own humanness. This is a topic that, like the ghostly figure of Teiresias, beckons from a moving place beyond the pages of my book. . .

REFERENCES

Anzieu, Didier. 1986. *Freud's Self-Analysis*. Peter Graham, tr. Madison, Conn.: International Universities Press.

Aristotle. *Poetics*. In Albert Hofstadter and Richard Kuhns, eds., *Philosophies of Art and Beauty: Selected Readings in Aesthetics from Plato to Heidegger*. Chicago and London: University of Chicago Press, 1964.

Arlow, Jacob. In press. Derivative manifestations of perversions. In Gerald I. Fogel and Wayne C. Myers, eds., *The Perverse and the Near Perverse in Everyday Life*. New Haven and London: Yale University Press.

Arnheim, Rudolf, 1966. *Toward a Psychology of Art*. Berkeley: University of California Press.

—— 1969. *Visual Thinking*. Berkeley: University of California Press.

—— 1974. *Art and Visual Perception*. Berkeley: University of California Press.

—— 1986. *New Essays on the Psychology of Art*. Berkeley: University of California Press.

Artaud, Antonin. 1976. *Selected Writings*. Susan Sontag, ed. Berkeley and Los Angeles: University of California Press.

Arthur, Marilyn. 1977. Politics and pomegranates: An interpretation of the Homeric *Hymn to Demeter*. *Arethusa* 10:7–47.

Auden, W. H. 1961. *Van Gogh. A Self-Portrait: Letters Revealing His Life as a Painter. Selected by W. H. Auden*. Greenwich, Conn.: New York Graphic Society.

The Babylonian Talmud, Tractate Shabbat 119A.

Balmary, Marie. 1979. *Psychoanalyzing Psychoanalysis: Freud and the Hidden Fault of the Father*. Ned Lukacher, tr., Baltimore: Johns Hopkins University Press.

Balter, Leon. 1981. Cabaret: The clinical exploration of a film. Lecture (Grand Rounds) presented at The New York Hospital-Cornell Medical Center, Westchester Division, June 19, 1981.

Barthes, Roland. 1972. *Mythologies*. Annette Lavers, tr. New York: Hill & Wang. (Originally published in 1957, Paris: Editions du Seuil.)

—— 1975. *The Pleasure of the Text*. R. Miller, tr. New York: Hill and Wang.

—— 1982. *A Barthes Reader*. Susan Sontag, ed. New York: Hill and Wang.

Bernheimer, Charles and Claire Kahane, eds. 1985. *In Dora's Case.* New York: Columbia University Press.

Bernstein, Jeanne W. 1987. Enframing the gaze: A psychoanalytic exploration of Edouard Manet's works. Paper presented at the Art History and Psychoanalysis Symposium, College Art Association, Boston, February 14, 1987.

Bernstein, Richard. 1989. Being nice or rotten in writing. *New York Times* 10/2/89, C15, C21.

Bersani, Leo. 1986. *The Freudian Body: Psychoanalysis and Art.* New York: Columbia University Press.

Bettelheim, Bruno. 1982. *Freud and Man's Soul.* New York: Knopf.

Bloom, Harold. 1975. *The Anxiety of Influence: A Theory of Poetry.* London: Oxford University Press.

Blos, Peter. 1962. *On Adolescence: A Psychoanalytic Interpretation.* New York. Free Press.

The Book of the Thousand Nights and One Night. 1972. Powys Mathers, tr. 4 vols. New York: St. Martin's Press.

Bouwsma, O.K. 1954. The expression theory of art. In M. Philipson and P. J. Gudel, eds., *Aesthetics Today*, pp. 243–266. New York: New American Library, rev. ed., 1980.

Bryson, Norman. 1981. *Word and Image: French Painting of the Ancien Régime.* Cambridge: Cambridge University Press.

—— 1983. *Vision and Painting: The Logic of the Gaze.* New Haven and London: Yale University Press.

—— 1984. *Tradition and Desire: From David to Delacroix.* Cambridge and London: Cambridge University Press.

Burkert, Walter. 1979. *Structure and History in Greek Mythology and Ritual.* Berkeley: University of California Press.

Calvino, Italo. 1983. *Mr. Palomar.* William Weaver, tr. San Diego: Harcourt Brace Jovanovich.

Carlin, John. 1986. Bombing History. Paper read in the Symposium: Art Without History, College Art Association, Boston, February 1987.

Castleman, C. 1982. *Getting Up.* Cambridge: MIT Press.

Cavell, Stanley. 1987. Freud and philosophy: A fragment. *Critical Inquiry* 13:386–393.

Cennini, Cennino. c. 1400. *The Craftsman's Handbook: Il Libro dell' Arte.* D. V. Thompson, Jr., tr. New York: Dover, 1960.

Chasseguet-Smirgel, Janine. 1983. Perversion and the universal law. *International Review of Psycho-Analysis* 10:293–301.

—— 1985. *Creativity and Perversion.* New York and London: Norton.

Clark, T. J. 1984. *The Painting of Modern Life.* Princeton: Princeton University Press.

Clay, Jenny Strauss. 1989. *The Politics of Olympus.* Princeton: Princeton University Press.

Coleman, D. 1988. A new index illuminates the creative life. *New York Times* 9/13; C1,9.

Cooper, Martha and Henry Chalfant. 1984. *Subway Art.* London: Thames and Hudson, Ltd.

Crapanzano, Vincent. 1987. Talking (about) psychoanalysis. The Fourth Abram Kardiner Lecture, sponsored by the Association for Psychoanalytic Medicine, delivered at the New York Academy of Medicine, February 3, 1987.

Crumb, George. 1970. *Ancient Voices of Children.* New York: C. F. Peters.

Dahl, E. Kirsten. 1989. Daughters and mothers: Oedipal aspects of the witch-mother. *The Psychoanalytic Study of the Child* 44:267–280.

Dante Alighieri. *The Inferno: The Paradiso.* John Ciardi, tr. New York: Mentor, 1954.

DAEDALUS. Twelve to Sixteen: Early Adolescence. Vol. 100, No. 4, of the Proceedings of the American Academy of Arts and Sciences, Fall 1971.

Danto, Arthur. 1981. *The Transformation of the Commonplace.* Cambridge: Harvard University Press. 1981.

Davis, A. Whitney. 1987. History and the first image. Lecture given at the College Art Association Annual Meeting, Boston, February 11, 1987.

Davidson, Arnold I. 1987. How to do the history of psychoanalysis: A reading of Freud's *Three Essays on the Theory of Sexuality. Critical Inquiry* 13(2):252–277.

Derrida, Jacques. 1975. The purveyor of truth. *Yale French Studies* 52: 31–114.

de Romilly, Jacqueline. 1985. *A Short History of Greek Literature.* Lillian Doherty, tr. Chicago and London: University of Chicago Press.

Detienne, Marcel. 1979. *Dionysos Slain.* Mireille Muellner and Leonard Muellner, trs. Baltimore and London: Johns Hopkins University Press.

Devereux, George. 1970. The psychotherapy scene in Euripides' "Bacchae." *Journal of Hellenic Studies* 90:35–48.

—— 1976. *Dreams in Greek Tragedy: An Ethno-Psychoanalytic Study.* Berkeley and Los Angeles: University of California Press.

Dialogue. 1987. Roger Brown: A universal language of the eye. 10(5):25–29.

Drewel, Henry John. 1988. Editor's statement: Object and intellect: Interpretations of meaning in African art. *Art Journal* 47(2):71–74.

duBois, Page. 1988. *Sowing the Body: Psychoanalysis and Ancient Representations of Women.* Chicago and London: University of Chicago Press.

Edmunds, Lowell. 1985. *Oedipus: The Ancient Legend and Its Later Analogues.* Baltimore: Johns Hopkins University Press.

Eisenstein, Samuel. 1966. Otto Rank: The myth of the birth of the hero. In F. Alexander, S. Eisenstein, and M. Grotjahn, eds., *Psychoanalytic Pioneers.* New York: Basic Books.

Erikson, Erik H. 1950. *Childhood and Society.* New York: Norton.

—— 1959. *Identity and the Life Cycle.* New York: International Universities Press.

—— 1968. *Identity, Youth, and Crisis.* New York: Norton.

—— Euripides. *Iphigenia in Aulis.* Charles R. Walker, tr., *Euripides IV.* Chicago: University of Chicago Press, 1958.

—— *The Bacchae.* William Arrowsmith, tr. In David Grene and Richmond Lattimore, eds., *Euripides V.* Chicago and London: University of Chicago Press, 1959.

—— *The Bacchae.* Geoffrey S. Kirk, tr. Englewood Cliffs, N.J.: Prentice Hall, 1970.

—— *Hecuba.* In Arthur S. Way, tr., *Euripides I: Iphigenia in Aulis; Rhesus; Hecuba; The Daughters of Troy; Helen.* Loeb Classical Library. Cambridge, Mass.: Harvard University Press; London: William Heinemann, 1978.

Feder, Stuart. 1978. Gustav Mahler, dying. *International Review of Psychoanalysis* 5:125–148.

—— 1980a. Gustav Mahler um Mitternacht. *International Review of Psychoanalysis* 7:11–26.

—— 1980b. Decoration day: A boyhood memory of Charles Ives. *The Musical Quarterly* 66:234–261.

—— 1981. Gustav Mahler: The music of fratricide. *International Review of Psychoanalysis* 8:257–284.

—— 1982. The nostalgia of Charles Ives: An essay in affects and music. *The Annual of Psychoanalysis* 10:301–332.

—— 1984. Charles Ives and the unanswered question. *The Psychoanalytic Study of Society* 10:321–351.

Feigelson, Thomas E. 1984. Sophocles' *Oedipus at Colonus:* Tragic agon and interpretation. Senior essay, Yale University, New Haven.

Feiner, Joel S. and S. M. Klein. 1982. Graffiti talks. *Social Policy* (Winter), pp. 47–53.

Felman, Shoshana, ed. 1982. *Literature and Psychoanalysis: The Question of Reading: Otherwise.* Baltimore and London: Johns Hopkins University Press.

Fine, J.V.A. 1983. *The Ancient Greeks: A Critical History.* Cambridge and London: Harvard University Press.

Foley, Helene P. 1985. *Ritual Sacrifice: Poetry and Sacrifice in Euripides.* Ithaca and London: Cornell University Press.

Fowles, John. 1969. *The French Lieutenant's Woman.* Boston: Little, Brown.

Freedberg, David. 1985. *Iconoclasts and Their Motives.* Maarssen, The Netherlands: Gary Schwartz.

—— 1989. The legacy of the second commandment: Jewish attitudes to art and their influence. The Gertrude Hallo Memorial Lecture, The Jewish Museum, April 9, 1989.

Freud, Sigmund. *Standard Edition of the Complete Psychological Works of Sigmund Freud.* 24 vols. James Strachey, tr. and ed. London: Hogarth Press, 1953–1974.

—— 1900–1901. *The Interpretation of Dreams. S.E.,* vols. 4 and 5.

—— 1905a. Fragment of an analysis of a case of hysteria. *S.E.* 7:7–122.

—— 1905b. *Jokes and Their Relation to the Unconscious*. *S.E.* 8:3–249.

—— 1905c. Psychopathic characters on the stage. *S.E.* 7:305–310.

—— 1905d. Three essays on the theory of sexuality. *S.E.* 7:125–243.

—— 1907. Delusions and dreams in Jensen's *Gradiva*. *S.E.* 9:3–95.

—— 1910a. *Leonardo da Vinci and a Memory of His Childhood*. *S.E.* 11:59–137.

—— 1910b. A special kind of object choice made by men (Contributions to the psychology of love). *S.E.* 11:164–175.

—— 1910c. The taboo of virginity (Contributions to the psychology of love), *S.E.* 11:200–208.

—— 1913. The theme of the three caskets. *S.E.* 12:291–301.

—— 1914. The Moses of Michelangelo. *S.E.* 13:210–238.

—— 1916. A mythological parallel to a visual obsession. *S.E.* 14:337–338.

—— 1917. Mourning and melancholia. *S.E.* 14:239–58.

—— 1919. The uncanny. *S.E.* 17:219–256.

—— 1920. *Beyond the Pleasure Principle*. *S.E.* 18:3–64.

—— 1923. *The Ego and the Id*. *S.E.* 19:12–66.

—— 1925. Negation. *S.E.* 19:235–239.

—— 1931. Female Sexuality. *S.E.* 19:225–243.

—— 1933. New Introductory lectures on psychoanalysis. *S.E.* 22:3–182.

—— 1939. *Moses and Monotheism*. *S.E.* 23:7–137. *S.E.* 22:3–182.

Freud, S. and J. Breuer. 1893–95. *Studies on Hysteria*. *S.E.*, vol. 2.

Fried, Michael. 1978. The beholder in Courbet: His early self-portraits and their place in his art. *Glyph*, no. 4, pp. 85–129. Baltimore: Johns Hopkins Textual Studies.

—— 1980. *Absorption and Theatricality: Painting and Beholder in the Age of Diderot*. Berkeley: University of California Press.

—— 1987. Courbet's Femininity. Paper presented at the Art History and Psychoanalysis Symposium, CAA, Boston, February 14, 1987.

—— 1988. Courbet's "Femininity." In Sarah Faunce and Linda Nochlin, eds., *Courbet Reconsidered*. New Haven and London: Yale University Press.

Fuller, Peter, Jr. 1980. *Art and Psychoanalysis*. London: Writers and Readers' Publishing Cooperative.

Gallop, Jane. 1987. Reading the (m)other tongue: Psychoanalytic feminist criticism. *Critical Inquiry* 13:314–329.

Gay, Peter. 1988. *Freud: A Life for Our Time*. New York: Norton.

Gedo, John. 1983. *Portraits of the Artist*. New York and London: Guilford Press.

Gilman, Sander. 1987. The struggle of psychiatry with psychoanalysis: Who won? *Critical Inquiry* 13:293–313.

Gombrich, E. H. 1960. *Art and Illusion*. Princeton: Princeton University Press.

Gouma-Peterson, Thalia and Patricia Mathews. 1987. The feminist critique of art history. *The Art Bulletin* 69:326–357.

Green, André. 1979. *The Tragic Effect: The Oedipus Complex in Tragedy*.

Alan Sheridan, tr. Cambridge, London, New York: Cambridge University Press.

Greenacre, Phyllis. 1957. The childhood of the artist: Libidinal phase development and giftedness. In *Emotional Growth: Psychoanalytic Studies of the Gifted and a Great Variety of Other Individuals*, vol. 2. New York: International Universities Press, 1971.

Grene, David and Richard Lattimore, eds. 1954. *The Complete Greek Tragedies: Sophocles I*. David Grene and R. Fitzgerald, tr. Chicago: University of Chicago Press.

Hampshire, Stuart. 1952. Logic and appreciation. In W. E. Kennick, ed., *Art and Philosophy*. New York: St. Martin's, 1979, pp. 651–657.

—— 1966. Types of interpretation. *Art and Philosophy: Readings in Aesthetics*. W. E. Kennick, ed. New York: St. Martin's.

Hansberry, Lorraine. 1959/1987. *A Raisin in the Sun*. New York: New American Library.

Heidegger, Martin. 1971. *Poetry, Language, Thought*. Albert Hofstadter, tr. New York: Harper & Row.

Herman, Nini. 1989. *Too Long a Child: The Mother-Daughter Dyad*. London: Free Association Books.

Harsh, P. W. 1979. *A Handbook of Classical Drama*. Stanford: Stanford University Press. (Originally published in 1944.)

The Homeric Hymn to Demeter. In H. G. Evelyn-White, tr., *Hesiod. The Homeric Hymns and Homerica*. Loeb Classical Library. Cambridge: Harvard University Press; London: William Heinemann, 1924.

Holland, Norman. 1980. Re-covering "The Purloined Letter": Reading as a personal transaction. In S. R. Suleiman and I. Crosman, eds., *The Reader in the Text*. Princeton: University Press.

Hopkins, Gerald Manley. 1877. God's grandeur. In G. D. Sanders, J. H. Nelson, and M. L. Rosenthal, eds., *Chief Modern Poets of England and America*. Vol. 1. New York: St. Martin's.

Huart, C. 1903. *A History of Arabic Literature*. New York: Appleton.

Isenberg, Arnold. 1973. *Aesthetics and the Theory of Criticism*, W. Callaghan et al., eds. Chicago: University of Chicago Press.

Johnson, Barbara. 1977. The frame of reference: Poe, Lacan, Derrida. *Yale French Studies*. 55/56:457–505.

Kainer, Rochelle G.K. 1984. Art and the canvas of the self: Otto Rank and creative transcendence. *American Imago* (Winter 1984) 41(4):359–372.

Kant, Immanuel. 1790. *The Critique of Judgement*. J. C. Meredith, tr. Oxford: Clarendon, 1978.

Kincaid, Jamaica. 1983. *Annie John*. New York: New American Library.

Kirk, Geoffrey S. 1970, *See* Euripides.

Kivy, Peter. 1980. *The Corded Shell*. Princeton: Princeton University Press.

Klein, Melanie. 1975. *Envy and Gratitude and Other Works. 1946–1963*. New York: Delacorte/Seymour Lawrence.

Kris, Ernst. 1952. *Psychoanalytic Explorations in Art*. New York: International Universities Press.

Kuhns, Richard. 1983. *Psychoanalytic Theory of Art*. New York: Columbia University Press.

Kuspit, Donald. 1987. Traditional art history's complaint against the linguistic analysis of visual art. *Journal of Aesthetics and Art Criticism* 45:345–349.

Kutash, Emilie. 1987. Archaic self and object imagery in modern figurative sculpture. *American Imago* 44(4):289–313.

Lacan, Jacques. 1977. *Ecrits: A Selection*. A. Sheridan, tr. New York and London: Norton.

—— 1980. Seminar on "The Purloined Letter." In M. Philipson and P. J. Gudel, eds., *Aesthetics Today*, pp. 382–412. New York: New American Library.

Langer, Susanne. 1953. *Feeling and Form: A Theory of Art*. New York: Scribner's.

Leavy, Stanley. 1985. Demythologizing Oedipus. *Psychoanalytic Quarterly* 54:444–454.

Lévi-Strauss, Claude. 1969. *The Elementary Structures of Kinship*. James Harle Bell, Richard von Sturmer, and Rodney Needham, trs. Boston: Beacon.

Lieberman, E. James. 1985. *Acts and Will: The Life and Work of Otto Rank*. New York: Free Press.

Liebert, Robert. 1983. *Michelangelo: A Psychoanalytic Study of His Life and Images*. New Haven and London: Yale University Press.

Loewald, Hans W. 1985. Oedipus complex and development of self. *Psychoanalytic Quarterly* 54:435–443.

Loraux, Nicole. 1987. *Tragic Ways of Killing a Woman*. Anthony Forster, tr. Cambridge and London: Harvard University Press.

Lorca, Federico García. 1955. *Selected Poems*. New York: New Directions.

Mahler, Margaret S. 1968. *On Human Symbiosis and the Vicissitudes of Individuation*. New York: International Universities Press.

—— 1972. On the first three subphases of the separation-individuation process. *International Journal of Psychoanalysis* 53:333–338.

Mahler, Margaret S., Fred Pine, and Anni Bergman. 1975. *The Psychological Birth of the Human Infant*. New York: Basic Books.

Mailer, Norman. 1974. *The Faith of Graffiti*. M. Kurlansky and J. Naar, eds. New York: Praeger.

Malraux, André. 1963. *Museum Without Walls. The Psychology of Art* 1. Garden City, N.Y.: Doubleday. (Originally published in 1947.)

Masson, Jeffrey. 1984. *The Assault on Truth: Freud's Suppression of the Seduction Theory*. New York: Farrar, Strauss, and Giroux.

McDougall, Joyce. 1980. *Plea for a Measure of Abnormality*. New York: International Universities Press.

—— 1982. *Théâtres du Je*. Paris: Editions Gallimard.

—— 1986. *Theaters of the Mind: Illusion and Truth on the Psychoanalytic Stage*. New York: Basic Books.

Mehlman, Jeffrey. 1980. Poe pourri: Lacan's Purloined Letter. In M. Philip-

son and P. J. Gudel, eds., *Aesthetics Today*, pp. 413–433. New York: New American Library.

Meltzer, Françoise. 1987. Editor's introduction: Partitive plays, pipe dreams. In *The trials of psychoanalysis. Critical Inquiry* 13(2):215–221.

Meltzer, Françoise, ed. 1988. *The Trial(s) of Psychoanalysis.* Chicago: University of Chicago Press.

Menaker, Esther. 1982. *Otto Rank. A Rediscovered Legacy.* New York: Columbia University Press.

Merleau-Ponty, Maurice. 1948. Cézanne's doubt. In H. L. Dreyfus and P. A. Dreyfus, trs., *Sense and Non-Sense.* Evanston: Northwestern University Press, 1982.

Meyers, Helen. In press. Perversions of everyday life: perversion in fantasy and furtive enactments. In Gerald I. Fogel and Wayne C. Myers, eds., *The Perverse and the Near Perverse in Everyday Life.* New Haven and London: Yale University Press.

Michels, Robert. 1983. The scientific and clinical functions of psychoanalysis. New York: International Universities Press.

—— June 1985. How psychoanalysts use theory. Paper presented to the Westchester Psychoanalytic Society, New York.

—— 1988. Psychoanalysts' theories. The Freud Memorial Lecture, University College, London, June 25, 1988.

—— 1986. Oedipus and insight. *Psychoanalytic Quarterly* 55:599–617.

Miller, Alice. 1981. *The Drama of the Gifted Child.* New York: Basic Books.

Mitchell, Donald, ed. 1946. *Gustav Mahler: Memories and Letters.* Seattle: University of Washington Press.

Mitchell, W. J. T. 1986. *Iconology: Image, Text, Ideology.* Chicago: University of Chicago Press.

√Mothersill, Mary. 1984. *Beauty Restored.* Oxford: Clarendon Press.

Muller, J. P. and W. J. Richardson, eds. 1988. *The Purloined Poe: Lacan, Derrida, and Psychoanalytic Reading.* Baltimore: Johns Hopkins University Press.

Nicholson, R. A. 1966. *A Literary History of the Arabs*, pp. 456–459. Cambridge: Cambridge University Press.

Nin, Anaïs. 1966. *The Diary of Anaïs Nin.* Vol. 1:*1931–1934.* New York: Harcourt, Brace, and World.

Nochlin, Linda. 1988. Courbet's real allegory: Rereading "The Painter's Studio." In Sarah Faunce and Linda Nochlin, eds., *Courbet Reconsidered.* New Haven and London: Yale University Press.

Oldenburg, Claes. 1967. *Store Days.* New York: Something Else.

Ovid. *The Metamorphoses.* Mary M. Innes, tr. Harmondsworth, Middlesex, England: Penguin, 1955.

Ozick, Cynthia. 1989 *The Shawl.* New York: Knopf.

Panofsky, Erwin. 1955. *Meaning in the Visual Arts.* New York: Doubleday/Anchor Books.

Perspectives: Angles on African Art. 1987. New York: The Center for African Art and Harry N. Abrams.

Poe, Edgar Allan. 1956. The Purloined Letter. In *Great Tales and Poems of Edgar Allan Poe*, pp. 199–219. New York: Pocket Library.

Pollock, George H. and John M. Ross, eds. 1988. *The Oedipus Papers*. Madison, Conn.: International Universities Press.

Poseq, Avigdor. 1989. Caravaggio's Medusa shield. *Gazette des Beaux-Arts*. (April 1989):170–174.

Rand, N. and M. Torok. 1987. The secret of psychoanalysis: History reads theory. *Critical Inquiry* 13:278–292.

Rank, Otto. 1907. *Der Künstler*. Vienna: Hugo Heller.

—— 1929. *The Trauma of Birth*. New York: Harcourt, Brace. (Originally published in 1924.)

—— 1959. *The Myth of the Birth of the Hero and Other Writings*. P. Freund, ed. New York: Vintage Books. (Original work published 1914.)

—— 1968. *Art and Artist*. C. F. Atkinson, tr. New York: Agathon. (Originally published in 1932.)

Raynor, W. 1984. The case against Simone. *Connoisseur* 214:60–61. (*See also* Discussion in 215:161–162, 1985.)

Richardson, William. 1985. Lacanian theory. In Arnold Rothstein, ed., *Models of the Mind: Their Relationships to Clinical Work*, Workshop Series of the American Psychoanalytic Association. Monograph One. New York: International Universities Press.

Riffaterre, Michael. 1987. The intertextual unconscious. *Critical Inquiry* 13:371–385.

Roazen, Paul. 1971. *Freud and His Followers*. New York: New American Library.

Roiphe, Anne. 1987. *Lovingkindness*. New York: Summit Books.

Rose, Gilbert. 1978. The creativity of everyday life. In S. A. Grolnick, L. Barkin, and W. Muensterberger, eds., *Between Reality and Fantasy*. New York: Jason Aronson.

—— 1980. *The Power of Form*. New York: International Universities Press.

—— 1987. *Trauma and Mastery in Life and Art*. New Haven and London: Yale University Press.

Rose, H. L. 1959. *A Handbook of Greek Mythology*. New York: Dutton.

Rosenblum, Robert. 1986. First Love. *New York University Magazine*, pp. 48–54.

Rudnytsky, Peter L. 1984. Rank: Beyond Freud? *American Imago* (Winter 1984), 41(4):325–341.

—— 1987. *Freud and Oedipus*. New York: Columbia University Press.

Saito, Y. 1985. Why restore works of art? *Journal of Aesthetics and Art Criticism* 44:141–151.

Schmitt, Abraham. 1975. Otto Rank. In Alfred M. Freedman, Harold I. Kaplan, and Benjamin J. Sadock, eds., *Comprehensive Textbook of Psychiatry/II* 1:637–641. Baltimore: Wiliams and Wilkins.

Schneider, Laurie. 1976. Donatello and Caravaggio: The iconography of decapitation. *American Imago* 33:72–91.

—— 1985. The theme of mother and child in the art of Henry Moore. In

Mary M. Gedo, ed., *Psychoanalytic Perspectives on Art*. Hillsdale, N. J.: Analytic Press.

Segal, Charles. 1978. Visual symbolism and visual effects in Sophocles. *Classical World* 72:125–142.

—— 1982. *Dionysiac Poetics and Euripides' "Bacchae"*. Princeton: Princeton University Press.

—— 1986. *Interpreting Greek Tragedy: Myth, Poetry, Text*. Ithaca and London: Cornell University Press.

Seif, Nancy Gordon. 1984. Otto Rank: On the nature of the hero. *American Imago* 41(4):373–384.

Sheon, Aaron. 1987. Van Gogh's "Sense of self" and his interpreters. Paper read at the Symposium, Art History and Psychoanalysis, College Art Association, Boston, February 1987.

Simon, Bennett. 1978. *Mind and Madness in Ancient Greece*. Ithaca and London: Cornell University Press.

—— 1984. "With cunning delays and ever-mounting excitement," or, What thickens the plot in tragedy and psychoanalysis. In John Gedo and George Pollock, eds, *The Vital Issues*, 2:387–434. New York: International Universities Press.

—— 1988. *Tragic Drama and the Family: Psychoanalytic Studies from Aeschylus to Beckett*. New Haven and London: Yale University Press.

Slater, Phillip E. 1968. *The Glory of Hera: Greek Mythology and the Greek Family*. Boston: Beacon.

Slochower, Harry. 1984. Rank's mythic hero and the creative will. *American Imago* 41(4):385–387.

Sophocles. *Antigone*. In Elizabeth Wycoff, tr., *Sophocles I*. Chicago: University of Chicago Press, 1954.

Spitz, Ellen Handler. 1985. *Art and Psyche: A Study in Psychoanalysis and Aesthetics*. New Haven and London: Yale University Press.

—— 1988. The inescapability of tragedy. In *Bulletin of the Menninger Clinic* 52:377–382. (See chapter 7 of this text.)

—— 1988. An insubstantial pageant faded. *Art Criticism* 4(3):50–63. (See chapter 2 of this text.)

—— 1989. Psychoanalysis and the legacies of antiquity. In Lynn Gamwell and Richard Wells, eds., *Freud and Art*. New York and London: Abrams.

Spitz, René A. 1965. *The First Year of Life*. New York: International Universities Press.

Steinberg, Leo. 1984a. *The Sexuality of Christ in Renaissance Art and in Modern Oblivion*. New York: Pantheon.

—— June 28, 1984b. Shrinking Michelangelo. *New York Review of Books*, pp. 41–45.

Stern, Daniel N. 1985. *The Interpersonal World of the Infant*. New York: Basic Books.

Stern, Laurent. 1980. On interpreting. *Journal of Aesthetics and Art Criticism* 39:119–29.

Stewart, H. 1961. Jocasta's crimes. *The International Journal of Psycho-Analysis* 42:424–430.

Stoller, Robert J. 1985. *Presentations of Gender*. New Haven and London: Yale University Press.

Stone, Leo. 1961. *The Psychoanalytic Situation*. New York: International Universities Press.

Tan, Amy. 1989. *The Joy Luck Club*. New York: Putnam.

Thompson, Robert Farris. 1987. Kongo—New Orleans, Kongo—Carolina: Recent Discoveries. Lecture delivered at the Center for African Art, October 21, 1987.

Tormey, A. 1978. Art and expression. In J. Margolis, ed., *Philosophy Looks at the Arts*, pp. 346–361. Philadelphia: Temple University Press.

Tunstall, P. 1979. Structuralism and musicology: An overview. *Current Musicology* 27:51–64.

Vernant, Jean-Paul and Pierre Vidal-Naquet. 1981. *Tragedy and Myth in Ancient Greece*. Janet Lloyd, tr. Atlantic Highlands, N.J.: Humanities Press.

Vidal-Naquet, Pierre. 1986. *The Black Hunter: Forms of Thought and Forms of Society in the Greek World*. Andrew Szegedy-Maszak, tr. Baltimore and London: Johns Hopkins University Press.

Vogel, Susan M. 1986. *Aesthetics of African Art: The Carlo Monzino Collection*. New York: Center for African Art.

Winnicott, Donald W. 1947. Hate in the countertransference. *Through Paediatrics to Psycho-analysis*. London: Hogarth, 1958.

—— 1953. Transitional objects and transitional phenomena. *International Journal of Psychoanalysis* 34:89–97.

—— 1956. The anti-social tendency. In *Collected Papers*. New York: Basic Books, 1958.

—— 1956. Primary maternal preoccupation. *Through Paediatrics to Psycho-analysis*. London: Hogarth, 1958.

—— 1965. *Maturational Processes and the Facilitating Environment*. New York: International Universities Press.

—— 1966. The location of cultural experience. *The International Journal of Psycho-analysis* 34:368–372.

Wright, Elizabeth. 1984. *Psychoanalytic Criticism: Theory in Practice*. London and New York: Methuen.

Yang, Emoretta. 1987. Letters of mourning and melancholy: The case of Watteau criticism. Paper read at the Symposium, Art History and Psychoanalysis, College Art Association, Boston, February 1987.

Yeats, William Butler. 1960. *The Collected Poems of William Butler Yeats*. New York: Macmillan.

Young-Bruehl, Elizabeth. 1988. *Anna Freud: A Biography*. New York: Summit Books.

—— 1989. Looking for Anna Freud's mother. *The Psychoanalytic Study of the Child* 44:391–408.

Zeitlin, Froma. 1985. Playing the other: Theater, theatricality, and the feminine in Greek drama. *Representations* (Summer) 11:63–94.

INDEX

PSYCHOANALYSIS AND CULTURE
A series of Columbia University Press

Edited by Arnold M. Cooper, M.D. and Steven Marcus

Nightmares and Human Conflict
John E. Mack, M.D.

Freud and Oedipus
Peter L. Rudnytsky

Adolescence and Culture
Aaron H. Esman, M.D.